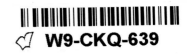

RUSSIAN IMPRESSIONISTS

and

postimpressionists

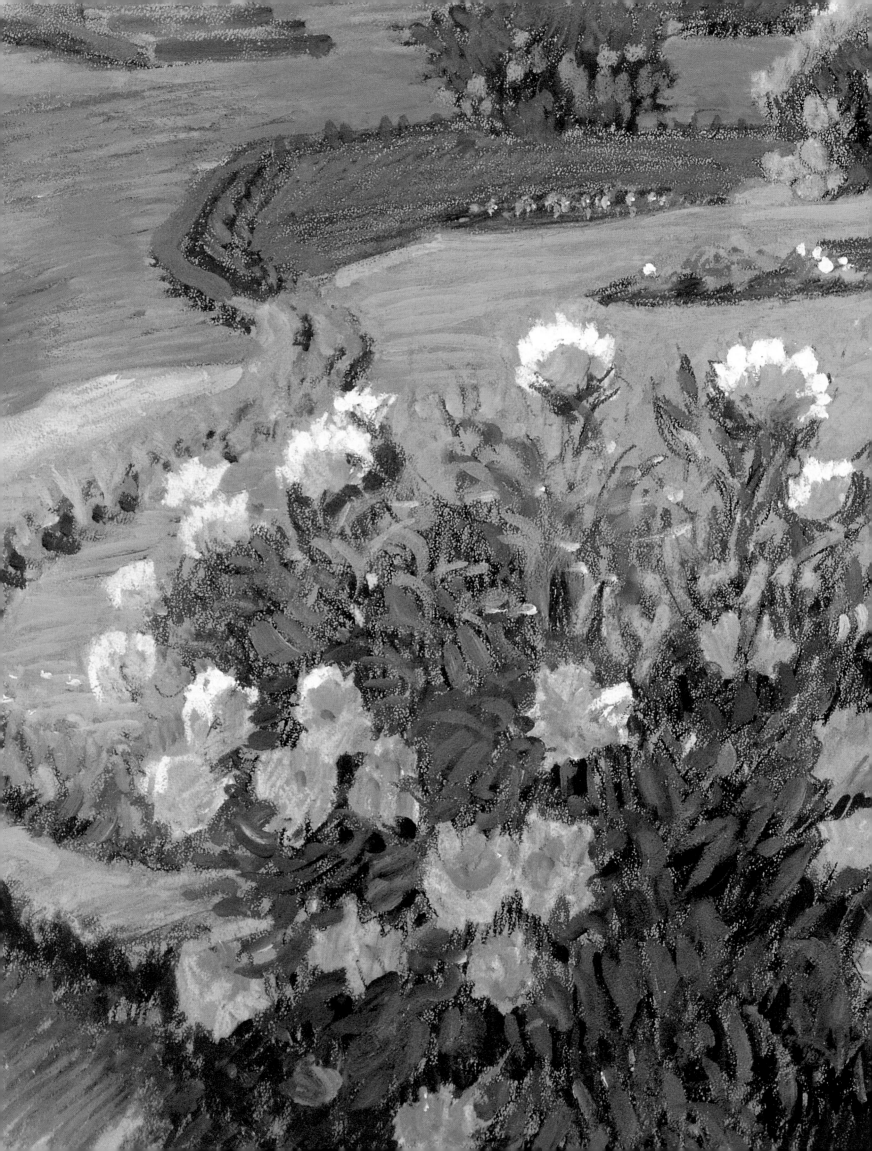

Previous page
1. Sergei Vinogradov
The Garden. 1910
Regional Museum of Fine Art, Irkutsk

Next page
2. Igor Grabar
September snow. 1903
Tretiakov Gallery, Moscow

Publishing Director: *Paul André*
Translated into English by: *Chandra Troescher*
Design: *Parkstone Press*
Typesetting: *Media Lengua*
Coordination: *Chantal Jameux*
Assistant: *Céline Gallot*

Printed in Europe
ISBN 1 85995 340 9

RUSSIAN IMPRESSIONISTS

and

postimpressionists

PARKSTONE PRESS

CONTENTS

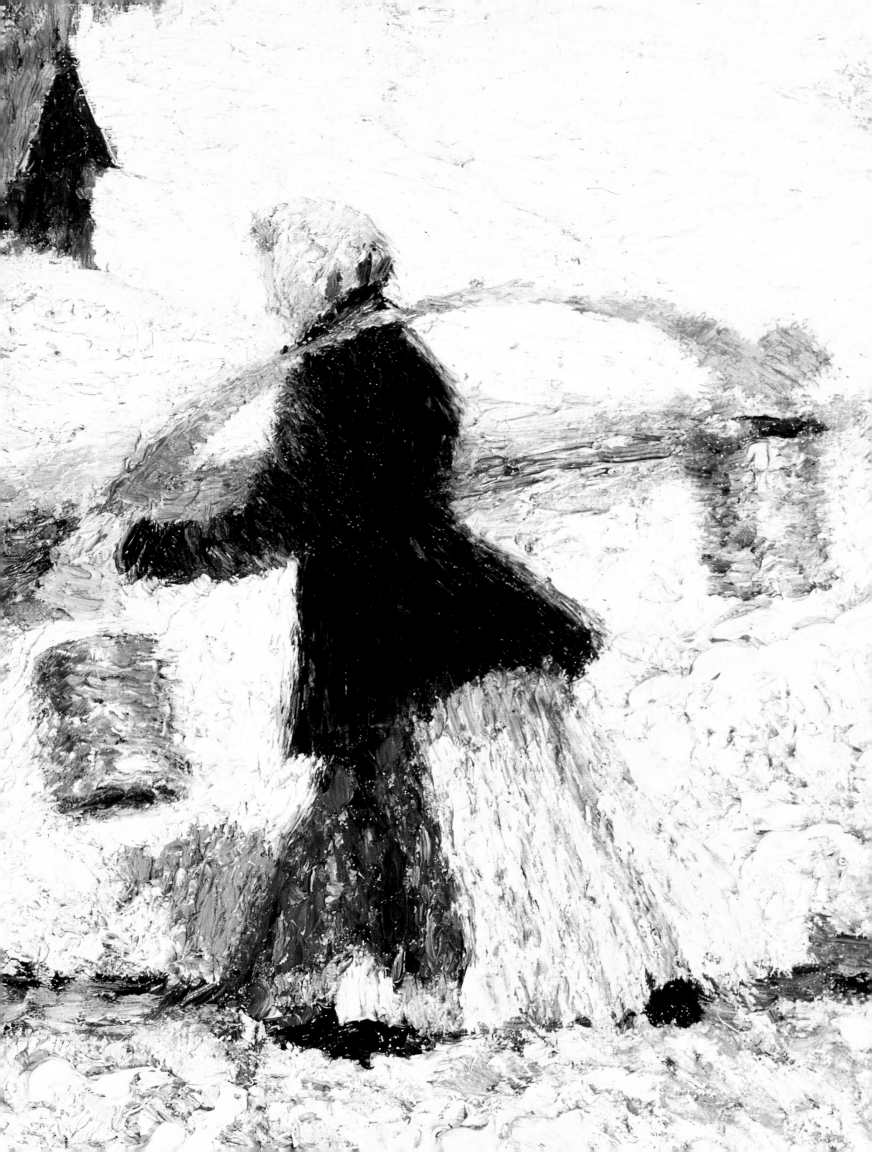

A woman was speaking: «Paintings these days... just terrible! Nothing but brushstrokes and brushstrokes. Quite impossible to understand. Horrible! The other day I saw an exhibition in St. Petersburg. I was told they were impressionists. There was one painting of a stack of hay, and just imagine, it was blue! Horrible I tell you. Our hay, and I believe, hay everywhere, is green, isn't it? But here the hay was blue! Nothing but brushstrokes and brushstrokes...They say it's the work of some famous French impressionist.»

Constantin Korovin

«We are condemned to know things only through the impression they make on us.»

Anatole France

3. Valentin Serov
Portrait of Adelaide Simanovitch. 1889
Oil on canvas. 87 x 69 cm
Russian Museum, St. Petersburg

Next page
4. Igor Grabar
Uncleared table in disarray
Russian Museum, St. Petersburg

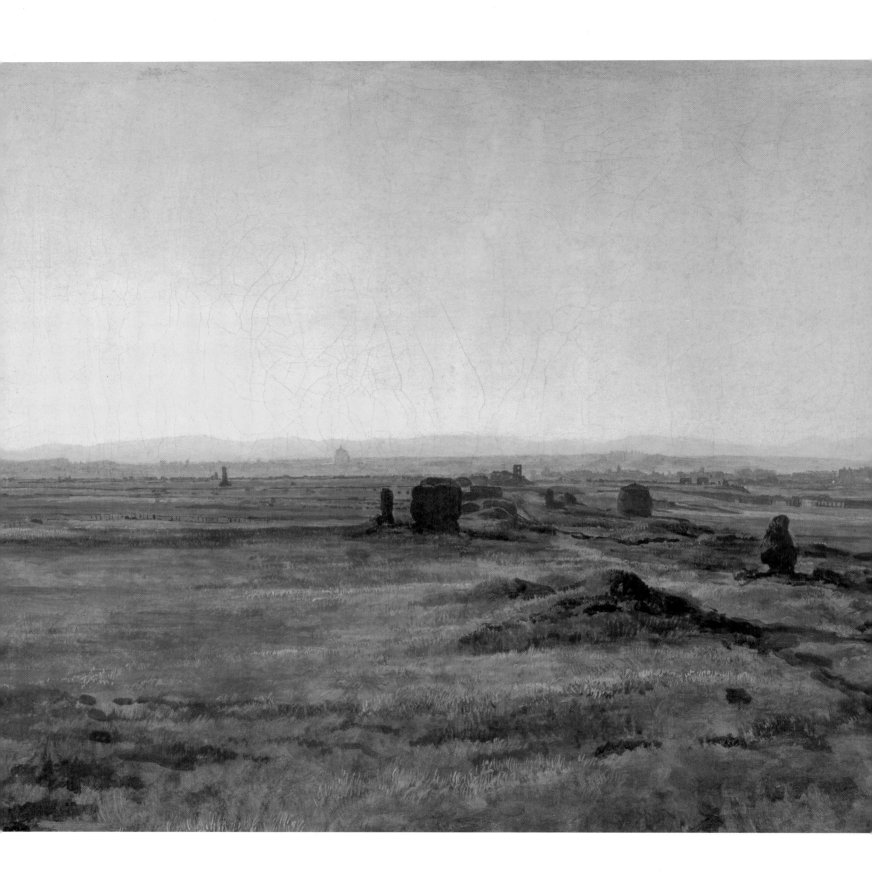

France - Russia
Sources of dialogue

There has probably never been another European culture more ready to take on Impressionism and its principles than the Russian culture.

No doubt, under the influence of the Impressionists, the palettes of many a painter, who had never even thought of giving up detailed subject-matter, became brighter and more artistic.

Of course, many who remained faithful to socialist realism painted canvases with a subtle understanding of values, vivacity of improvisation and vigorous artistry. There were also painters in Russia, who, filled with the powerful spirit of impressionism, used its system and poetics.

But if while speaking of Russian art , historians calmly use the terms «classicism» «romanticism», and later «*avant-garde*», or non-figurative art, they hesitate to use the words «Russian Impressionism».

And rightfully so. For, the preceding tendencies which transformed the plastic, spatial, and chromatic structures and changed the styles- going from volume and lines, to spots and colours, from surface to depth, from rules and regulations to improvisation- never questioned the pre-eminence of content and idea.

Furthermore, even the Russian *avant-garde*, having done away with subject and narration, kept content and program. Russian cultural tradition could hardly accept spontaneity and pure aestheticism.

The influence of French culture on Russian culture has always been powerful but never simple.

Opening «a window to Europe», (1) Russia was more turned towards Germany and Holland than France. Germans were called to serve in

5. Alexander Ivanov
The Appian Way at sunset.
1845
Tretiakov Gallery, Moscow

6. Alexander Ivanov
Branch. Study.
Late 1840s
Tretiakov Gallery, Moscow

7. Portrait of Alexander Ivanov

1 In Russian this expression is attributed to A. S. Pushkin in *The Bronze Horseman,* but belongs to the Italian traveller Algarotte (see Algarotte F. *Viaggi di Russia.* Parma 1991).

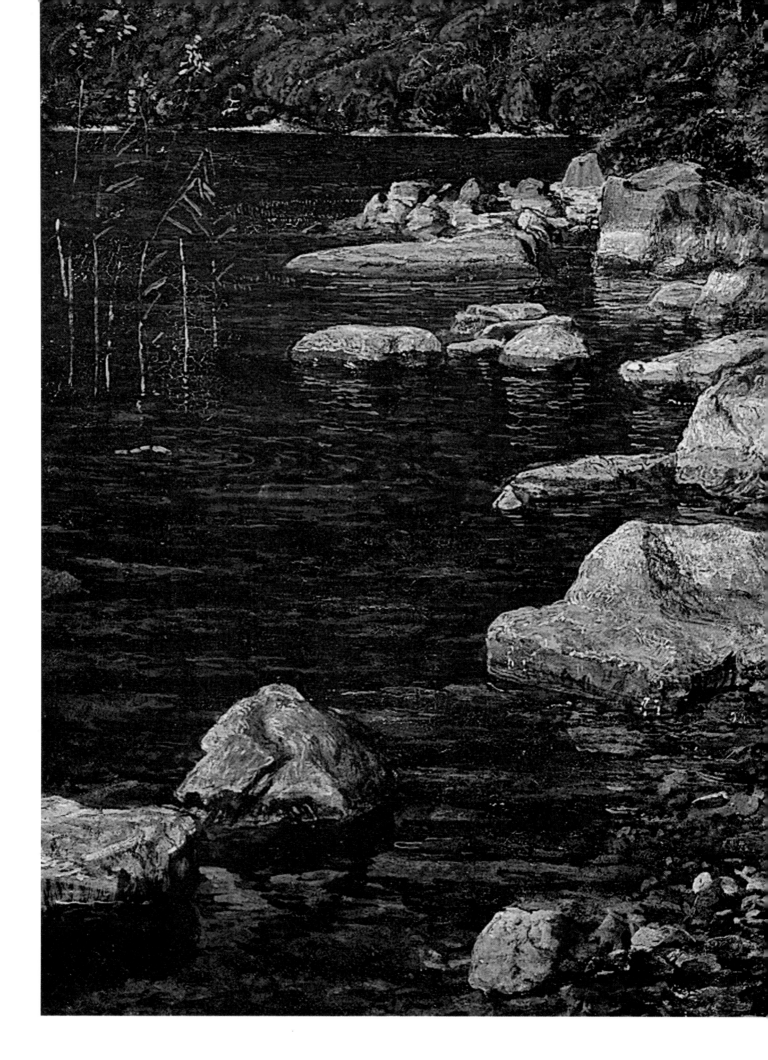

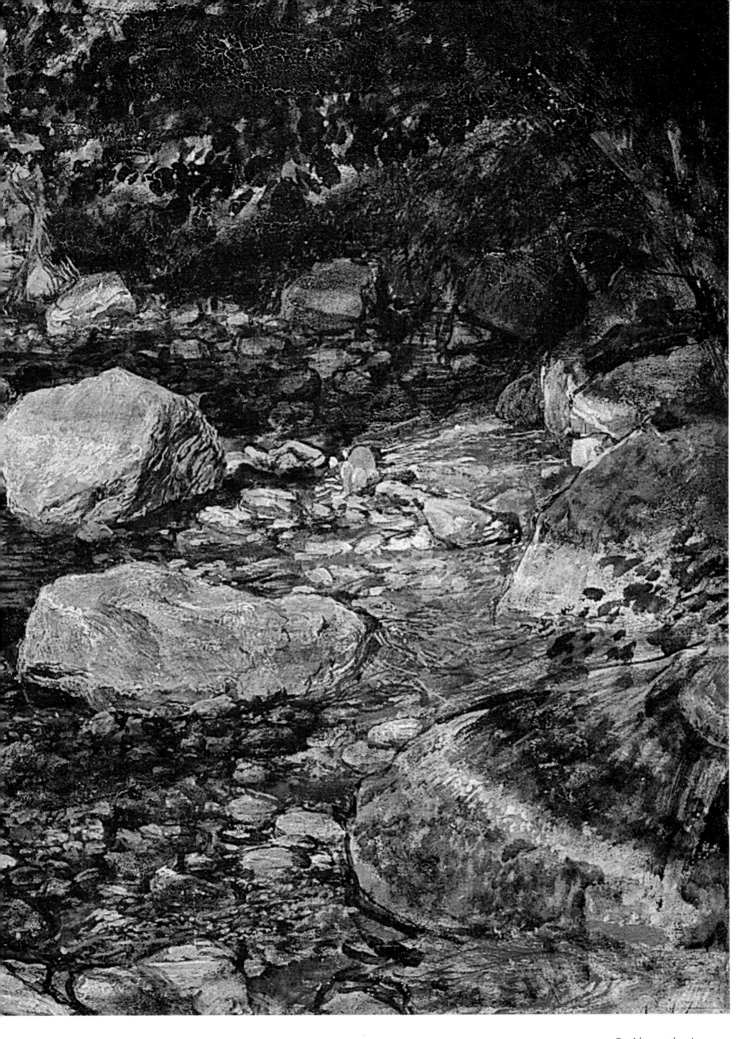

8. Alexander Ivanov
Water and stones near Pallazzuolo.
Early 1850s
Tretiakov Gallery, Moscow

Russia, the nobility of St. Petersburg was educated in German, and German became the primary language of Russian science.

More prone to self-analysis than to pragmatism, the Russian mentality, prone to pragmatism, has always been closer to the gloomy German genius than to the sharp Gallic wit. (Alexander Blok)

The situation only started to change as of 1789, when many members of the French nobility immigrated to Russia. However, the precise Cartesian clarity was not accepted in Russia as easily as it was in France and met with suspicious resistance.

Through the mouth of the Italian hero in his famous essay called «Rome», Nikolai Gogol at once admires and refutes the French value system: «He saw how the French seemed only to work in their heads. With all their shining traits, with all their noble impulses and knightly outbursts, the entire nation is somehow pale and incomplete, a light vaudeville.

Not one great and majestic idea has taken root there. Everywhere there are nothing but allusions to thoughts without the actual thoughts themselves.

Everywhere, nothing but feeble passions but no real passion. Everything seems unfinished, as if sketched

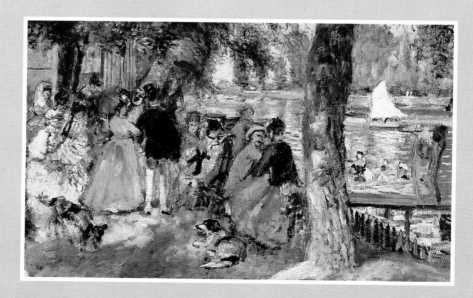

9. Auguste Renoir
Bathing in the Seine (La Grenouillère). 1869
Oil on canvas. 59 x 80 cm
Pushkin Museum of Fine Art, Moscow

with a quick hand. The entire nation is a bright vignette, but not the painting of a great master.»

Despite the obvious injustice, this passage brilliantly

expresses not so much the Italian, but the Russian literary conception of French civilisation.

The last sentence even seems to anticipate the accusation of ideological art against the Impressionist system: the unfinished aspect, the absence of a grand and great idea were considered mortal sins up until the end of the last century.

The roots of Franco-Russian cultural discussions, however, lie far deeper. The Russians felt both chained and proud of their lack of freedom, their inclination towards an almost morbid self-analysis and apathy. Russian intellectuals recognised that the Russian national consciousness lacked

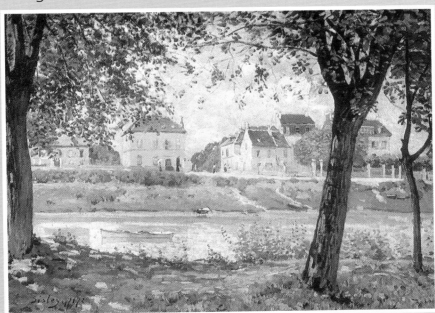

the clarity and concreteness of thought that the French were so rightly proud of.

Of course, the lack of freedom of Russian culture lay in their idea of duty, their noble dedication, moral responsibility, and exalted conscience. In short, it lay in what had always been the prerogative of Russian artistic creation.

There was probably something in the way of jealousy on the Russian side.

Russian culture was jealous of the freedom that French culture possessed: freedom to experiment, independence from rules and censorship and liberal rigorism, freedom of expression and finally, the freedom from moral and social obligations.

10. Alfred Sisley
*Villeneuve-la-Garenne
(Village by the Seine). 1872*
Oil on canvas. 59 x 80.5 cm
Museum of Modern Occidental Art,
Moscow
(former S. Shchukin Collection)

2 P. J. Chaadaev, Collected Works and Selected Letters, Moscow, 1991, p. 489 The original was written in French and published in the same volume.

3 ibid, p. 493.

4 *The Bee*, 1878, No. 10.

No other thinkers have ever judged their own country as severely as the Russians. «Woe to the nation that slavery knew not how to degrade. It is born to be a slave.» (2) wrote Peter Chaadayev. And later: «Everything in Russia carries the mark of slavery - the morals, the aspirations, education and freedom itself, if such a concept can exist in this country.» (3)

For the Russian artist, the feeling of pain and duty have always dominated over creative problems. Content and ethics provided the motives for cultural change.

In the 1860s, rebels appeared among artists in Russia as well as in France. The artists who demonstratively left the Academy, demanded one thing: the right to give up, in the name of social truth, the traditional mythological themes and to turn towards the authentic «life of the people».

The creation of the «Artists' Association» (1863) and later the «Society of Itinerant Art Exhibitions» (1870) marked exclusively the quests in content but not plastics. Adrian Prakhov (1846-1916), archaeologist and art expert from St. Petersburg University wrote: «The search for truth, no matter what, at once guarantees the normal evolution of natural artistic forces and frees this evolution from all outside oppression... it is the most sincere and truest quest for freedom. This important process of inner emancipation came to an end in the Russian art of the last decade.» (4) Such was the Russian understanding of freedom in art.

In 1863, that very same year in France, artists who aspired exclusively to a new plastic language, a different vision, rejecting all social engagement, were becoming the heroes of the famous «Salons des Refusés».

Rainer Maria Rilke, one of the few western thinkers who understood Russian culture, wrote: «The Russian man spends his entire life so immersed in deep thought, that any beauty becomes unnecessary, any brightness, a lie…

He stares fixedly at his neighbour, seeing him, suffering with him as if looking at his own unhappiness. This gift of vision bred great writers; without it there would

11. Portrait of Vasily Grigorievitch Perov

12. Vasily Perov
Portrait of the author Fyodor Dostoevsky. 1872
Oil on canvas. 99 x 80.5 cm
Tretiakov Gallery, Moscow

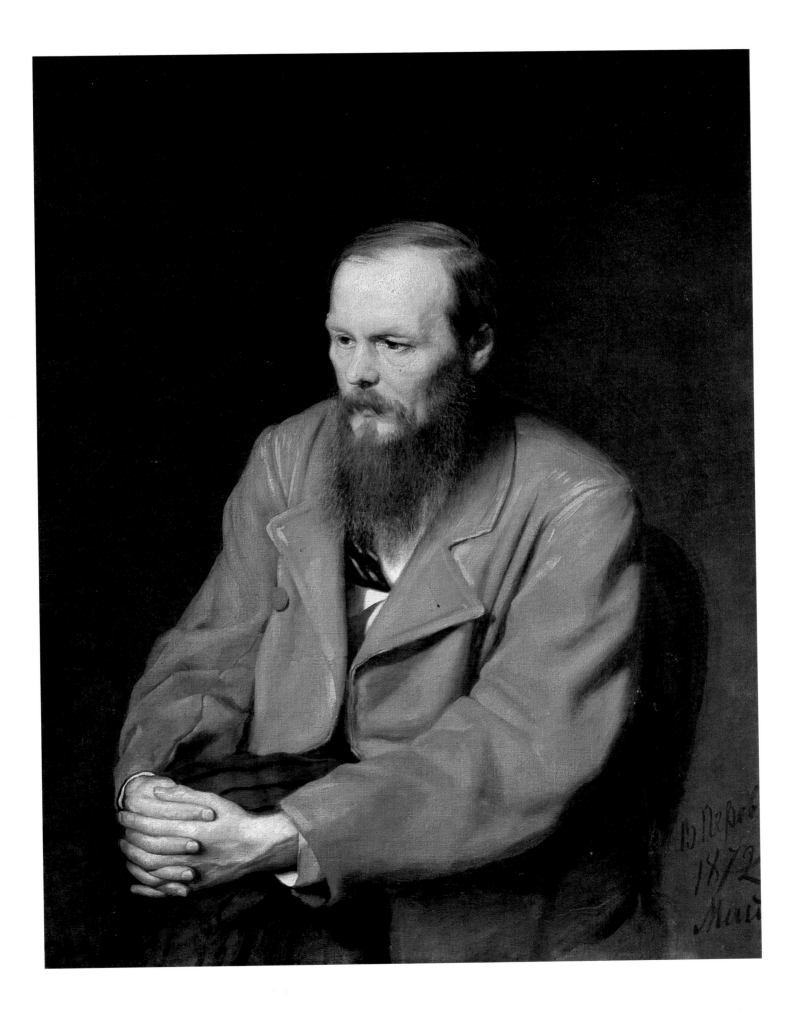

have been no Gogol, no Dostoevsky, no Tolstoy.
But it was not able to create great painters. The Russian man lacks the impartiality necessary to observe a face from a painter's point of view. He lacks the ability to look at it calmly and disinterestedly without sympathy, as if at

an object. He goes from contemplation to compassion, from love to a desire to help, in other words, from image to subject. It is not by chance that Russian artists painted «subjects» for such a long time» (5)
Nor is it surprising therefore, that later the harsh and often unjust protests of the young members of the «World Artist Movement», were aimed precisely at that subject-matter.
Alexander Benois wrote: «We need to get away from the backward Russian artistic life, from our provincialism,

13. Auguste Renoir
Outside the Moulin de la Galette
Oil on canvas. 81 x 65 cm
Pushkin Museum of Fine Art, Moscow

from the literary aspect, and closer to western culture, to the purely artistic searching's of the foreign schools.» (6) Grounded in the literary egocentricity of the Russian culture, this literary aspect was often praised or blamed but rarely analysed. And yet it is precisely this aspect that characterised the dramatic entry of Russian art into the world art scene.

In Russia, literature meant shackles. After fifteen years of imprisonment the archpriest Avvakum (1620/21-1682) was sentenced to burn at the stake for his writings against the government. The most famous Russian writers were either sentenced to hard labour, exiled or repressed.

5 R. M. Rilke, Modern Russian Endeavours in Art. Collected works in 12 volumes. Frankfurt a. M., 1976, Vol 10 pp. 613-614.

6 Alexander Benois, The Rise of *The World of Art*. Leningrad, 1928, p. 21.

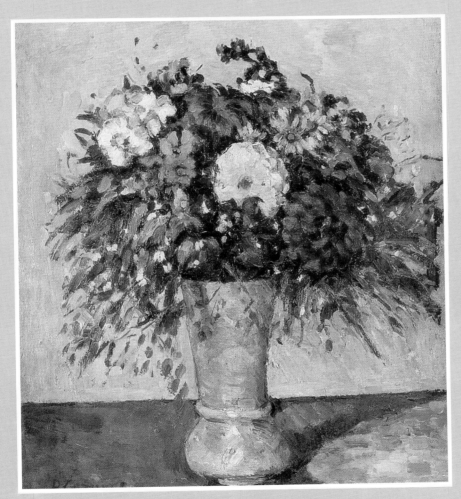

It is enough to mention Raditshev, Pushkin, Lermontov, Herzen, Chernishevsky... Dostoevsky was sentenced to death. And those who were more fortunate, became victims of their own exacerbated conscience and exaggerated feeling of duty. Take for example the last years of Lev Tolstoy's life.

14. Paul Cézanne
Bunch of flowers in a blue vase.
1873-1875
Hermitage Museum, St. Petersburg

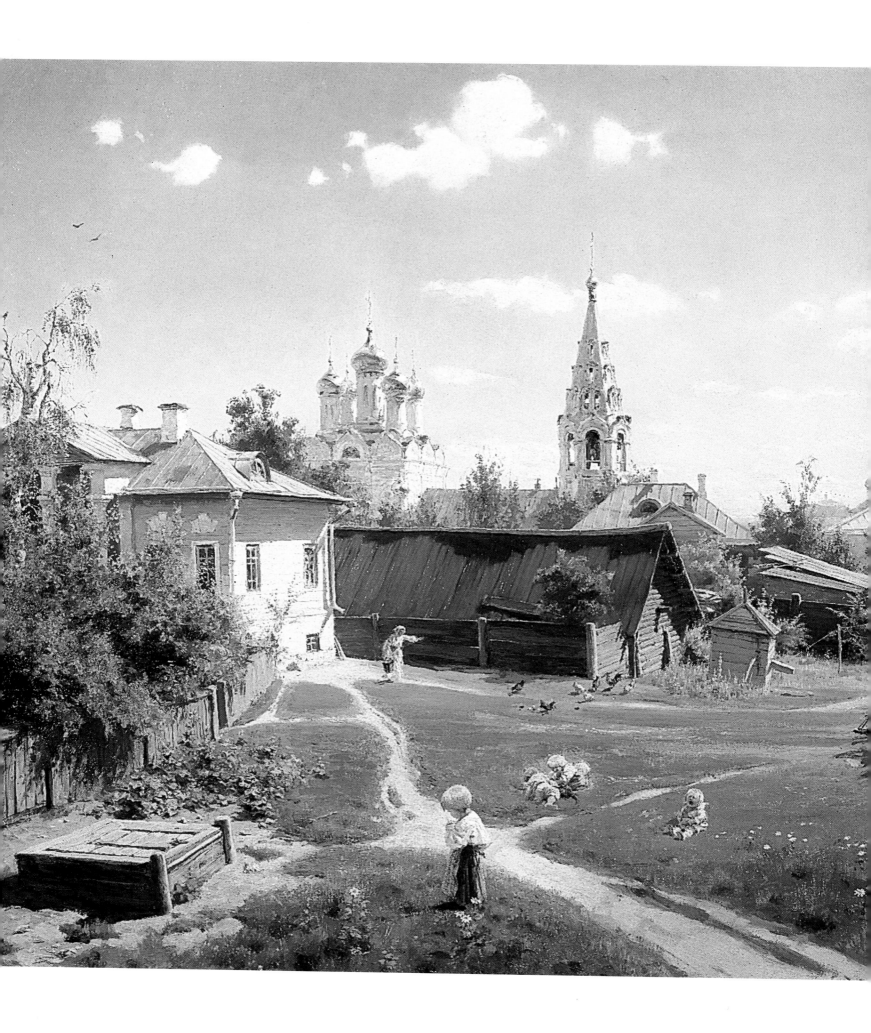

The word was the reference point in other artistic fields and the centre of Russian cultural consciousness.
French art criticism stemmed from literature and poetry that had understood plastic art. Baudelaire's articles, Zola's subtle and passionate apologia of Manet, Valerie's work, are just some examples.(7)
Russian writers and thinkers, however, all remained devoted to ethics and subject. For example, in his treatise «What is art?» and in earlier works, Lev Tolstoy preached the importance of an ethical and social dominant in art.

As regards the way in which Russian writers perceived new French painting, take for example the following farcical text about an early painting of Edward Manet «The Nymph and the Satire» that was displayed at the 1861 exhibition of the Petersburg Academy, a reviewer wrote: «The *Nymph* painting has surely been exhibited in order to show just how ugly the fancy of an artist can be. The artist has created the flattest thing and given the body of his nymph the colour of a five-day old corpse.» (8)
And later: «By sending his *Nymph and Satire* to our exhibition, Manet, the foreign painter (from Paris! says the catalogue) has certainly distinguished himself. There is nothing worse at the exhibition.
The drawing, the disposition of the figures, the colouring - everything is to such an extent inexact that one wonders at the audacity of the French artist. What is even more amazing is that Manet is asking a thousand Roubles for his painting» (9) The reviewer was F. Dostoevsky. (sic!)
Russian painters were far better judges of literature than the writers were of painting.
While enhancing their culture and sensitivity and opening up their minds, this all the more enslaved them to the idea of the ethical and social struggle, instead of helping them to create an independent art. The most famous Russian painters, such as Alexander Ivanov, Nicholas Kramskoi and Nicholas Gay, turned to religious philosophy, trying to

of course one should not make any generalisations about this phenomenon. In his novel *Fort comme La rt*, Maupassant writes about young artists with el irony: «It was a laudatory dythyrambos of four or young painters who, gifted with real colouristic alities and exaggerating them for the effect, claimed be revolutionaries and brilliant innovators.» But in er works, *Miss Garriett* for example, the writer is re sympathetic towards the young painter who is y similar to those *brilliant innovators* in the previous otation.

. M. Dostoevsky, Collected Works vol. 19, Leningrad 79,p. 159.

oid, p. 164.

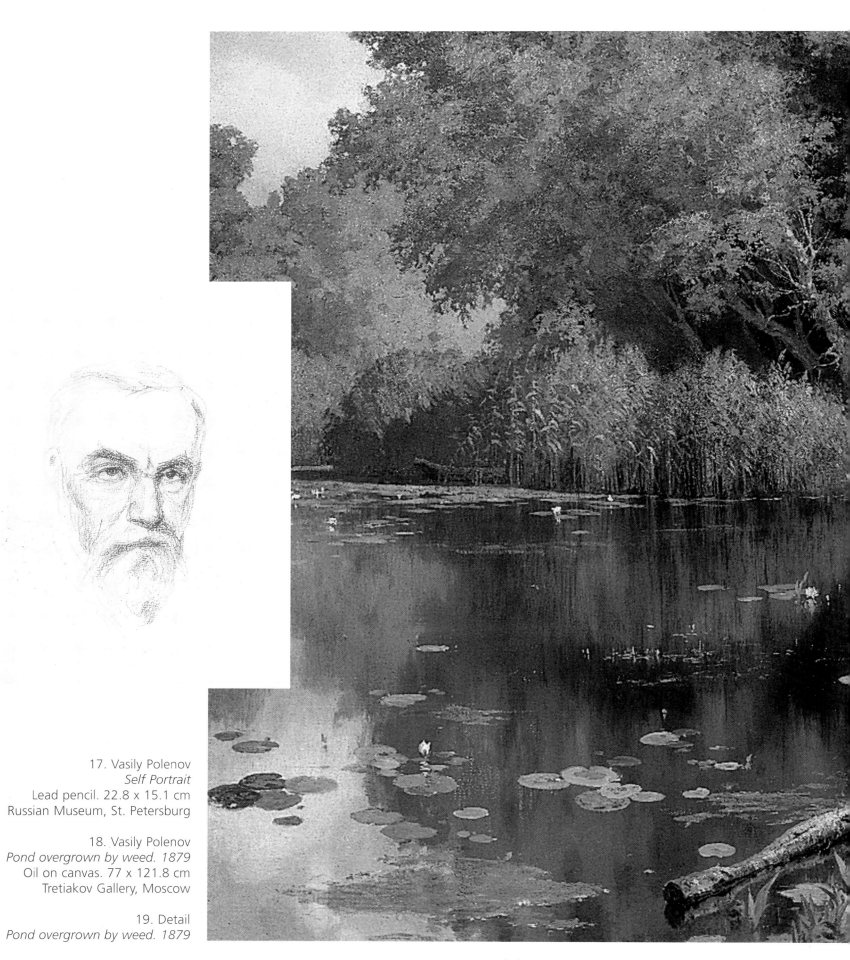

17. Vasily Polenov
Self Portrait
Lead pencil. 22.8 x 15.1 cm
Russian Museum, St. Petersburg

18. Vasily Polenov
Pond overgrown by weed. 1879
Oil on canvas. 77 x 121.8 cm
Tretiakov Gallery, Moscow

19. Detail
Pond overgrown by weed. 1879

24

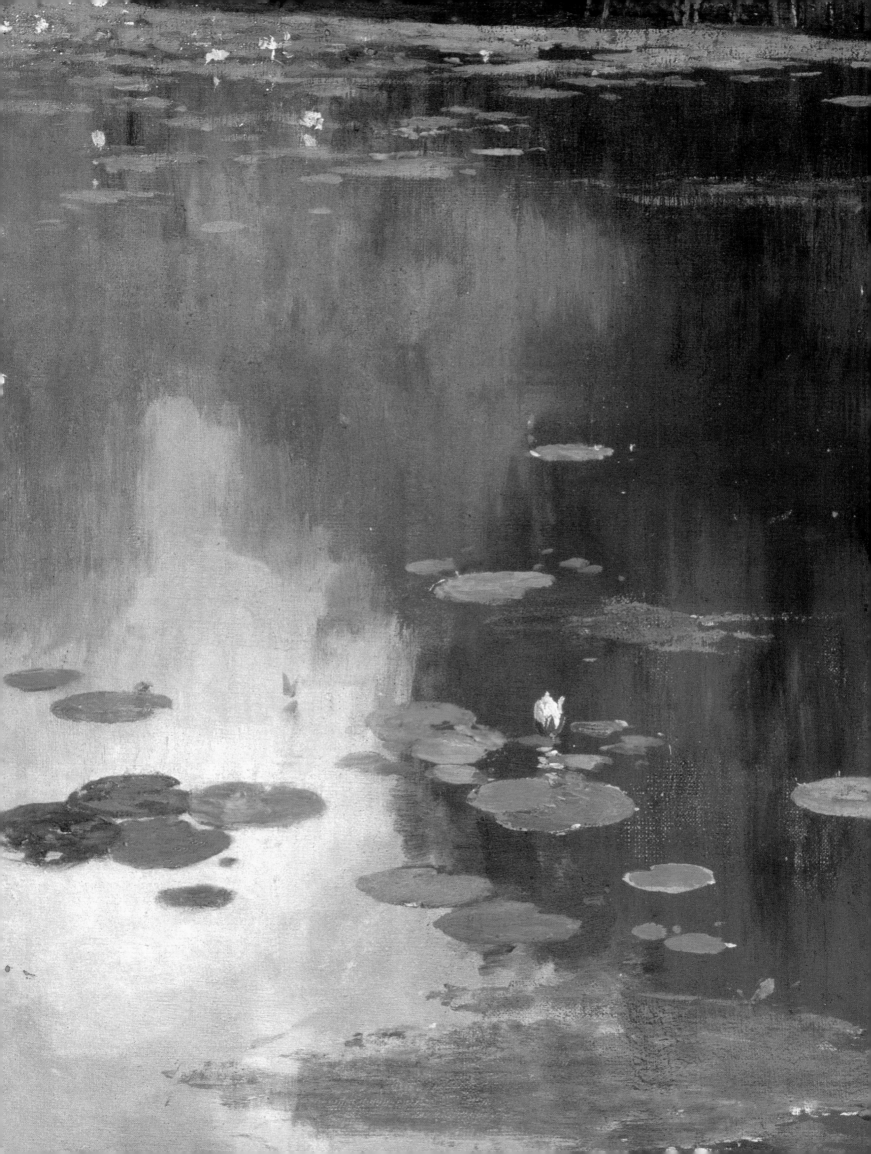

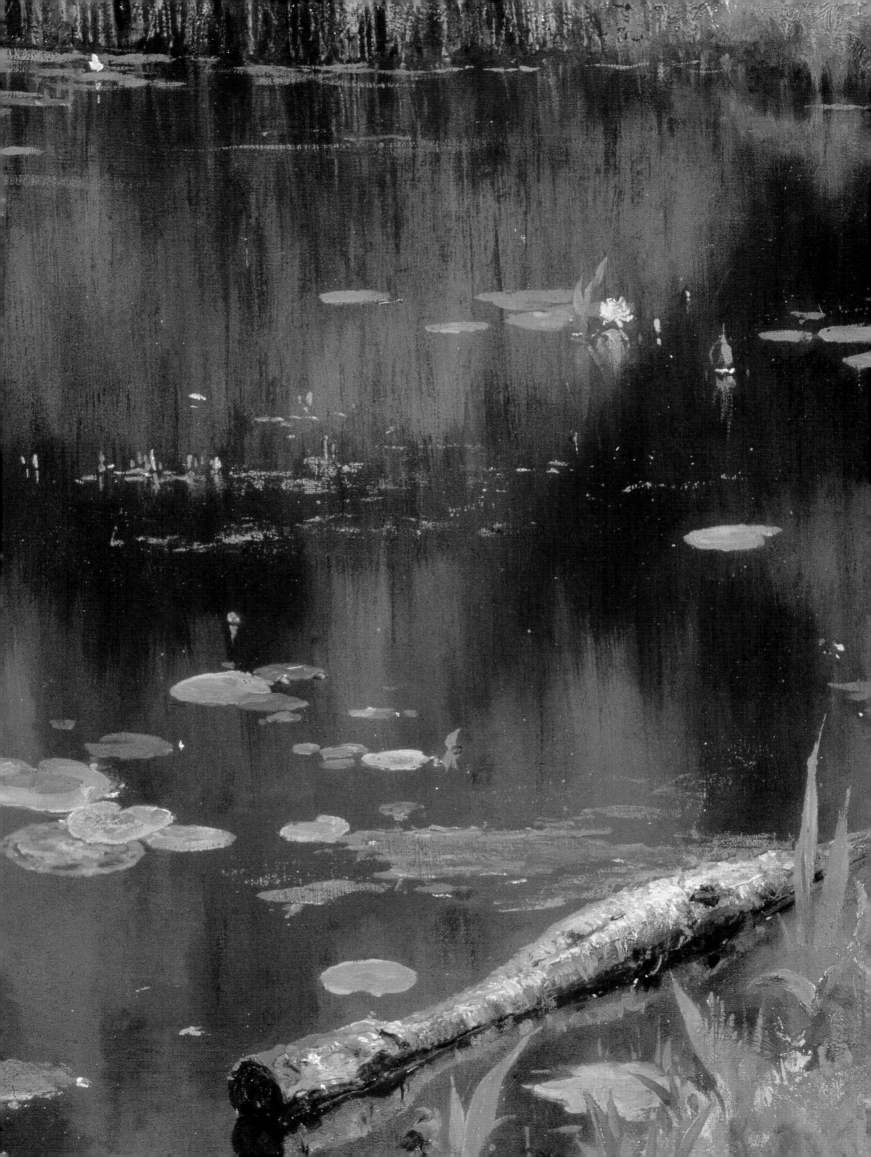

find solutions to the problems of existence and answers to theological questions, associating them with the monumental plastic form.

These problems had long since been considered insurmountable on the world art scene. It is quite important to note that the most important painting of this type, «The Apparition of Christ before the people» took its author, Alexander Ivanov, several decades to paint, but was never in fact finished.

It was precisely the impressionist movement that shook the Russian egocentric literary tradition, and brought art to the forefront for the first time. «We are condemned to know things only through the impression they make on us.» (10)

These words from Anatole France remind us again just how important the concept of impressionism was for all contemporary culture, and how it went far beyond the limits of art history.

The word impressionism has several meanings. First of all it represents a precise moment in the history of French painting: names, destinies, events and problems; a completely new and different system of seeing and interpreting reality on canvas.

It is this meaning, perhaps the first, that remains the most exact and fundamental. Secondly, it refers to the international movement in Plastic Art of Europe and America.

Thirdly, it represents a spontaneous and improvisational way of seeing and realising art that is similar to sketching.

And finally, impressionism is a fundamentally new culture that breaks with the centuries-old art experience. It is a new step towards creative freedom, a new way of thinking, of perceiving different principles of artistic creation,

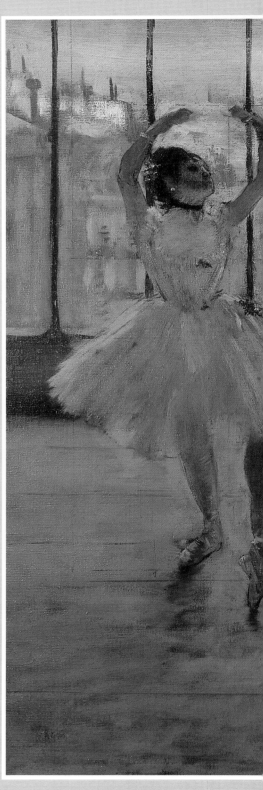

20. Edgar Degas
Dancer at the photographers.
1875
Oil on canvas. 65 x 50 cm
Pushkin Museum of Fine Art,
Moscow

28

including literature, music and theatre. It is a time that marked almost all European civilisations.

One must therefore take into account all of these meanings. The word impressionism itself now goes far beyond the scientific norms. All the more so because impressionism, in the large sense of the word, is not only a phenomenon of art but a long-lasting historico-cultural phenomenon that spread far and deep.

Whether or not one can speak of impressionism outside of painting is still a question being discussed. Of course literature has its classic examples of impressionist techniques and even declarations. Charles Baudelaire's article *Salon 1846,* published in the *Bibliographie de la France,* May 23rd of that same year, was in some ways prophetic. In the chapter «About colour», Baudelaire proposes a written version of the new vision, creating a sample of painted-impressionistic prose: «Imagine a beautiful expanse of nature, where everything becomes green, red, and shimmers freely into a powdery dust, where everything is coloured according to its molecular constitution, changing from second to second with the movement of the shadows and the light; agitated by the inner activity of the hues, a constant vibration makes the lines tremble and completes the law of eternal and universal movement...

The trees, the rocks are mirrored in the waters where they lay their reflections; all the transparent objects catch the close and distant lights and colours in passing.» (11)

One must agree with the general opinion that the favourite locutions of the Goncourts, such as *it seems that, as if,* etc. also evoke the fleeting impressions used by the impressionist painters. There are famous examples of «impressionist poetics» if not impressionist poetry. Baudelaire.

10 A. Franc,. Collected Letters, Paris, 1926, vol. I,9.

11 Charles Baudelaire, Aesthetic Curiosities of Romantic Art. Paris, 1962, p. 105.

29

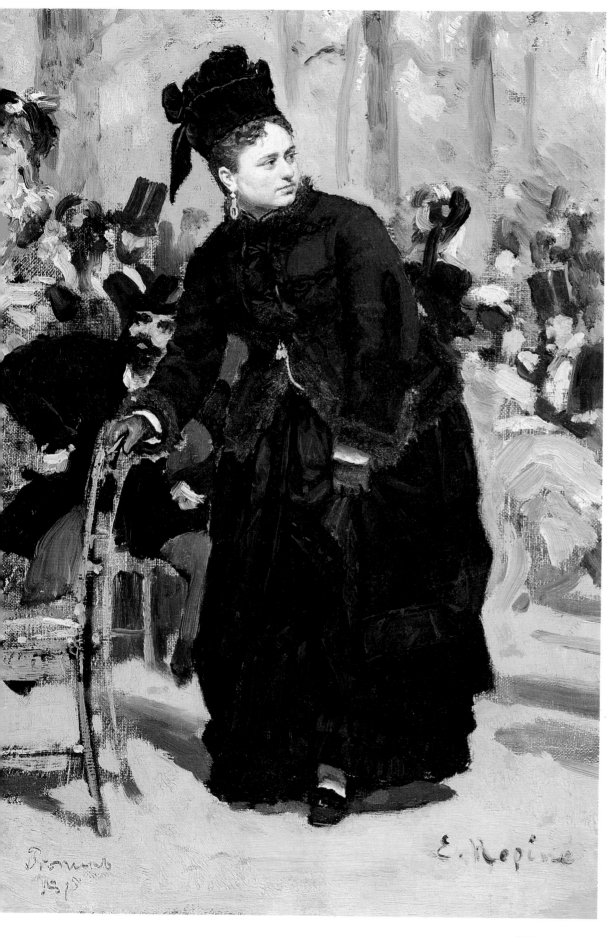

21. Ilya Repin
*Lady leaning on the back of a chair.
1875*
Study for the painting Café Parisien (1875
Oil on canvas. 40.3 x 26.5 cm
Russian Museum, St. Petersburg

22. Ilya Repin
Self Portrait. 1878
Indian ink and pen on paper.
17.8 x 13.3 cm
Tretiakov Gallery, Moscow

However, no matter what is said about impressionism in literature, one basic objection arises. For only in painting can there be the full simultaneity of impression, that constitutes the very nature of Impressionism. Without this, the essence of impressionism is lost. Literature creates images that change one after the other. Thus, only certain aspects of these different arts remain similar. Moreover, the notion of autonomous art, an important achievement of Impressionism, only exists in painting.

Impressionism in music has been discussed seriously. The great Spengler wrote with complete conviction: «There is a strong affinity between Wagner and Manet, that has been sensed by few, but long established by Baudelaire, that connoisseur of decadence.

The miracle of Impressionism was to create a world with brushstrokes and spots, as if by magic. Wagner also achieved this effect, concentrating the entire world of the soul in three measures.» (12)

12 O. Spengler, The Decline of the West, Novosibirsk, 1993, p. 383.

13 Yearbook of Comparative and General Literature, 1967, No. 17, (Indiana University, Indiana).

23. Ilya Repin
Near Paris - Montmartre. 1885
Tretiakov Gallery, Moscow

Next page
24. Ilya Repin
On the raised bench
Oil on canvas. 36 x 55.5 cm
Russian Museum, St. Petersburg

Whether correct or not, this statement shows that beyond the limits of painting, the understanding of the essence of impressionism was extremely vague and the sense of the word was approximate (or broad) at the beginning of the century. One must therefore be careful.

It is not for nothing that at a famous symposium held in the United States in 1968, it was declared: «The time has come… to take the words impressionism and impressionist out of the vocabulary of music and literature. In doing so, nothing will be lost except confusion.» (13)

The notion impressionism may be used for certain phenomena in literature, but only with great circumspection and care and

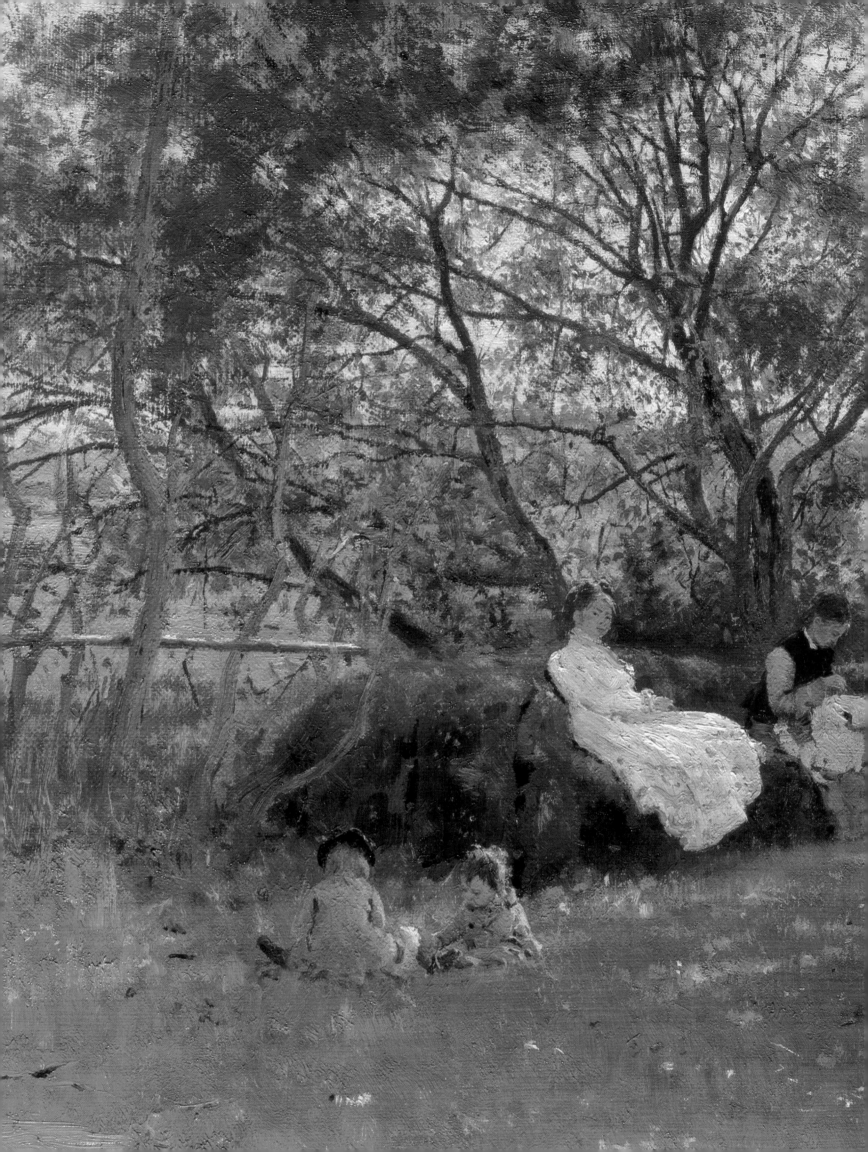

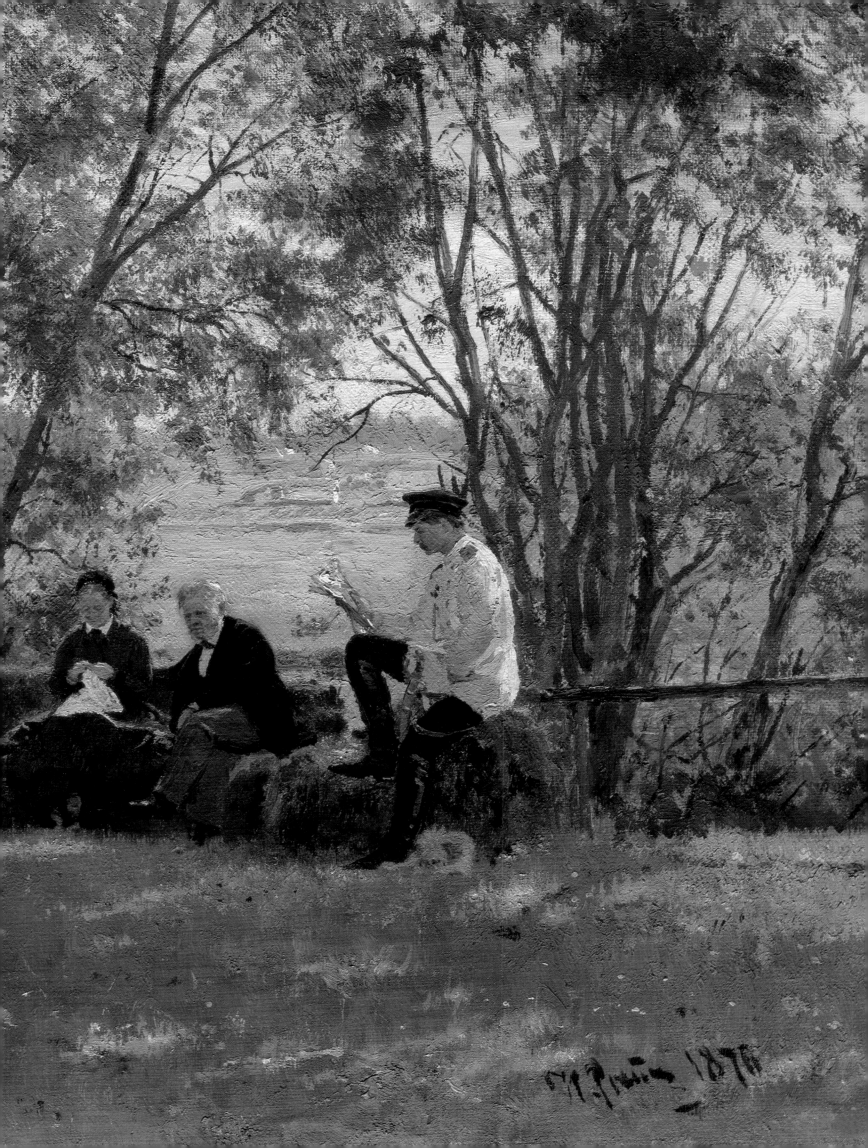

even more so in music.

The concepts and views of Impressionism found their way slowly and with difficulty into Russian art. The process can be divided into three aspects, or more precisely three periods, that are however, sometimes impossible to distinguish chronologically. First, Impressionism penetrated into traditional figurative realism, above all into the works of Repin and Serov.

This period began at a time when Impressionism was already an important movement in France, whereas little was known about Russian impressionists.

Secondly, a separate characteristic of Russian impressionism, *étudisme,* appeared; although it remained somewhat marginal because of its formality and distance from the ideological disputes of the time.

This phenomenon is found in the paintings of Constantin Korovin, and to a certain extent in the works of Vinogradov, Jukovsky, and Grabar, whose impressionist paintings were seen as quaint studies of nature. Finally, Impressionism, already at its apex, became one of fundamental components of Russian *avant-garde*, an epilogue that stimulated the art to come (Mikhail Larionov, Kasimir Malevitch and

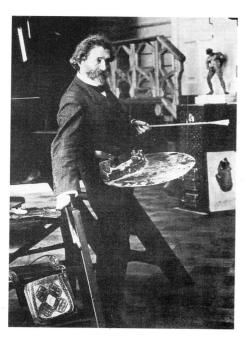

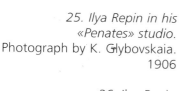

25. Ilya Repin in his «Penates» studio.
Photograph by K. Glybovskaia. 1906

26. Ilya Repin
Man and woman at table.
Two seated women
Man putting on a glove. 1873
Study for the painting
Café Parisian (1875)
in a private collection in Stockholm
Oil on canvas glued to paper.
31.5 x 47.5 cm
Russian Museum, St. Petersburg

27. Ilya Repin
Portrait of Countess Nathalia
Golovina. 1896
Oil on canvas, 90 x 59 cm
Russian Museum, St. Petersburg

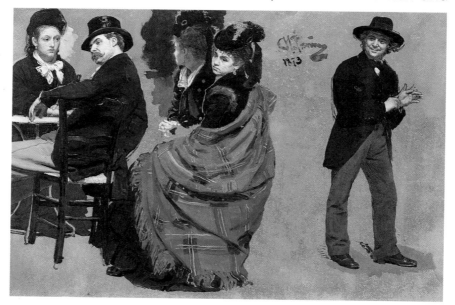

others). The dialogue with French painting had a long history, the ambiguous attitude towards French contemporary art appearing far earlier than the word impressionism itself. The «exalted distrust» of Russian artists for the French school became more and more acute.

The beginning

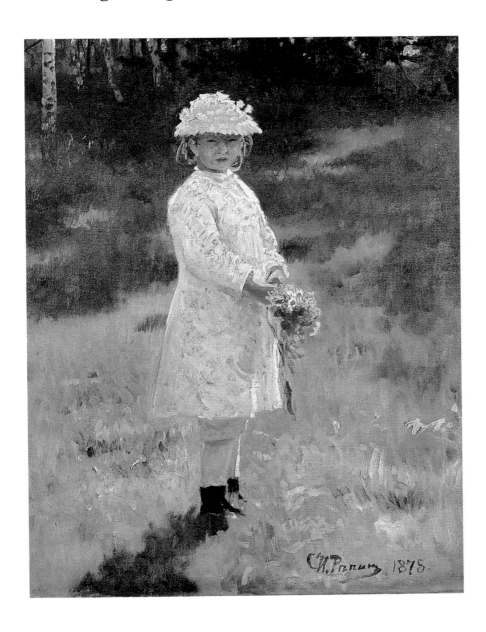

Gogol's thoughts about the «grand and majestuous idea» are curiously echoed by the simple but spontaneous and absorbing opinions of Nikolai Kolt from the

14 Quotation by N. V. Yavorskaya Landscape of the Barbizon School, Moscow, 1962, p. 286.

15 The first collector in this family was the chancellor Alexander Bezborotko (1746-1799), continued by his great-nephew, Alexander Kouchelev-Bezborotko (1800-1855), who opened a gallery at Gagarinskaya Street in St. Petersburg. The collection was divided among his sons Nicolas and Grigori. Grigori led a dissolute life (he supposedly served as the prototype for Dostoevsky's Prince Myshkin), and became very much in debt. He sold part of the collection himself and the rest was sold after his death. Nicolas Alexandrovitch was an art connoisseur and patron, and tried to help writers and artists. He was elected honorary «participant» at the Fine Arts Academy.

16 By testament, the collection was given «as a gift to the Imperial Academy of Fine Arts to create a public gallery always open to artists and the public, who would have access to it without tickets nor special clothing» At the time visitors to the Hermitage Museum needed entrance tickets and respectable clothing in order to visit the museum. The revolt of the Academy students coincided with the inauguration of the Kushelov gallery.

Petersburg Academy of Fine Arts: «I was puzzled by the direction the French school had taken, and completely astonished at the negligence with which they finish their paintings… I wouldn't say at the moment that this sketchy aspect is to their credit. I believe that a painting should be completely finished, on the whole, as in the details. But despite this, with time, I have discovered a world of qualities in the French school. One cannot help but be surprised at the natural force and the simplicity of the French painters. Their choice of landscapes is always simple and poetic, but ... they pay too little attention to the drawing; so the natural aspect of the colours conflicts with the unnatural forms and the problem is therefore not completely solved.» (14) He was referring to the works of the Barbizon school, Daubigny, Troyon and others, whose poetic «negligence», anticipating the impressionist style, so irritated Russian painters.

In general, Russian artists discovered the Barbizons and mid-nineteenth century French painting, not so much through travelling abroad, where they were mainly interested in classical art, but mostly thanks to the collection of the brothers Nikolai (1834-1862) and Giorgy Alexandrovitch (1832-1876) and Kushelevikh-Bezborotka (15), a good part of which was dedicated to the Barbizons. After his death, Nikolai Kushelov's collection was left to the Academy of Fine Arts and was opened to the public in 1863. (16) Also exhibited in the Kushelov collection, were the works of Delacroix, Millet and Courbet. Thus, not only travelling Russian artists were

Previous page
28. Ilya Repin
Summer landscape in Kursk province. 1881
Study for the painting Religious procession in
Kursk Province (1880-1883)
Oil on card. 14 x 20 cm
Tretiakov Gallery, Moscow

29. Ilya Repin
Small girl with bunch of flowers (Vera Repin,
the artist's daughter). 1878
Oil on canvas. 62.5 x 48.5 cm
Brodski Memorial Museum, St. Petersburg

30. Ilya R*
In the sun (portrait of Nadia Repin, the artist's daughter). 1
Oil on canvas, 111 x 65
Tretiakov Gallery, Mos*

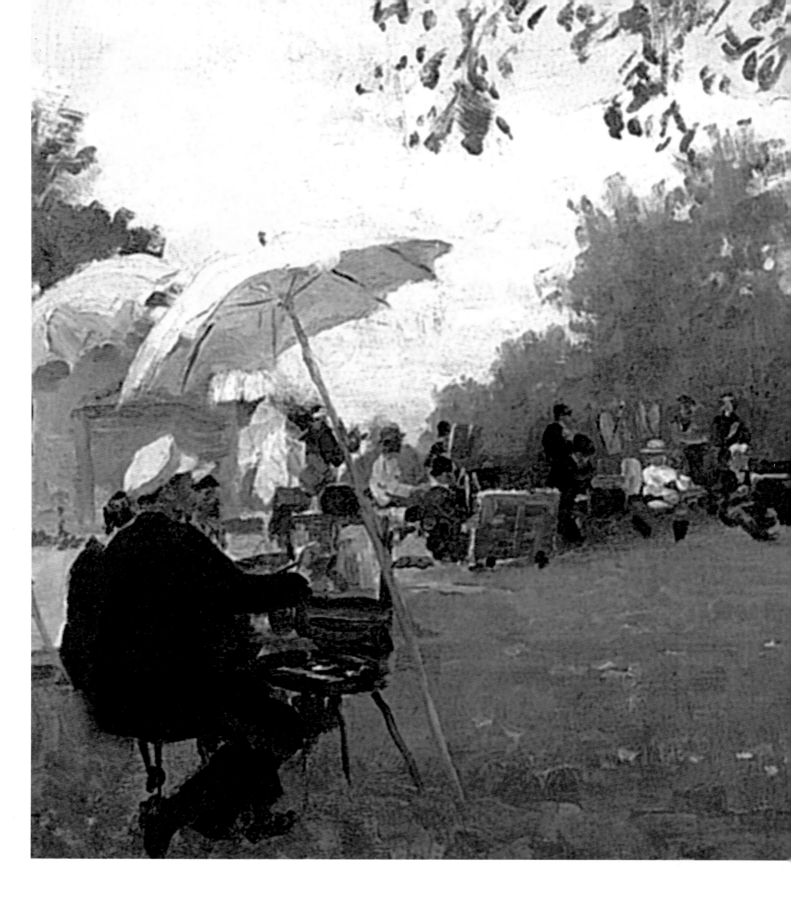

31. Ilya Repin
At the Academy's house in the country. 1898
Oil on canvas. 64 x 106 cm
Russian Museum, St. Petersburg

Previous page
32. Detail
At the Academy's house in the country, 1898

40

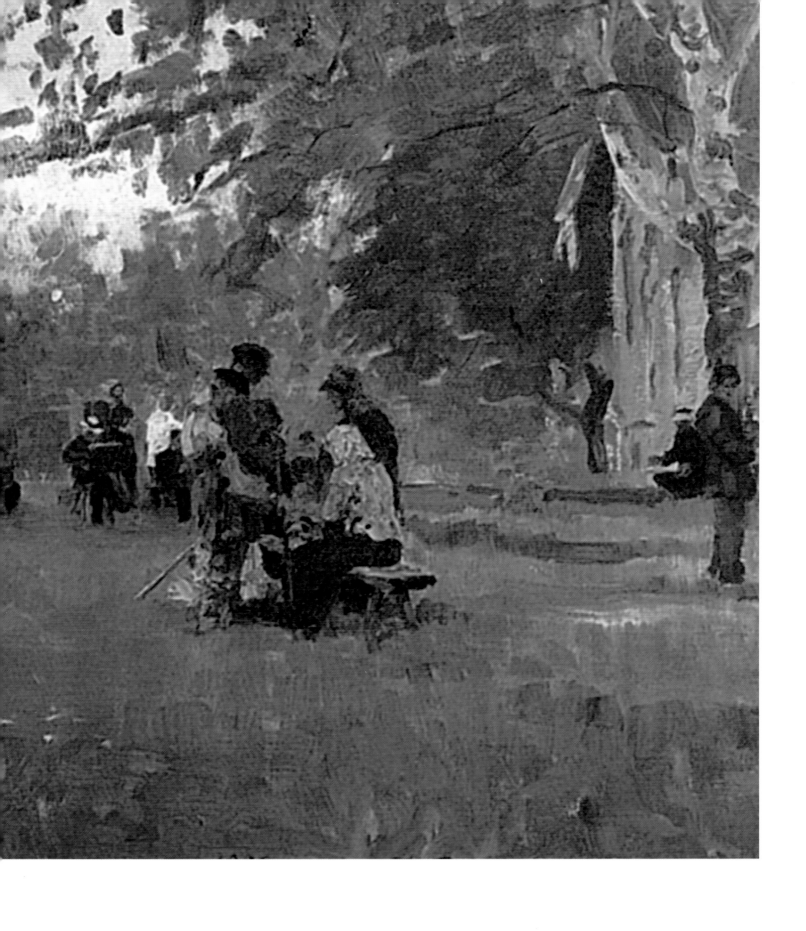

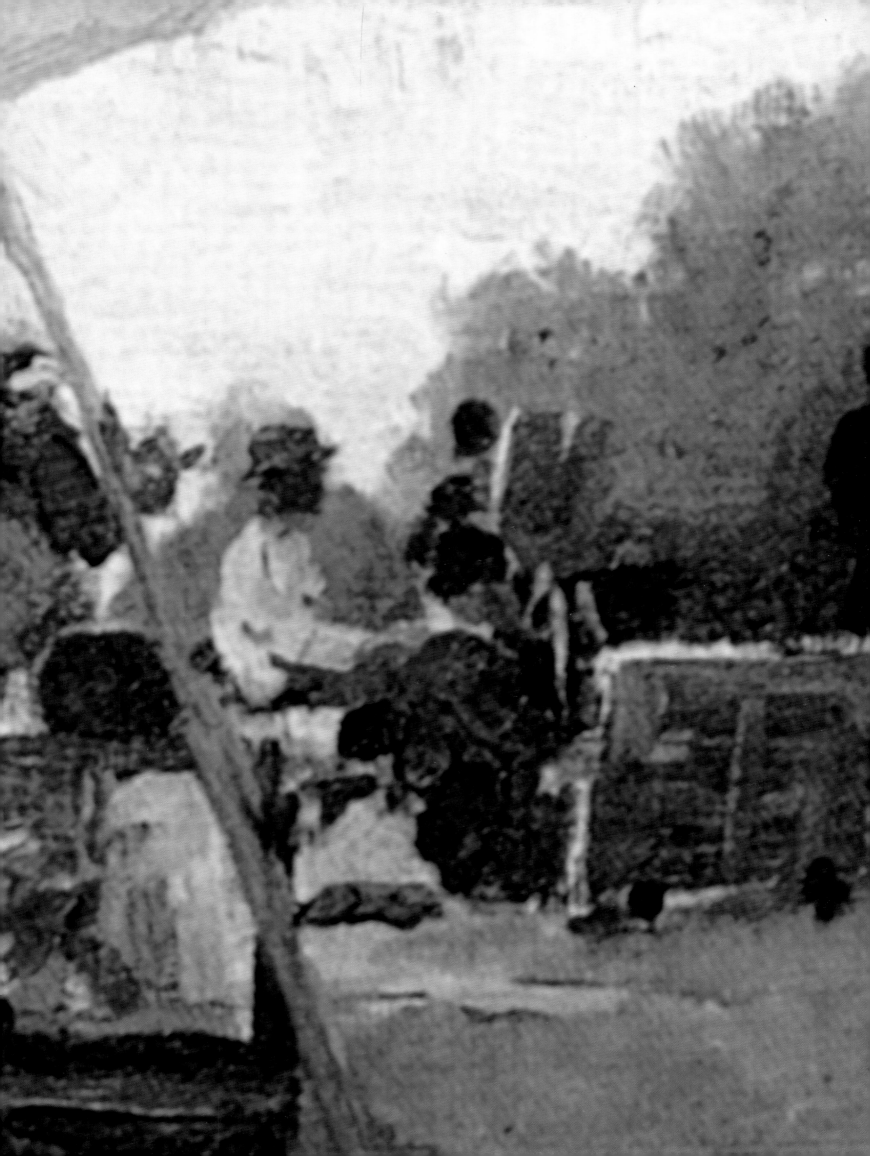

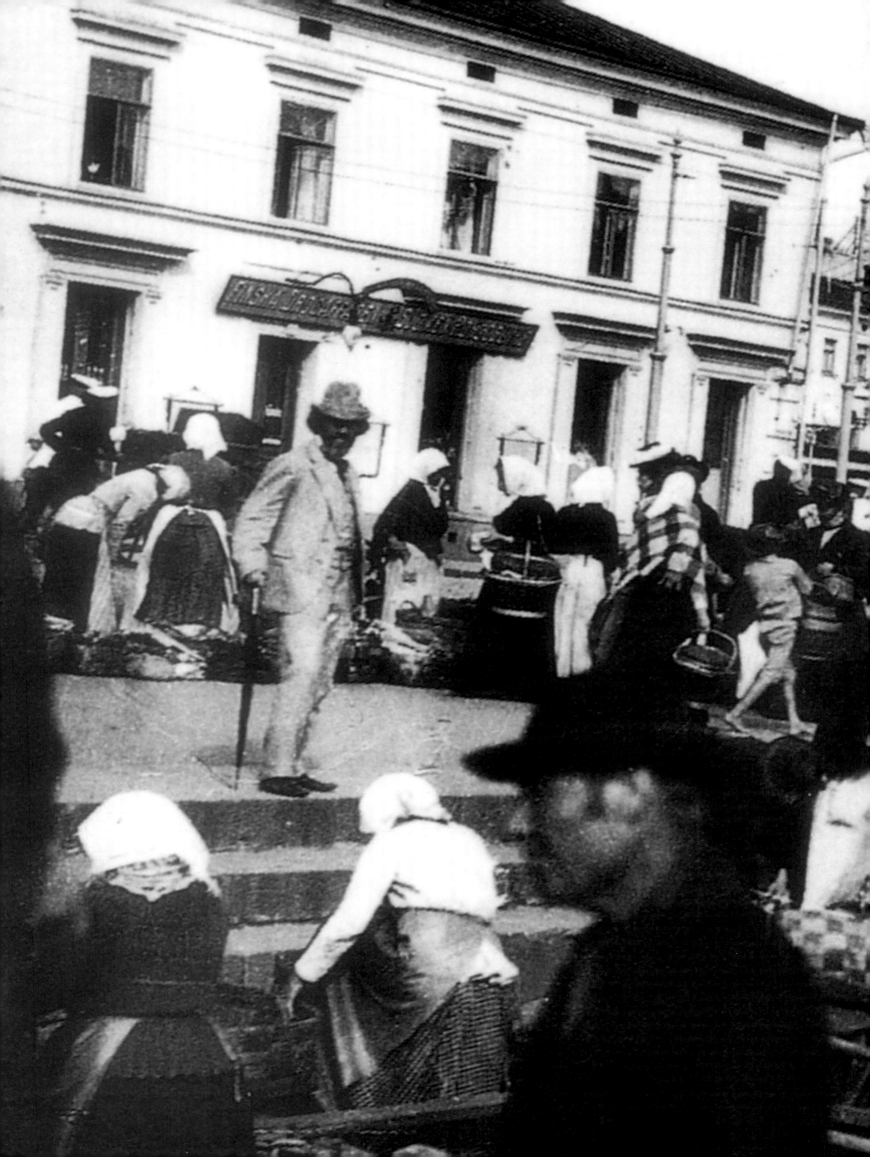

able to become acquainted with the works of the new French landscape painters, but also the St. Petersburg public. In Moscow the public had access to a similar collection left to the city by Pavel and Sergeï Tretiakov. Obviously, traditional Russian art critics did not see the search for new artistic values in the works the Barbizons, but perceived them mainly as hymns to nature.

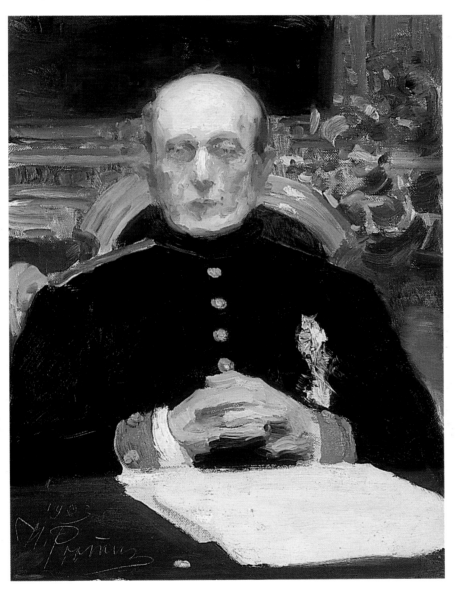

Thus, Vladimir Vasilievitch Stasov, a central figure in Russian democratic art, and a critic as brilliant and deep as he was fanatic and limited, marvelled at the paintings of the Barbizons, who «no longer painted landscapes, but created from life, arranging nothing, not decorating nor sweetening, but communicating the true forms of nature, French nature, while

45

expressing their own inner impressions». (17)

On purpose or by accident, Stasov, the faithful servant of the social democratic movement, irreconcilably against art «without content» or «without an idea», uses the word impression.

It is of utmost importance to try *sine ira et studio* to see the complexity of the relationship between Russian and French cultures at the end of the last century; to see the strange mixture of admiration and suspicion, astonishment and dismay, and elation mixed with irritation; in short, everything that testifies to their indivisible union and yet insurmountable division.

It is important to understand the strange tragedy that bore such interesting fruit. For the outcome of this incredible love-hate relationship was the maturing of Russian *avant-garde*, the decisive break in the history of world culture. «Something is rotten in the state of Denmark». This sentence from Shakespeare's Hamlet could serve as an epigraph to the analysis of the thoughts of many Russian artists at the end of the nineteenth century.

Contemporaries of the French impressionists, they undoubtedly felt the ambiguity of their own activities. Concerning the third Itinerants exhibition, Kramskoi wrote Repin: (1874) «You go to an exhibition, look at everything and think: no that's not it!» Now when I paint or see how others paint, I don't lose the impression of nature for an instant, and I see how it is all just a pale copy, a slobbering painting, such a childish state of art! How far we are from true art, when we should be making «the stones speak» (18) as in the Gospels. How eloquent but desperate: on the one hand, the desire «not to lose the impression of nature for an instant», the understanding that Russian art is in a «childish state», and on the other,

46

the indestructible conviction that it is necessary to «make the stones talk», in other words, solve the eternal literary and philosophical problems. And yet, only a year before, Kramskoi had finished his «Christ in the Desert» (1872, Tretiakov Gallery, Moscow), and probably already knew he had failed.

In 1874, the year of the first Impressionist exhibition, the young Repin wrote: «Yes, we're completely different, and besides, we're at an earlier stage in our development French painting is now in full blossom, free from the fetters of imitation, from the academy, free… At last, true French art reigns, fascinating the entire world with her brilliance, taste, lightness, and grace» (19) In answer to Kramskoi's fears that while searching for light and air, the artist might lose «his most precious quality - his heart», Repin wrote: «Our problem is the content; our themes - the face, the soul of a man, the tragedy of life, the impressions of nature, its life and meaning, the spirit of history. Our colours are the instruments with which we must express our thoughts, our colouring, not elegant spots.» (20)

Surikov remarked, that «the French have mastered what is best in life, the joyful side, the exterior, they understand beauty and style. They are deep on the outside (21). And again in 1884, Surikov, that disciple of historico-philosophical painting, admits: «Manet's Countesses are higher than any idea.» (22)

As of 1875, (23) the Russian journal «The European Bulletin» (24) started publishing Emile Zola's articles, specially prepared for the «Parisian letters» rubric. These articles constitute a very interesting fact of Russian artistic life, but have not yet attracted the attention they deserve from Russian and French historians. They give an idea of which Western art criticism was available to Russian artists in Russia.

17 V. V. Stasov, Selected works, vol. II, Moscow, 1937, p. 516.

18 I. N. Kramsoi Letters, Articles in two Volumes, vol. 1 Moscow, 1965, p. 233.

19 I.N. Kramsko,i Correspondance vol. 2 Moscow, 1954, p. 302.

20 ibid, p. 303.

21 Masters of Art about Art, vol. 4, Moscow, 1959, p. 419. Surikov, the painter of historical drama, was fond of traditional theatre and understood the new language of the French artists: «Go to the Luxemburg Museum! You'll see such beautiful pieces of new art! Monet, Dégas, Pissarro, and many others.» (Vasily Surikov, Letters, Recollections of an Artist, Leningrad, 1977, p. 137) As a professional, he even appreciated Picasso's manner: «A true painter must begin all compositions precisely in that way: with right angles and general masses. But Picasso wants to stop there, so that the force of expression becomes stronger. This is strange for the general public but for a painter it's perfectly compehensible.»(ibid, p. 189.)

22 E. V. Sakharov, Vasily Polenov, Elena Polenova, Chronicle of a Family of Artists, Leningrad, 1965, p. 338.

23 This exhibition is often mistakenly dated as being in 1878.

24 The European Bulletin was founded in 1866 by the historian, and journalist Stassiulevitch (1826-1911). The title was taken from the famous European Bulletin which N. M. Karamzin published from 1802-1830. Zola regularly sent articles under the rubric Parisian Letters on various themes, especially analyses dedicated to problems in art and literature.

25 Unfortunately many of Zola's originals were lost. Stassiulevitch wrote Zola: «Unfortunately many of the French manuscripts have been lost and only the Russian translations are left.», ibid, p. 189

26 European Bulletin, 1876 XV.

27 ibid.

The first substantial article about French painting by Zola, was published in Russian, in the third issue of the «Vestnik Evropy» (1875) under the title «A painting exhibition in Paris». Every year from then on, the journal published the writer's analytical articles about artistic life in Paris. The following year, in an article entitled «Two Art exhibits in May» *(Vestnik Evropy*, issue XV) Zola proposed a detailed description of the most radical French artists. For the most part, Zola repeated the thoughts of earlier French publications, but naturally, after a ten-year lapse of time, he added new facts and ideas while preparing the Russian edition. (25) Take for example, what the Russian public could read about Edward Manet: «Some fault-finding critics will never forgive Manet for not marking the details of his

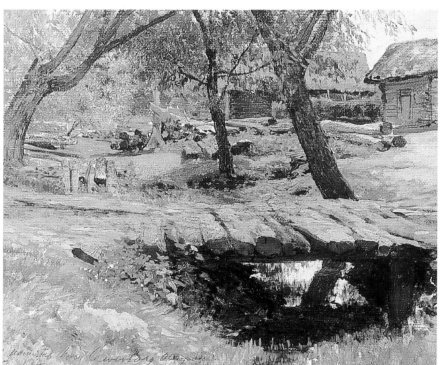

laundress's face. Two dark dots form the eyes, the nose and lips are marked by simple pink lines. I therefore understand the indignation that such a painting can provoke, but for myself, I find it quite interesting and original… He doesn't invent anything, doesn't compose anything, but is simply content to draw the objects he has grouped together in a corner of his studio. Don't demand anything other than a literal translation.» (26)

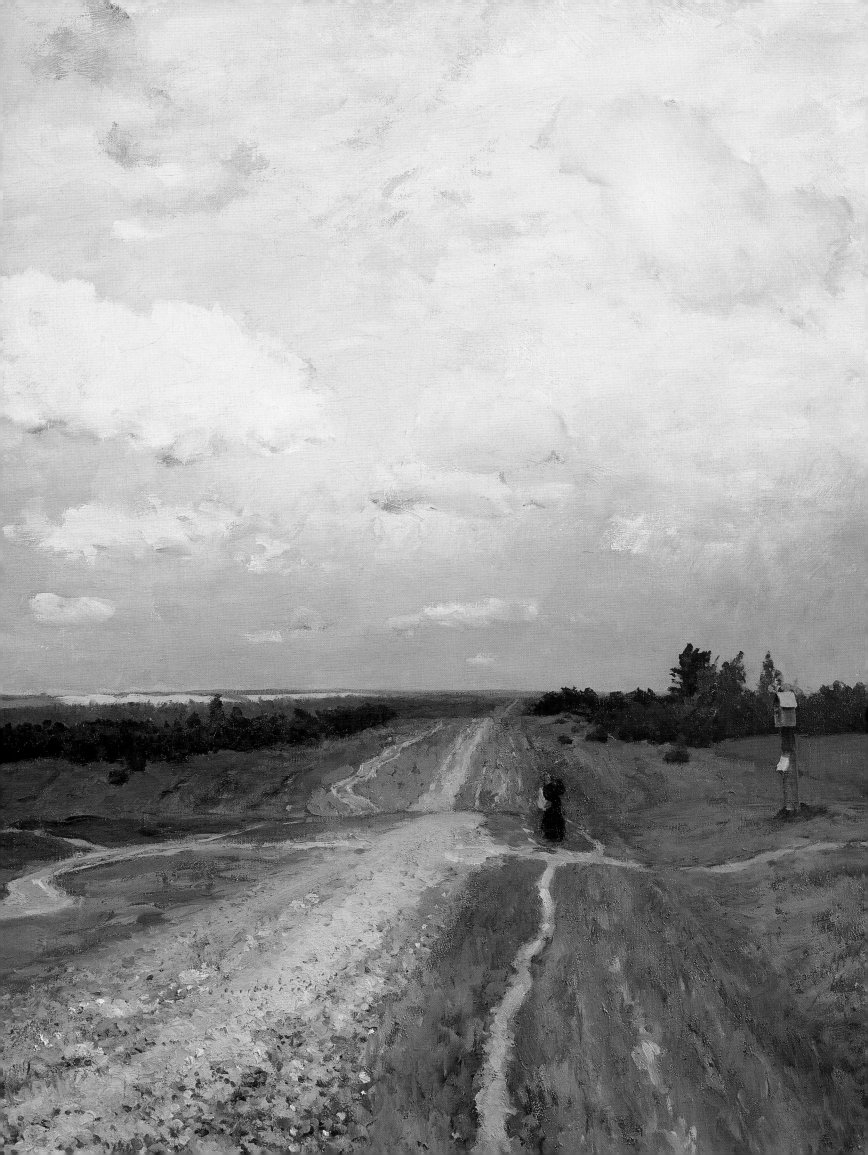

For the Russian artist who read these words, Zola's speaking of «understanding the indignation» but finding the painting nonetheless «interesting and original» was surprising. The impassioned tone of art criticism in Russian journalism had never associated tolerance with antinomy . Just as unusual was the fact that a man of letters would speak with such precision and subtlety about a painting, without suggesting looking for content or deep ideas in painting as the Russian writers and critics did. Russia was no doubt fortunate. For Zola's o p i n i o n s differed greatly from the usual critical or even abusive p a s s a g e s concerning the «new» painters. He was able to see and appreciate the importance of the fledgling aesthetics. In June 1876, at the *Rue Le*

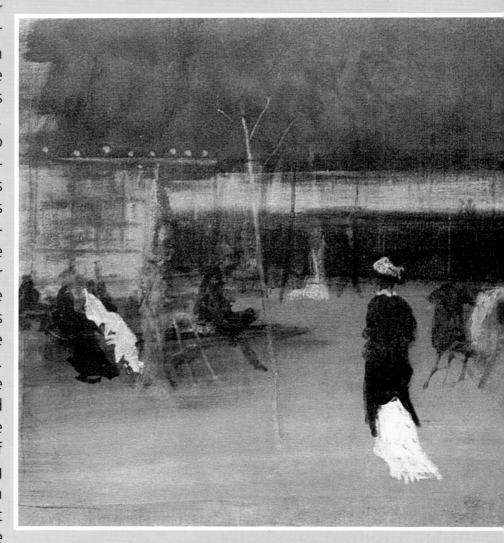

43. James McNeill Whistler
Cremorne Gardens, no. 2.
1872-1877
Oil on canvas. 68.5 x 134.9 cm
The Metropolitan Museum of Art,
New York

Peletier Exhibition he wrote in the *The European Bulletin:* «There is no doubt that we have before us the germination of a new movement. (Speaking of the Impressionists, M.G.). One remarks in this group a revolutionary fermentation that will contaminate little by little the Academy of Fine Arts itself, and in some twenty years completely change the face of the official exhibition from which these innovators have been banished. One

54

could say that Manet set the example. But he no longer stands alone. A dozen painters are already following his footsteps, besieging the sacred rules. And if you look closely at the paintings accepted at the official exhibition, you'll see some that imitate the new school, although not often. The painters I'm speaking about are called «Impressionists» because most of them are striving to get across and communicate the exact impression that

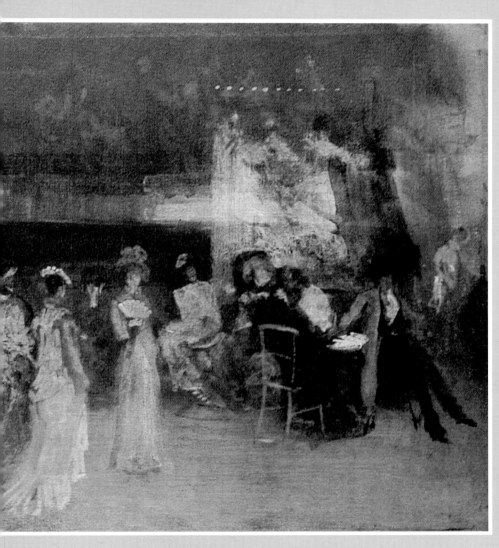

the animate and inanimate objects made on them, to seize it and transmit it immediately, without resorting to small details... My first impression was one of youth, of wonderful beliefs, of strong and daring conviction. Even the mistakes, even the extravagant and excessive artifices had a charm for those who like freedom of expression in art... They heard the babble of the future, before them stood the art of tomorrow. (27) Claude Monet is undoubtedly the head of the group... His landscape bestows us with a sun... Pissarro is an even more violently revolutionary than Monet, his brush is simpler and more naive. Renoir paints mainly human figures.

A gamut of light tones predominates in his work, sliding

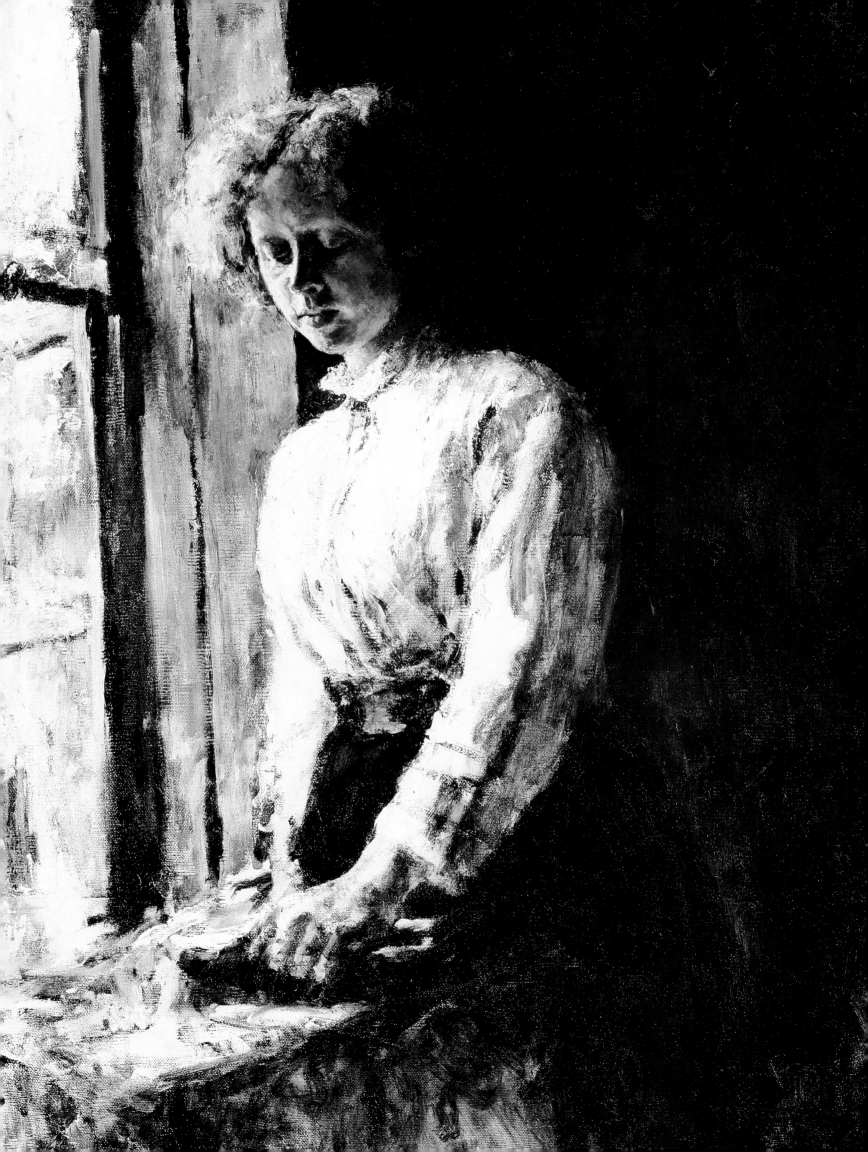

from one to another with miraculous harmony. One would say a Rubens illuminated by the vivid sun of Velasquez. To conclude I repeat: the revolutionary movement that has just begun will definitely transform our French school in less than twenty years. That's why I feel such affection for the innovators... » (28)

Three years later Zola expresses strange doubts concerning his favourite painters: «Moreover, all impressionist painters are guilty of imperfection in their technique. In painting, as in literature, form alone establishes new ideas and new methods. In order to be talented, a man must realise everything that lives inside him, otherwise he is but a pioneer... In my opinion impressionists are just that; pioneers... They mistakenly neglect the solidity of work that is conceived slowly. Therefore, I fear they are only showing the way for a great painter of a new time, that the whole world is waiting for.» (29)

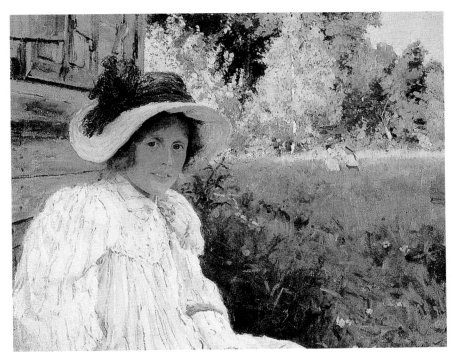

44. Valentin Serov
At the window. Portrait of Olga Trubnikova (the artist's wife).
1886
Unfinished
Oil on canvas glued to board.
74.5 x 56.3 cm
Tretiakov Gallery, Moscow

45. Valentin Serov
In summer. 1895
Oil on canvas. 73.5 x 93.8 cm
Russian Museum, St. Petersburg

46. Valentin Serov
Old bath at Domotkanovo. 1888
Oil on canvas. 76.5 x 60.8 cm
Russian Museum, St. Petersburg

One way or the other, Zola does not see impressionism as the final form of a new and great art. True, a year later he writes, in complimentary terms, about the impressionists: «Truly revolutionary forms only appeared with Edward Manet and the Impressionists: Claude Monet, Renoir, Pissarro, Guillaumin and others. They decided to leave the studios, where painters have been

57

28 ibid.

29 European Bulletin, 1879, L.

30 European Bulletin, 1880, LVIII.

locked up for so many centuries, and paint outside. It seems so simple, but brought on enormous consequences. Light is no longer homogeneous outside, but vacillates and appears in different tones, varying and radically transforming the living and the non-living. This study of light and its eternal changes was, more or less successfully called «Impressionism», because the painting

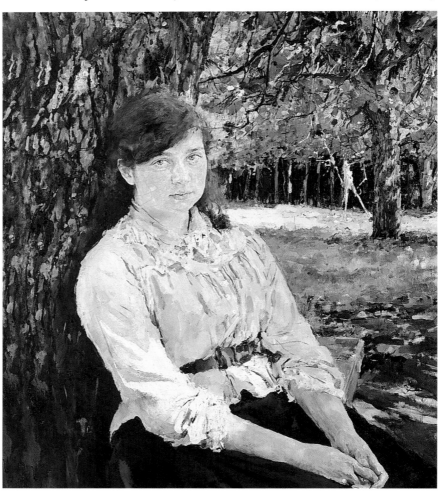

49. Valentin Se[rov]
Girl with peaches. Portrait
Vera Mamontova. 18[...]
Oil on canvas. 91 x 85
Tretiakov Gallery, Mosc[ow]

becomes the impression of the minute *lived* in nature…» But again in this text, Zola speaks of «precursors of a genius» (30) that has yet to come.

Perhaps it was this growing dissatisfaction that pushed Zola to create Claude Lantier, the character of his novel «l'Œuvre», originally published in 1886. This character however was received in Russia with the full tradition of radicalism. Having praised Zola's work, Stasov declared in his article about the novel that Edouard Manet was «not at all the type of hero suited for this type of role…» (Zola

47. Valentin Serov
Sunlight girl (Portrait of Maria
Simanovitch). 1888
Oil on canvas, 89.5 x 71 cm
Tretiakov Gallery, Moscow

48. Portrait of Valentin Serov

Next page
50. Detail
Sunlight girl. 1888

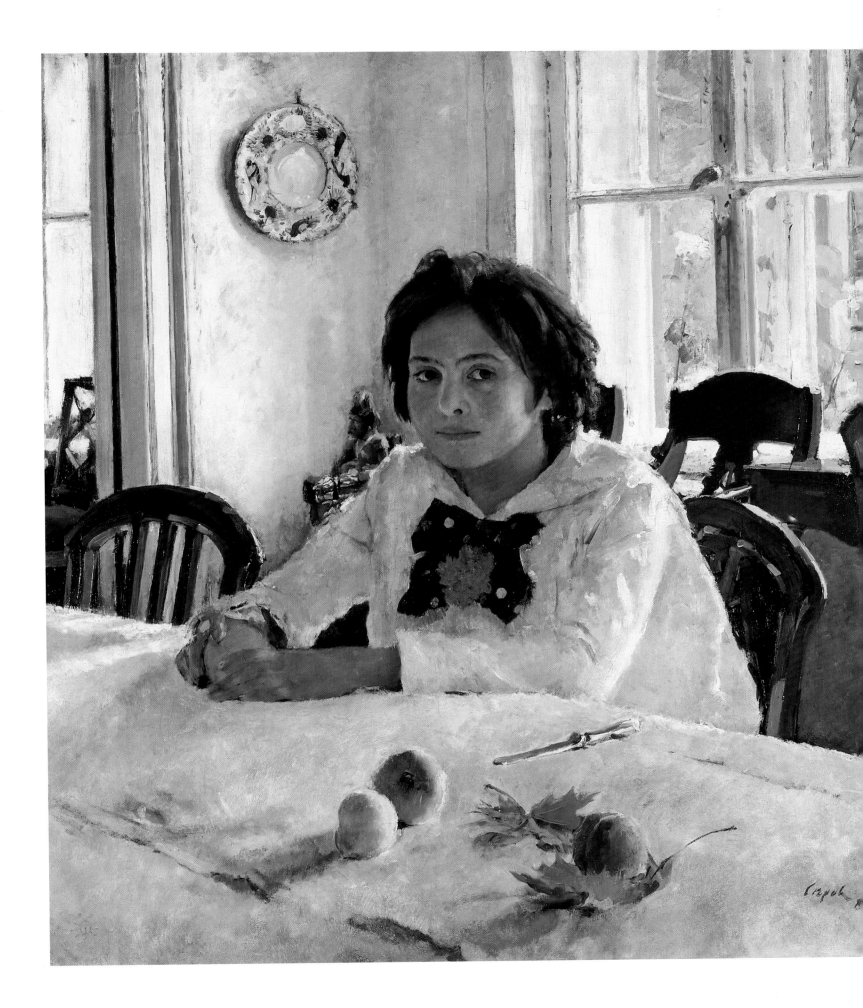

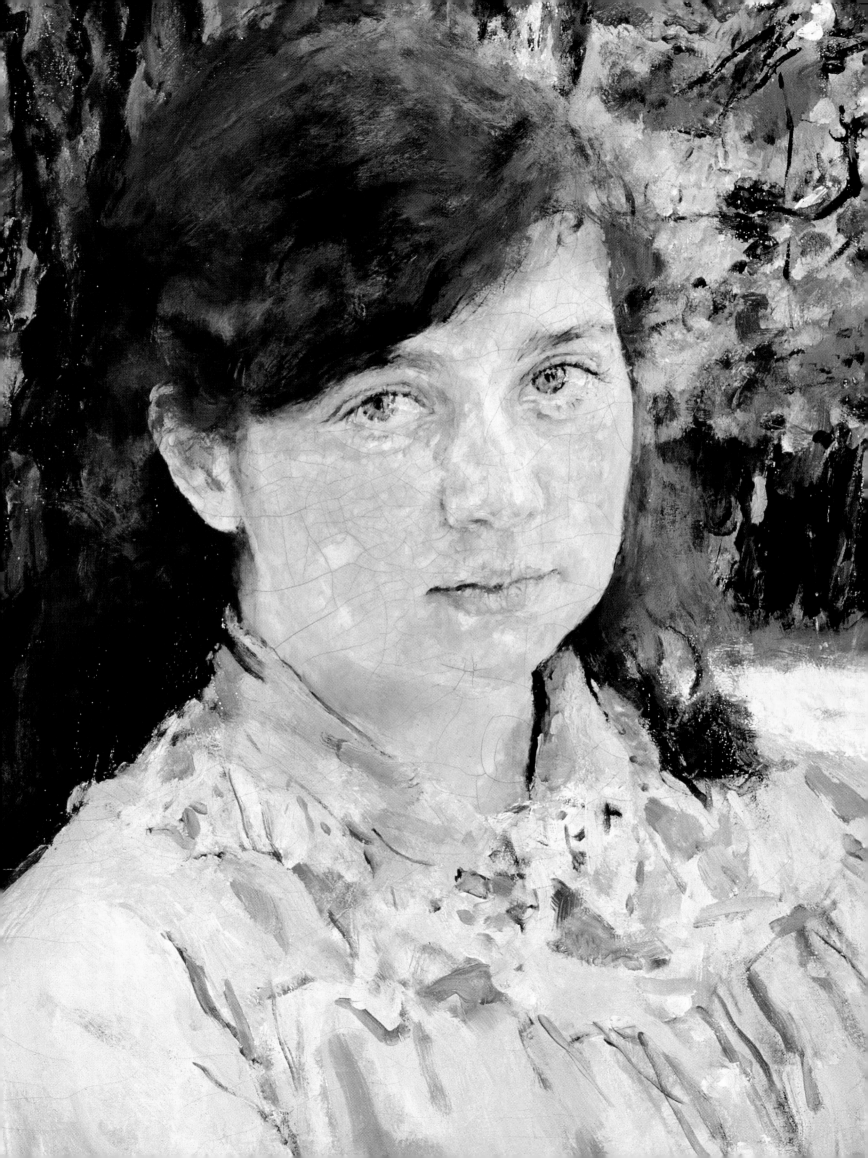

said that the prototype for Claude Lantier was Manet and Cézanne, but mostly Cézanne.) It is not an artist who just contests the school routine, who is, himself, only capable of painting faithfully from nature, and transmitting the forms, types and colours that is needed here, but an artist who is capable of creating entire paintings and entire scenes from true forms taken from real life, and all this with a deep, important and necessary content.» (31)

He suggested Zola choose Gustave Courbet for the part. Such was the intolerance and touching self-assurance of

31 Stock Exchange News, no 185, June 8th, 1886, Quotation V.V. Stasov, Selected Works in three Volumes vol. 3, Moscow, 1952, p. 53.

32 Stasov never accepted Impressionism. In his text XIX Century Art (1901) he called Edward Manet's *Déjeuner sur l'Herbe* «a steril and inept meeting of naked women and clothed men depicted only for the sun's effect.» (V. V. Stasov Selected works in three volumes, vol. 3, Moscow, 1952, p. 554.) The critic went into a rage when he saw his contemporaries' enthusiasm for Impressionism. He wrote the sculptor Antokolsky, in 1897; «Many young artists have declared themselves *«impressionists»*. The only thing they're interested in is colour and the way to apply it; the rest is just nonsense. No need to talk to them about subject or content! ...» (V.V. Stasov, Collected Works, vol. IV, St. Petersburg, 1906, p. 13).

Russian democratic criticism. (32)

The new depth of art that appeared as a result of the formal quests was not so much incomprehensible, but rather foreign to Russian art. It was not so easy to accept the principal position of Western culture, that searched for freedom while creating a new language art. The autonomy of art, that Lionello Venturi hailed as the main prerogative of the New Age, was built on artistic values, free from life's problems and social tragedies. This was

51. Valentin Serov
Portrait of Princess Olga Orlova.
1911
Tempera on canvas. 237.5 x 160 cm
Russian Museum, St. Petersburg

52. Mikhail Vrubel, Vladimir Derviz and Valentin Serov
Students of the Academy of Art
1883 - 1884

53. Valentin Serov
Portrait of Henrietta Girschmann.
1907
Tempera on canvas. 140 x 140 cm
Tretiakov Gallery, Moscow

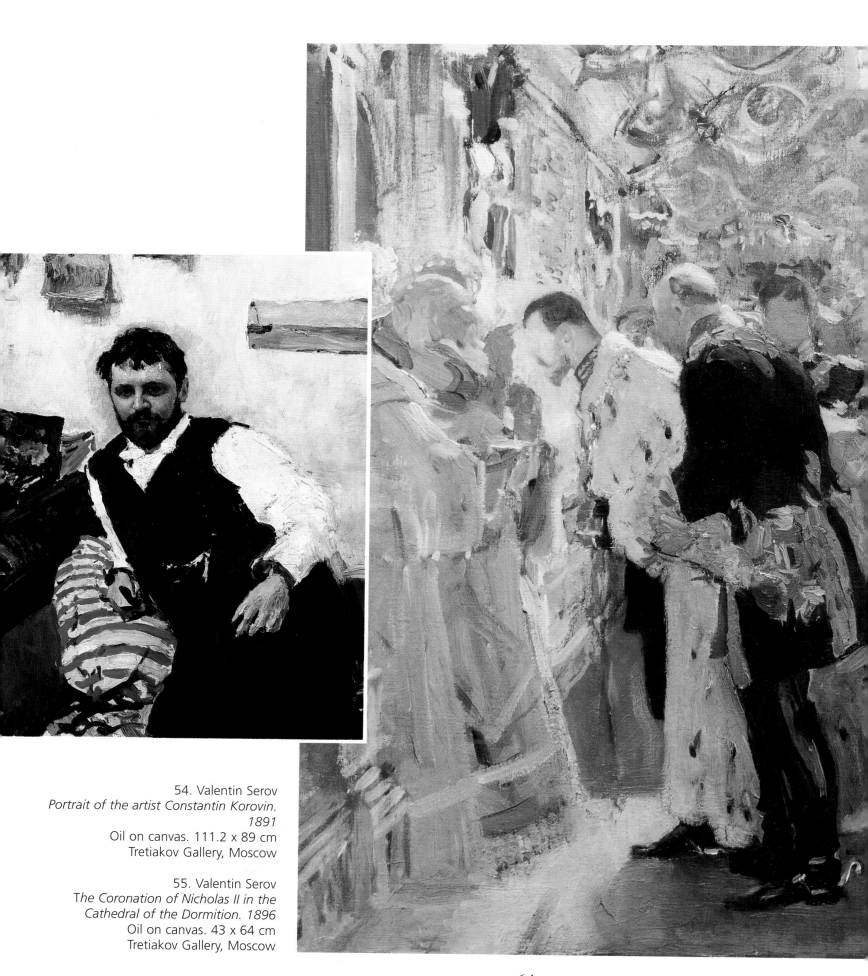

54. Valentin Serov
Portrait of the artist Constantin Korovin.
1891
Oil on canvas. 111.2 x 89 cm
Tretiakov Gallery, Moscow

55. Valentin Serov
The Coronation of Nicholas II in the
Cathedral of the Dormition. 1896
Oil on canvas. 43 x 64 cm
Tretiakov Gallery, Moscow

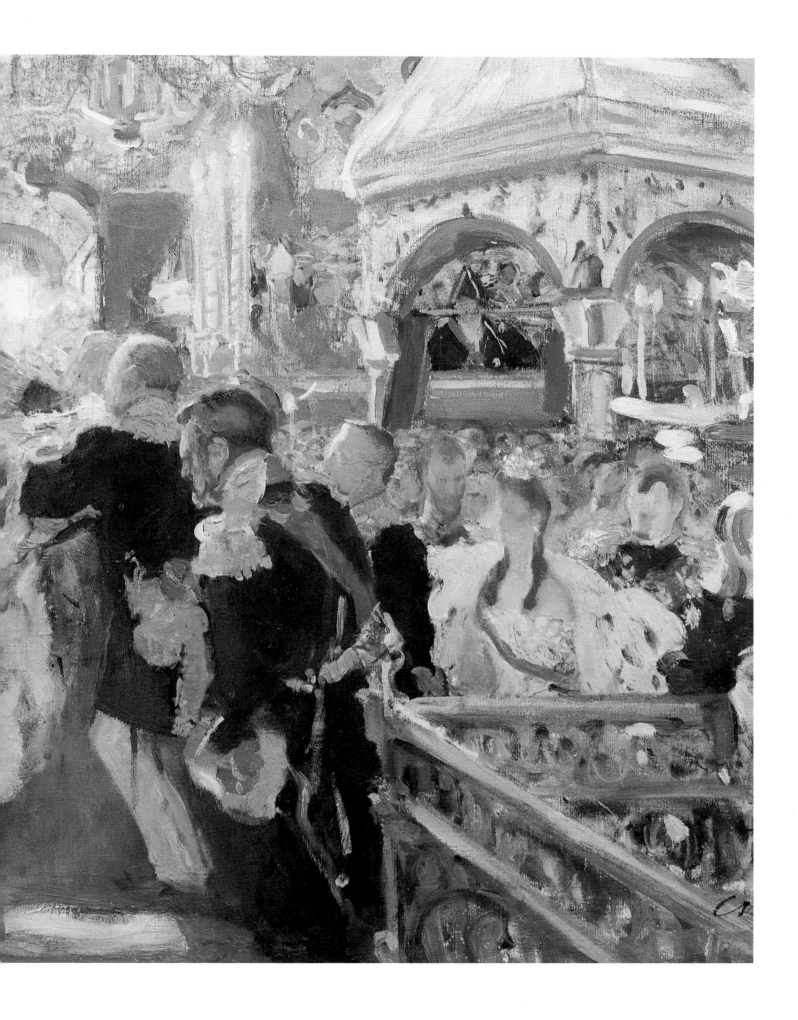

something new and somewhat awkward for Russia. Although the young Vrubel already insisted that an artist «must have something special of his own, where he is the best judge, something he must respect and not

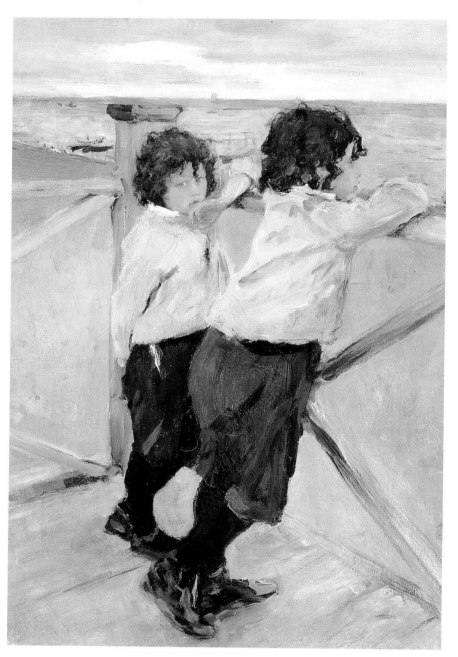

mutilate into an instrument for social and political journalism».(33) However, to consider Impressionism as a local (French) revolution in the areas of colour and interpretation of space, would make our judgement too inert to be trustworthy. Along with the movement towards autonomy in art, there was a growing interest for *plein air* work, for painting

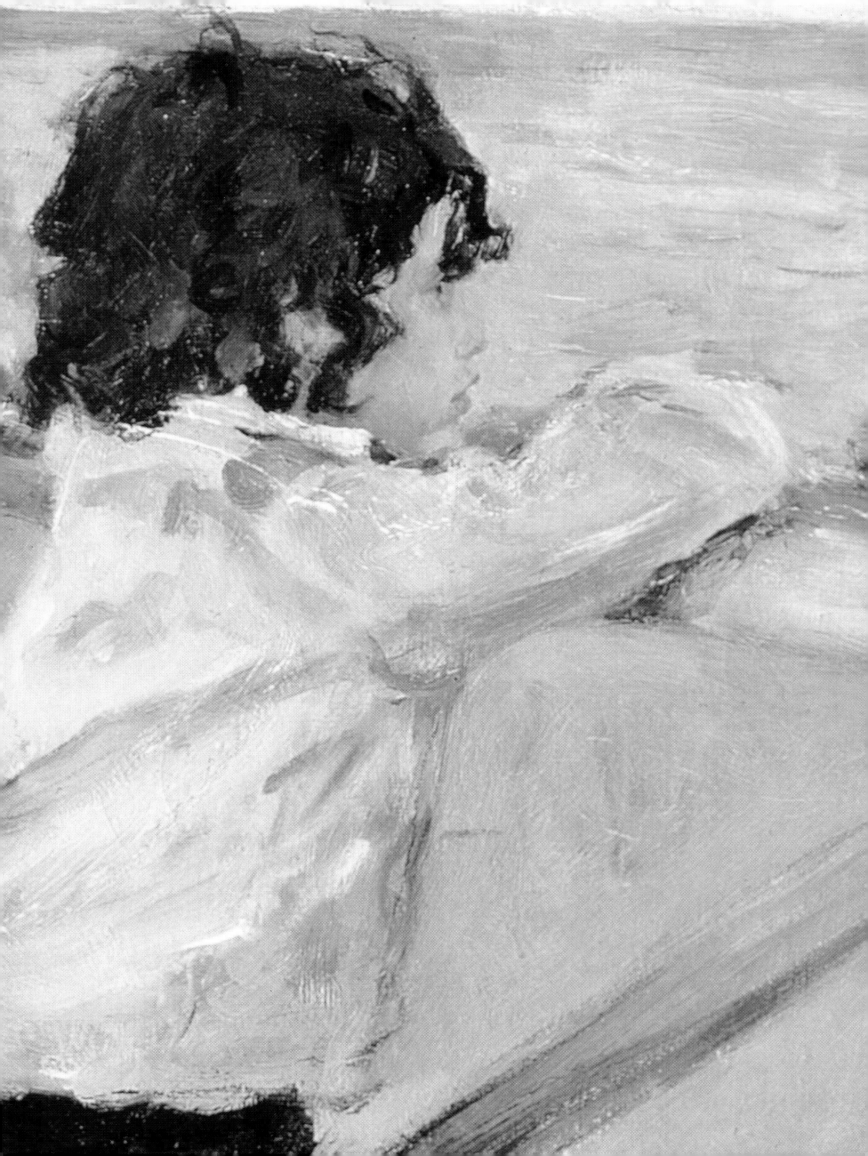

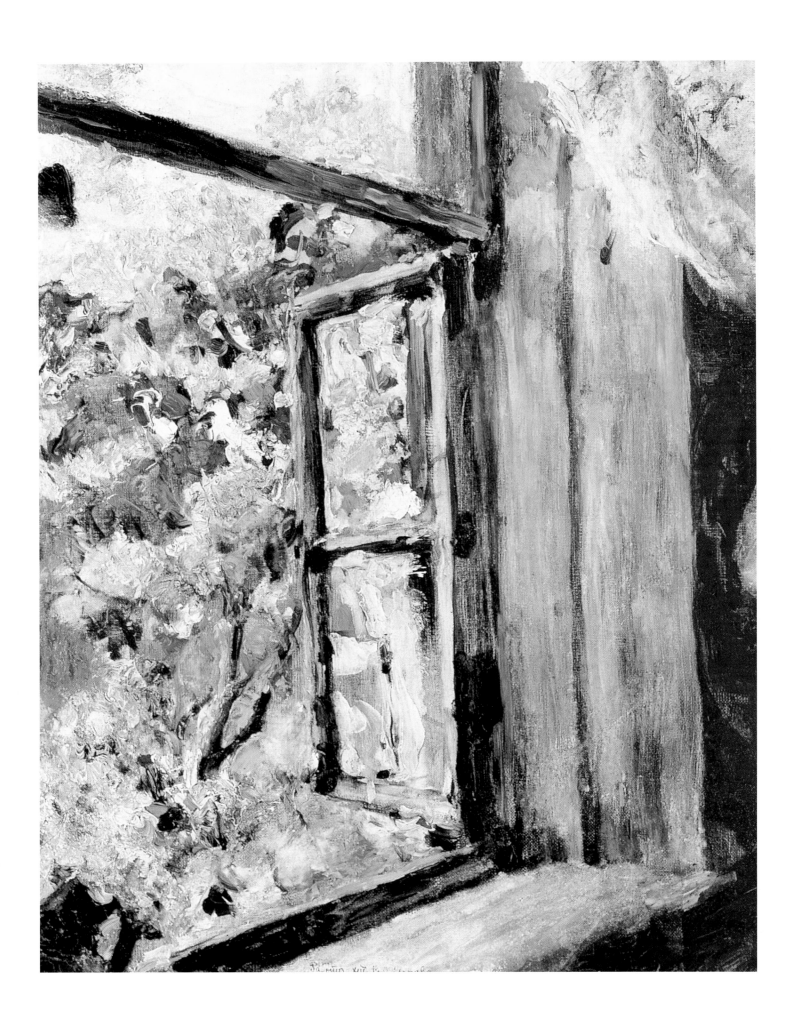

based on live studies, for a lighter palette.

French Impressionism was a way of looking at the world that conflicted with the outdated academic form. It meant independence of vision and a new stroke of the brush. This no doubt brought about unavoidable losses for national culture. It is known that Claude Monet, the classic impressionist painter, and probably the most faithful disciple, was confused and dispirited, realising

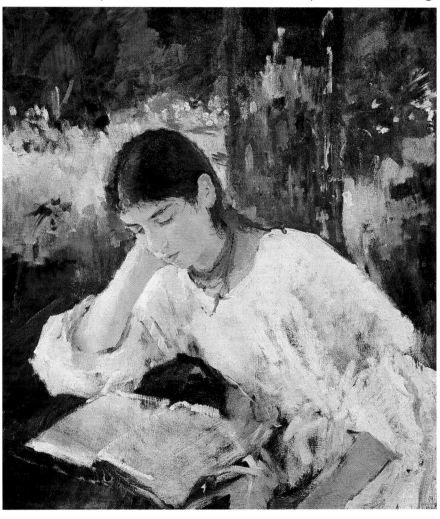

the extent to which he had become enslaved to his contemplation of the wonderful and impassive side of the world. Looking at the face of his deceased wife, Camille, he noticed the fascination with which his eyes regarded the changing colour on her cold face: «It is a persistent thought, the joy and torment of all my days. To such an extent that at the bed-side of the departed, who was and remains so dear to me, I was astonished at how my eyes were as if fastened to her temple, at how they

Previous page
56. Valentin Serov
Children (Sasha and Youra Serov). 1899
Oil on canvas. 71 x 54 cm
Russian Museum, St. Petersburg

57. Portrait of Valentin Serov. 1900

58. Valentin Serov
Portrait of Adelaide Simanovitch. 1889
Oil on canvas. 87 x 69 cm
Russian Museum, St. Petersburg

59. Valentin Serov
Open window. Lilacs. 1886 Study
Oil on canvas. 49.4 x 39.7 cm
Bielorussian Museum of Fine Art, Minsk

Next page
60. Detail
Open window. Lilacs. 1886

33 M.A. Vrubel, Correspondence, Recollections of an Artist, Leningrad, 1976, p. 38.

34 Georges Clemenceau, Claude Monet, *Les Nymphes,* Paris, 1928, p. 19.

automatically watched how the changing and interacting colours that death had thrown upon the immobile face, went out. Blue, yellow, what do I know? That's how far I'd gone…» (34)

All of this was completely alien to Russia. If Russian painting was to refuse social - and ethical- inspired subject-matter, it would be in direct conflict with its

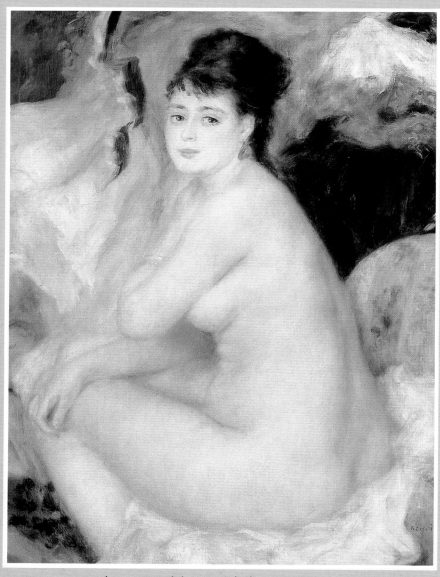

61. Auguste Renoir
Nude. 1876
Oil on canvas. 92 x 73 cm
Pushkin Museum of Fine Art,
Moscow

own nature, in opposition with literature, its main force. This is precisely why the first Russian painters who followed the Impressionist doctrine, remained marginal. Those who took advantage of the Impressionist experience, while remaining relatively faithful to content-matter, rendered its conquests, less radical, but more manifest to the public.

This is why «Russian Impressionism» (the term must be

used with great care) was incapable of creating anything wholly original, as the *avant-garde* did.

Moreover, if what is called Russian Impressionism had not existed, the basis necessary for that very same avant-garde movement, which incontestably became a determining phenomenon in world art culture, would never have been formed. The historical paradox is, that even though Impressionist art was in essence quite passive, it was the decisive step that freed art from the yoke of nature. It was precisely through the controversy of Impressionism that its most recent disciples, (Cézanne, Van Gogh, Gauguin), elaborated a new vision, based on the reconstruction of their own inner perception of the world and not on a reflection of reality. The Impressionist

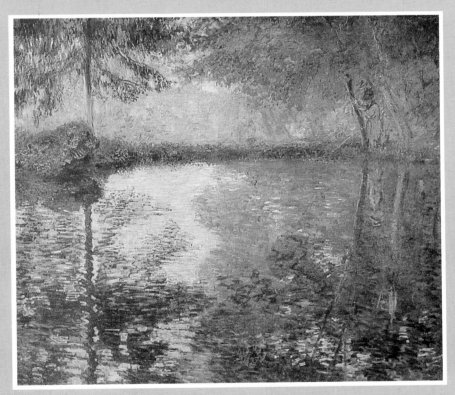

freedom from subject (although *La Grenouillère* and *Le Moulin de la Galette* were purely literary for the French) became a completely new and unusual phenomenon for the Russian artist. Curiously enough, the democratic aspect, and the non-aristocratic characters - the customers and waiters in the cafés, the boulevards, the laundresses, the rowers, the *demimonde* women, the strollers, the saleswomen, the children playing - corresponded perfectly to the Itinerant tradition. But the

62. Claude Monet
Pond at Montgeron. Around 1876
Oil on canvas. 173 x 193 cm
Museum of Modern Occidental Art, Moscow

pre-eminence of method over subject in the paintings made them forget all the serious care their French colleagues donated to the details of existence.

Although relatively interested in catching the brief

moment on canvas, the Russian artist was simply frightened by the autonomy of form. Impressionism was only assimilated among Russian artists once the conservative rigidity of the former chromatic methods became obvious. The Impressionist tendency pervaded Russian painting slowly and with difficulty. Only the most subtle and curious

Previous page
63. Mikhail Vrubel
*Small girl against a Persian rug
Maria Dakhnovitch. 1886*
Oil on canvas. 104 x 68 cm
Museum of Russian Art, Kiev

Previous page
64. Mikhail Vrubel
*Photographed around 1900 in the study
of the collector Y. Jukovski*

65. Detail
*Small girl against a Persian rug
1886*

66. *Mikhail Vrubel at work around
1900*

76

painters, using their own impressions - some on purpose (Kramskoi, Repin), and some by accident (Serov), in the 1870s-1880s - seriously considered the achievements of the French Impressionists as worthy of being analysed.

Not only did the Russians become interested and start studying the Impressionist conception of outdoor painting ten years later than the French, they did so for other reasons, and their quest developed differently.

Social passions had practically disappeared from French painting. French painters, from David to Courbet, had served too many revolutions in vain for too long (be they

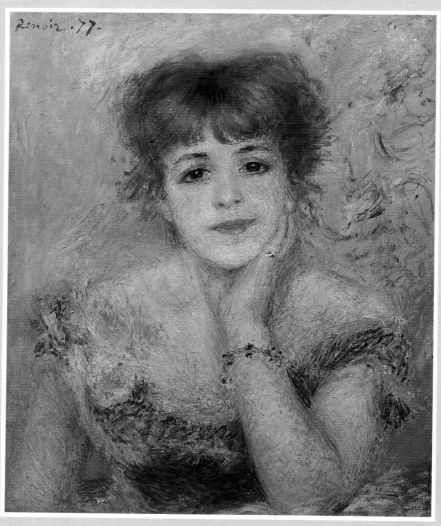

67. Auguste Renoir
Portrait of the actress Jeanne Samary. 1877
Oil on canvas. 54 x 46 cm
Pushkin Museum of Fine Art, Moscow

Utopian or real). Through their disillusionment they demonstrated that art cannot change the world.

The heirs of the insurgent bourgeois, who once lauded Louis David, the petty bourgeois of Rougon-Macquart's time, satisfied with the reality that Daumier so derided, were neither searching for disturbing problems nor a

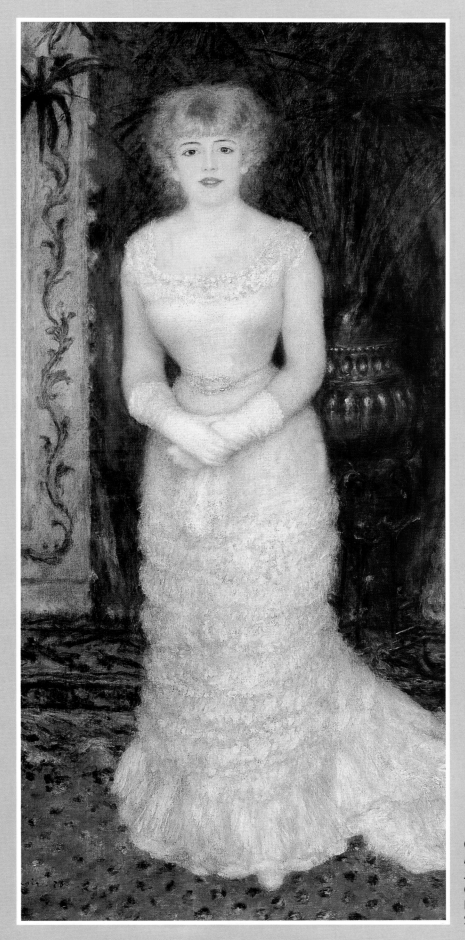

68. Auguste Renoir
Portrait of the actress Jeanne Samary. 1878
Oil on canvas. 173 x 102 cm
Hermitage Museum,
St. Petersburg

new language in art. The truly gifted painters were pushed aside by the attention given to the glossy and insipid works of Leman, Cabanel, or Couture. The most talented painters, having long since renounced the Messianic role, dedicated themselves to the quest for new figurative methods, simplifying the subject and condensing the themes to the eternal motifs. Seriously

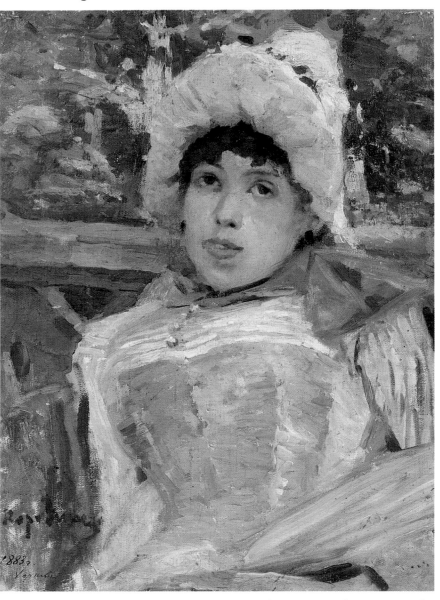

interested in politics and morals, (Pissarro, for example was an anarchist) and knowing poverty, the Impressionists felt that these problems had nothing to do with painting, this having its own concerns.

Contrary to France, Russia was still awaiting her revolution, fearful, anxious and filled with romantic hope. Although a rather sceptical and sometimes negative

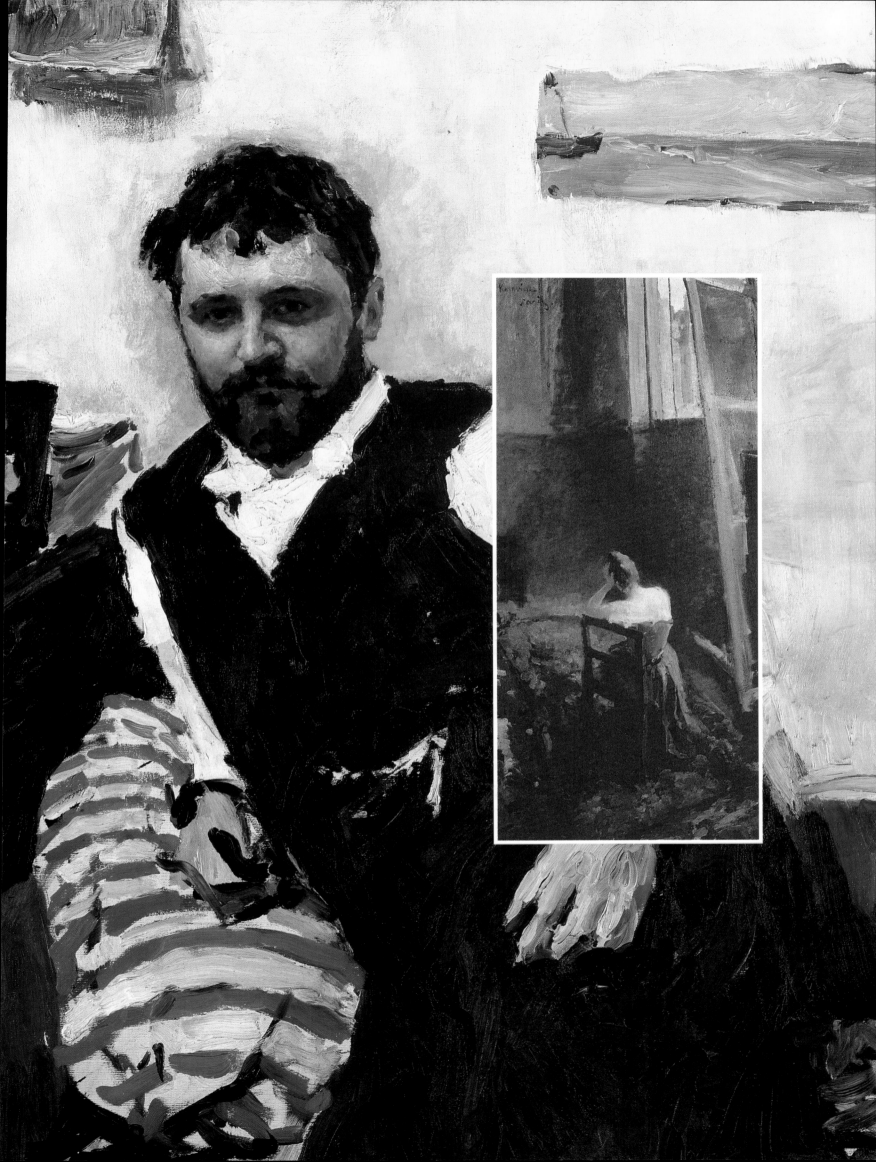

attitude towards the revolution could be found in literature (Dostoevsky, later - Leonid Andreyev, Andrei Bely), painting, unburdened by deep philosophy, but much more prone to conformity, wanted to see the revolutionaries as heroes. They poeticised the revolutionaries (Repin, «*We weren't expecting it*», 1884, «The arrest of a propagandist», 1882-1892), and the suffering oppressed

people (Repin, «*The Barge Haulers on the Volga*», 1870-1873), as the fruit of the cruel logic of history. (Surikov: «*The morning of the execution of the Streltsy*», 1881, «*The Boyarina Morsova*», 1887). Moreover, the raging censorship of literature, was hardly felt in painting. Paintings that denounced the «sores of the present day», presented no threat in the eyes of the authorities. Repin's «*Barge Haulers*» was bought for the palace of a

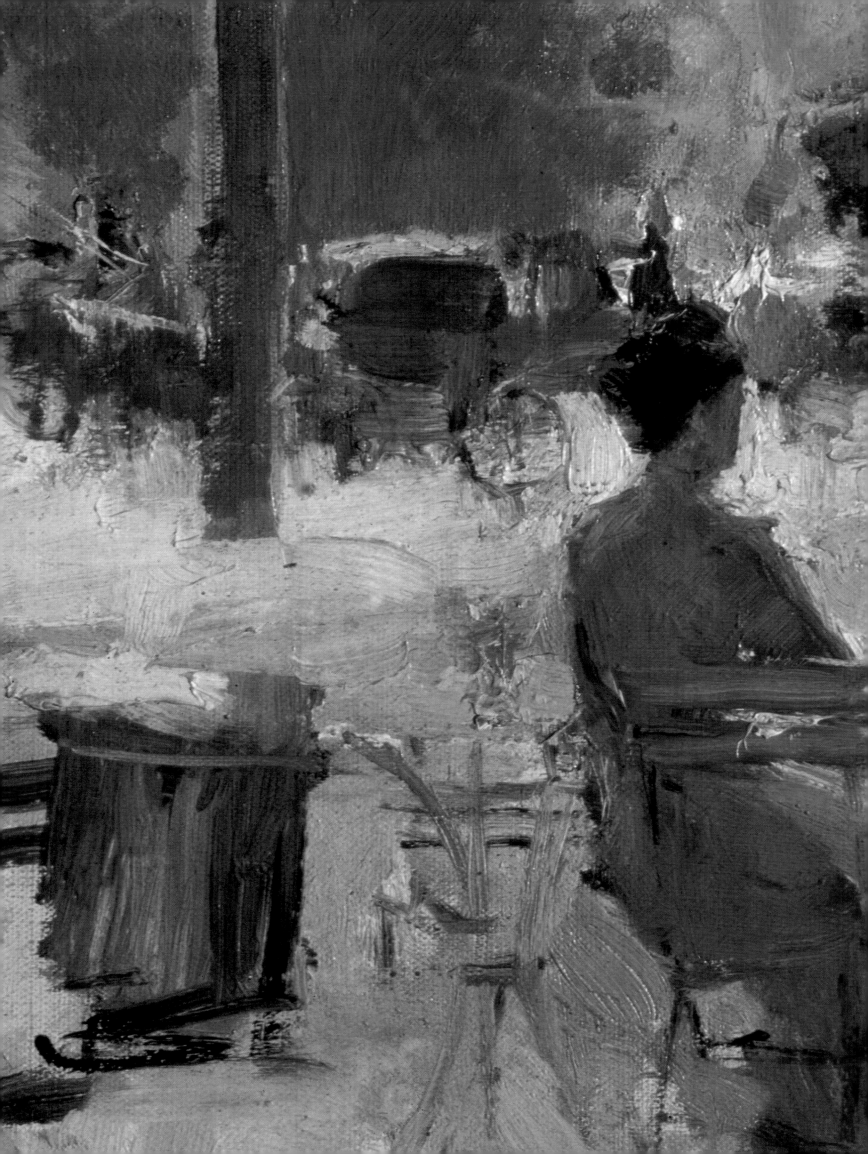

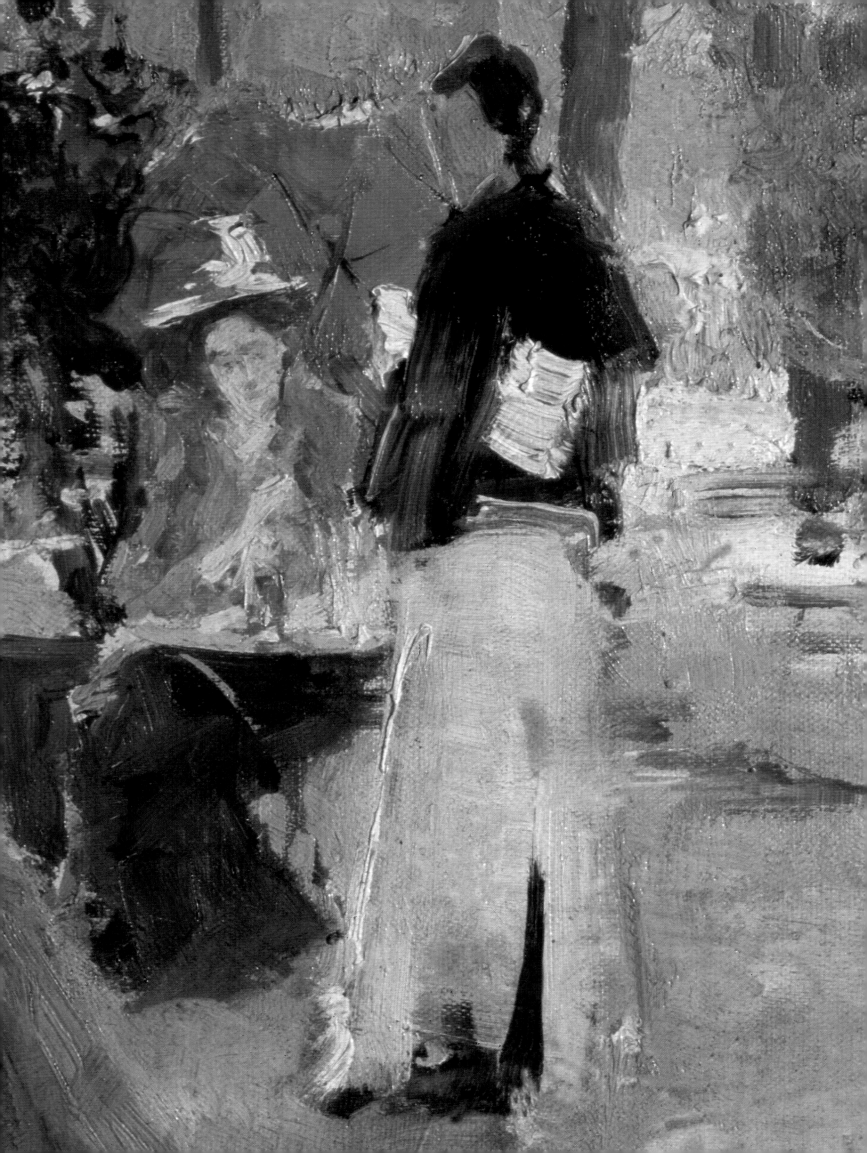

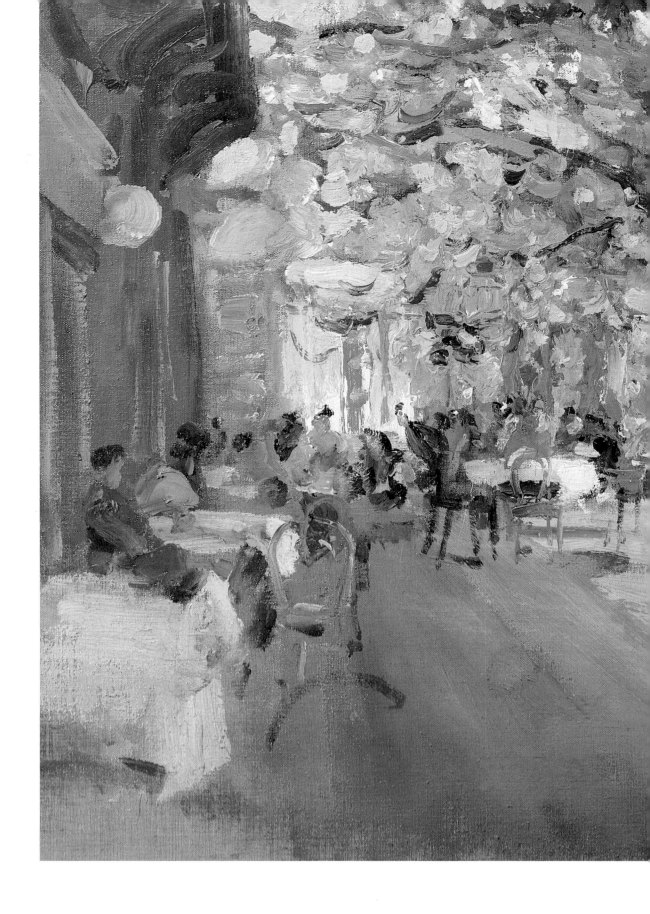

75. Constantin Korovin
Café in Yalta. 1905
Tretiakov Gallery, Moscow

76. Constantin Korovin
Paris at night, Boulevard des Italiens. 1908
Tretiakov Gallery, Moscow

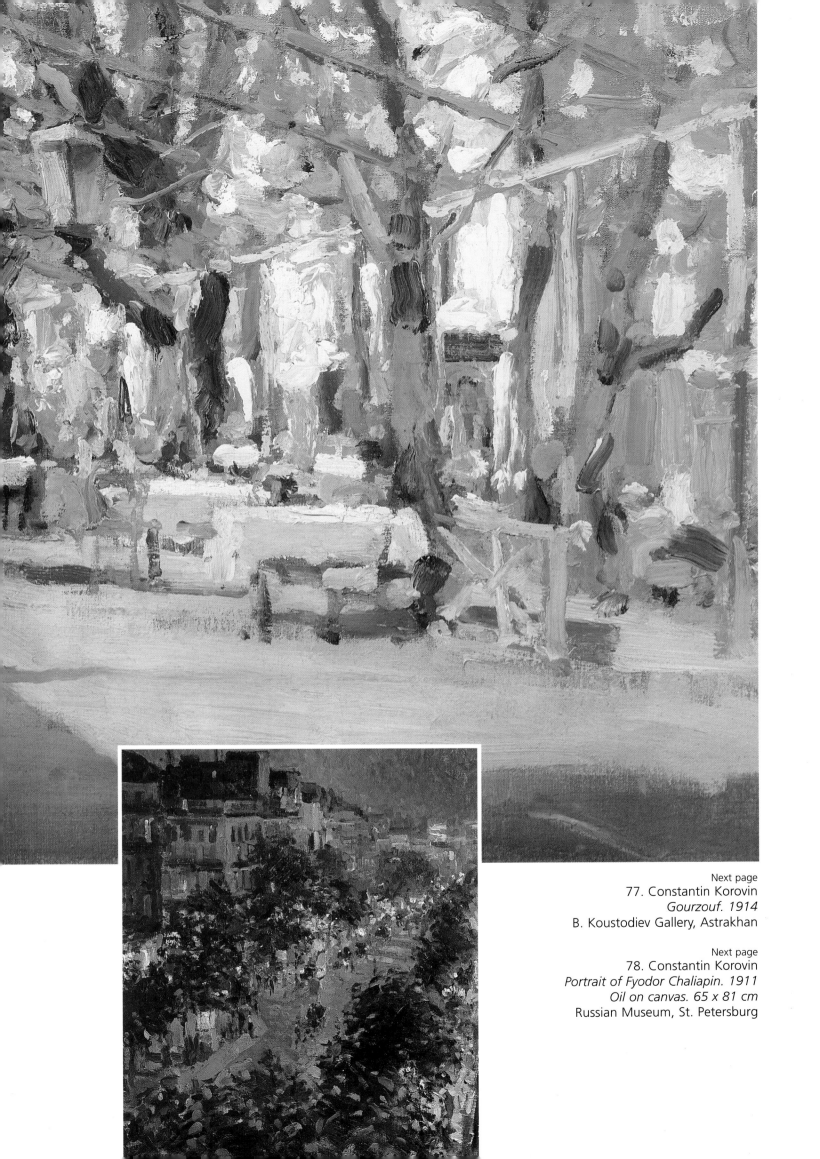

Next page
77. Constantin Korovin
Gourzouf. 1914
B. Koustodiev Gallery, Astrakhan

Next page
78. Constantin Korovin
Portrait of Fyodor Chaliapin. 1911
Oil on canvas. 65 x 81 cm
Russian Museum, St. Petersburg

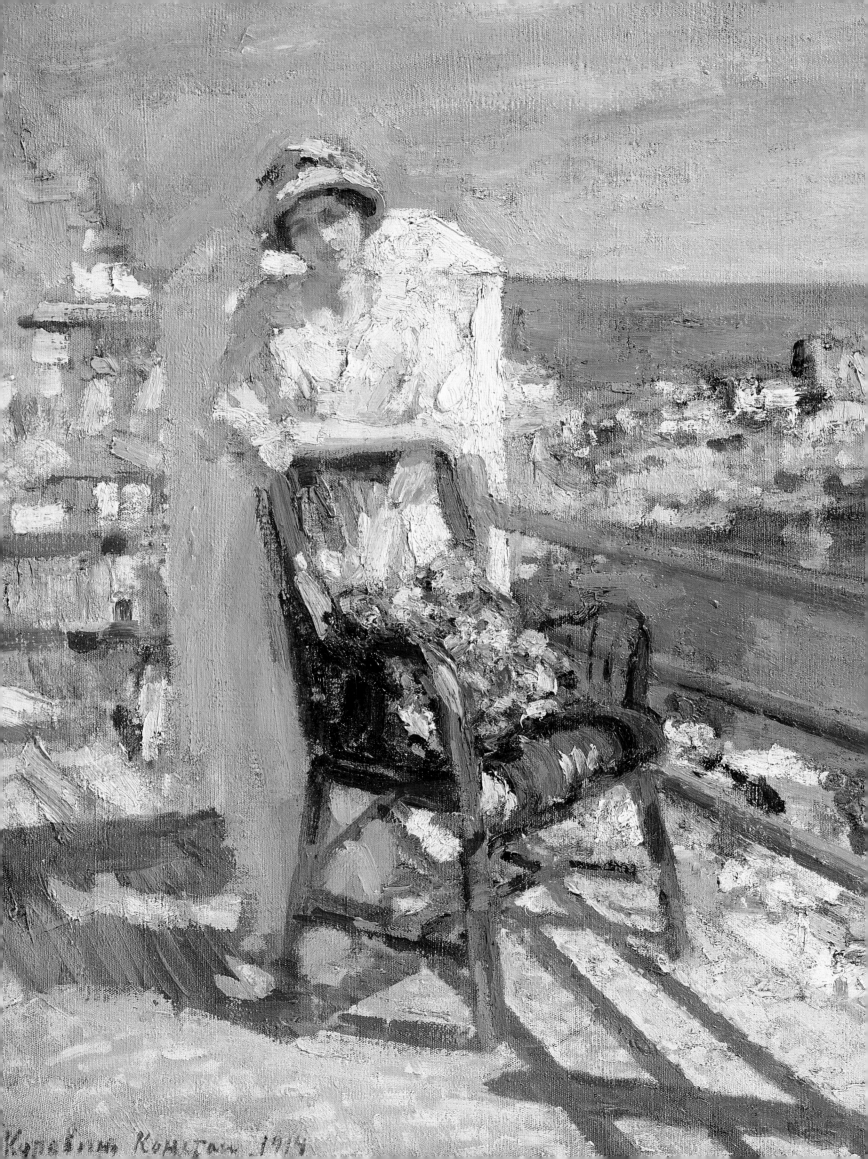

grand-duc. With time, the intransigent Kramskoi, leader of the Itinerants, became a high-society portraitist. Contrary to writers, painters were not persecuted in Russia. Members of the liberal intelligentsia, who were the main, if not only, visitors of exhibitions, remained indifferent to art without political or sincere passion. Only the members of the «World of Art», who had clearly declared their opposition to social subject matter at the end of the XIX century, were remarked upon and harshly criticised by the defenders of the democratic tradition, and especially by Stasov. Up until 1917, the Itinerant subject tradition remained at the centre of attention and the Impressionist trends, along with all other quests in form were confined, so to speak, within art. Kramskoi however, rated the French quests and discoveries very highly: «… their's something there that we need to keep constantly in mind - something trembling, indefinite and immaterial in the technique, an

imperceptible movement of nature, that, if you look closely, becomes material, roughly defined and sharply delineated. When you don't think about it, and forget you're a specialist for a moment, you see and feel how everything is flowing, moving and alive. There aren't any contours, and one doesn't notice light or shadows, but

there's something caressing and warm, like music. One moment you're enveloped in warm air, the next, the wind under a dress; the only thing that the French were not able to do, and, it seems, cannot do, is portray a human face with its cold suffering, questioning mien or deep and mysterious peace.» (35)

Naturally, Impressionist techniques were used in Russian painting, especially in the 1870s, but only as a means of livening up that same social, art subject-matter, that «human face» with its «cold suffering». It is characteristic that the first Russian painting to be marked by the Impressionist influence was painted by Repin, the most famous Russian painter, and called *Parisian Café,* (Finished in 1875, the Monson Collection, Stockholm).

79. Paul Cézanne
Fruit. 1879-1880
Hermitage Museum,
St. Petersburg

Contemporaries

It cannot be excluded that Repin, being influenced by the previously cited letter from Kramskoi, began working on his *Parisian Café* in 1874, the year of the first Impressionist exhibition. The subject of this painting, and some of the techniques employed seem, if not identical, then very close to those of Manet, Degas and especially Renoir in his «*Bathing in the Seine*». (1869, Pushkin Fine Arts Museum, Moscow.) It is impossible and fruitless to search for precise paintings of the French school that may have particularly influenced Repin. He no doubtedly saw many different things of very different value. Judging by his letters he noted mostly trends but not names. At the end of the century he wrote: «The freshness of their canvases has invigorated art. After seeing their unpolished canvases, even the carefully finished paintings seemed boring and old.» (36)

35 I.N. Kramskoi, Correspondence, vol. 2, Moscow, p. 260.

36 Artists about Artists, vol. 4, Moscow, 1959, pp. 388-389.

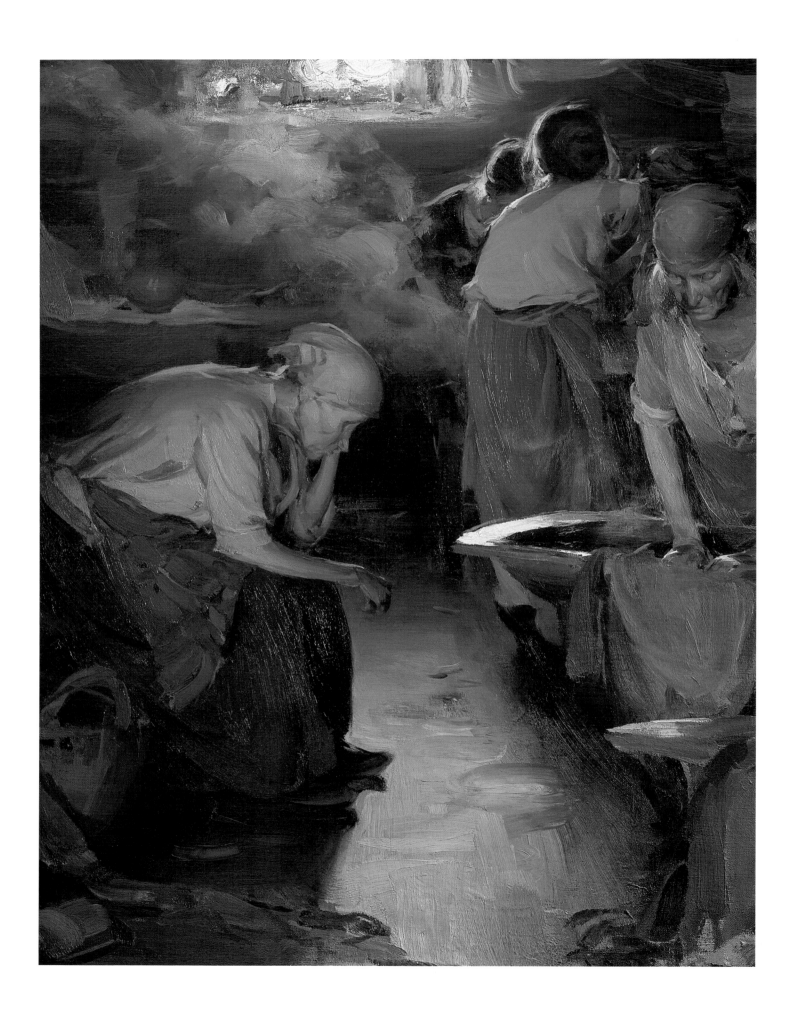

Indeed, in his *Parisian Café* Repin kept that study aspect on purpose, although he knew the «unfinishedness» of Impressionist paintings to be a consistent program the the «incompleteness» being fully feigned, just as with the «absence of composition». In refusing excessive and depersonalised canvases and academic structure of composition, the Impressionists were only protesting against the dogma of the official aesthetic. Beyond the chaos of the brushstrokes, an attentive viewer sees the elaborate structure, the improvisation full of logic, and the audacious calculation in the apparently accidental compositions of the cadres. Étudisme was a characteristic of the Russian interpretation of Impressionism. Despite the energy and clarity of his brushstrokes, despite the effects of the sun and the changing of the colours according to the luminosity, and despite his talent in using the Impressionist devices, Repin painted a social painting. The dramatic aspect, which is characteristic of Repin, does not dissolve in the radiance of the painting, but is enhanced by the contrast. «The human face with cold suffering, with the questioning mien or the deep and mysterious peace «undoubtedly remains Repin's main concern. Even if the subject of the painting contains no food for social or psychological drama, the artist accentuates the psychological and dramatic aspects in every way possible. But one must note here, that while striving to perfect the forms and elevate art, the artist who is drawn to psychology, must intensify that psychological aspect in order to prevent the subject from being pushed aside by the quality of the purely pictorial elements. The powerful impulse from the new formal structure could not change the course of Russian painting. But perhaps, the lessons of Impressionism brought movement to the traditional subject painting that Russian art mastered so well. The hero of an Impressionist painting remains the painting itself with its pictorial elements; it is the synthetic image where the character, the subject and the pictorial factors are completely equal, indivisible and almost identical. The subject, be it apparent or

80. Abram Arkhipov
Washerwomen.
Late 1890s
Oil on canvas. 91 x 70 cm
Russian Museum, St. Petersburg

81. Portrait of Abram
Lefimovitch Arkhipov

evoked, remains the hero of a Russian painting.

One must not forget that at the turn of the century, Russian painters were more influenced by the French examples than they were by the German masters. As we all know, the influence of an interpretation (always less radical and more didactic and consistent than the original) is sometimes stronger than direct contact with the «primary source». Thus, the works of Max Libermann were hardly less familiar to Russian artists

82. Auguste Renoir
Girls in black
Oil on canvas. 80 x 65 cm
Pushkin Museum of Fine Art,
Moscow

than those of Monet or Renoir. At the end of the 1870s, Libermann lived in Paris and his paintings combined the poetry of Impressionism with traditional ponderation. In Germany, Impressionist devices were often associated with social themes, genre scenes, sharp characters, and even religious subjects, like in the works of Fritz von Uhde (1848-1911). This was very close to what Russian

94

painters sought.

It is difficult to say, however, whether Repin knew the German followers of Impressionism, at least at the time of his *Parisian Café.* But despite the pictorial innovations of Repin's canvases, the hierarchy of the elements of the painting -from the type and personality of the character, to the palette and the freedom in the posing of the colours - is rigorously respected in the true spirit of Russian or German tradition. Kramskoi recognised later that : «…the café is spoiled by the trend from Russia, a trend that is to a great extent, literary…» (37) This man possessed the refined taste and rare understanding of the

37 I. N. Kramskoi, Lessers, Articles in two Volumes, vol. 1, Moscow, 1965, p. 387.

tragedy of the art he served perseveringly but without hope. The main achievement of Impressionism - the realisation that «expressing thoughts with colour» was of no interest at the end of the nineteenth century - remained alien to Russian art. Impressionism as a synthetic image of an instant, as the first step toward creating a new reality and expressing an inner state with colours, toward elaborating a figurative model of the subconscious

83. Jules Bastien-Lepage
Pastoral love. 1882
Oil on canvas. 194 x 180 cm
Pushkin Museum, Moscow

processes, in other words toward the art of the twentieth century. All this remained beyond the limits of the art at Repin's and Serov's time.

Apparently sometimes, Repin felt the burning desire to work just for the joy of painting. An extremely spirited artist, far from realising his talent, he sometimes set free his social-burdened muse. This was probably the precursor for the appearence of such works as his *«Bench of Turf»* (1876, Russian Museum St. Petersburg), and later his «Road to Montmartre in Paris» (1885, Tretiakov Gallery, Moscow). These paintings are bursts of free colouristic passion where all the colours are overflowing

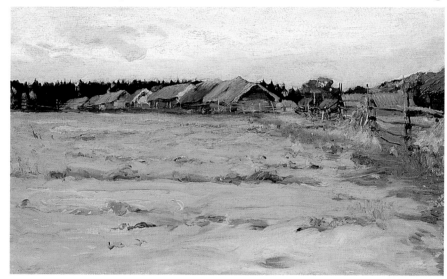

with light, where the shadows are not at all discoloured, but themselves slightly darker colours penetrated with reflections of light. However, in these paintings, free of traditional subject matter, Repin remains a stranger to the fundamental principle of Impressionism: the inherent value of the painting itself. Impressionists painted neither objects nor space, but a «blanket» woven with colour and light. The impalpable luminescent substance alone interested them. Applied to the canvas, this substance absorbed the objects, the spatial depth, and volumes, becoming fully autonomous.

Thus the movement toward the «autonomous art» of which Venturi spoke was born. The surface of Repin's *«Bench of Turf»* certainly possesses the qualities of «pure painting» but space and form continue to dominate, leaving, if not the illusion of depth, then a convincing

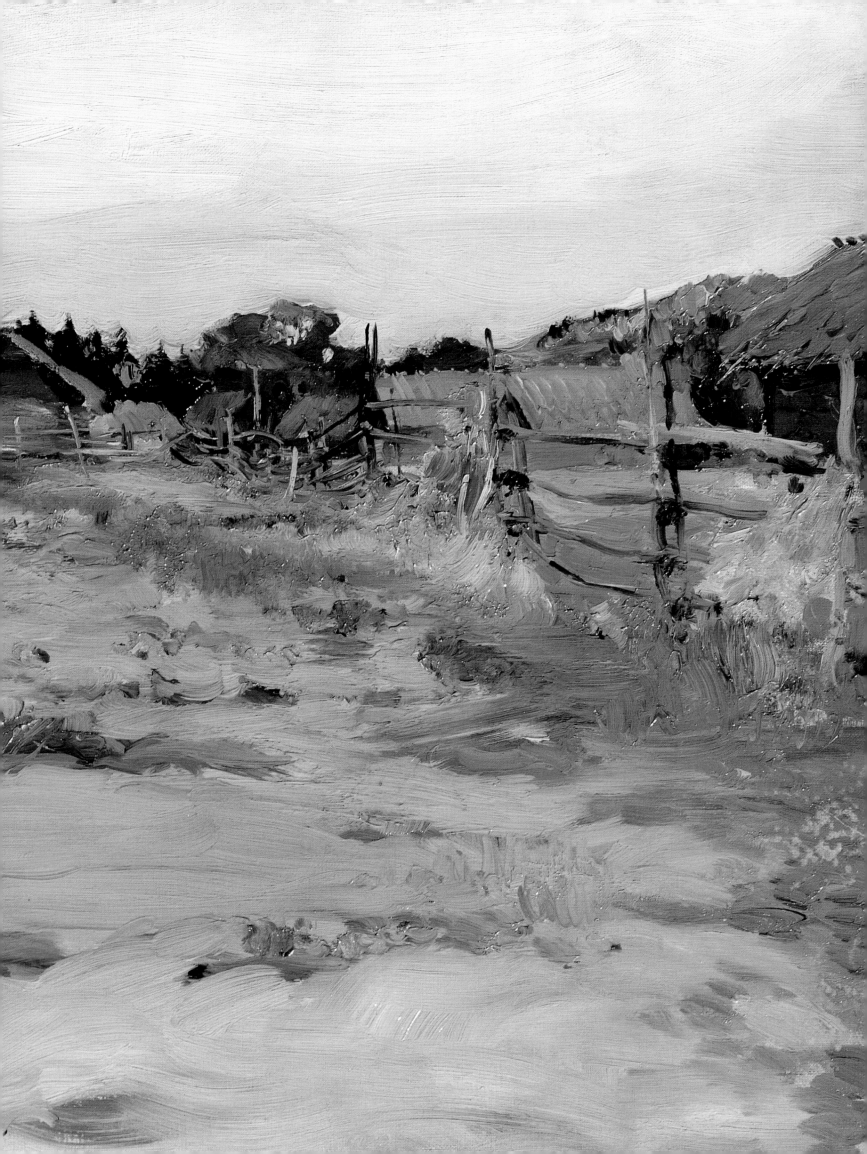

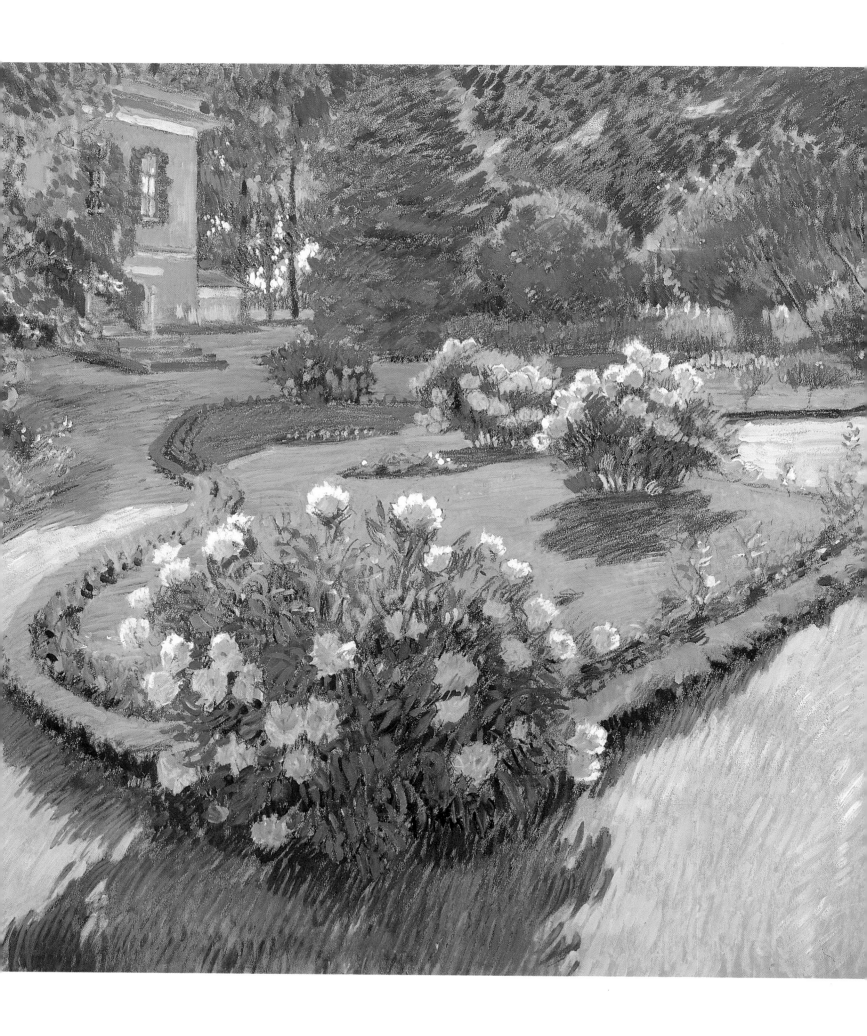

representation of it. One of the essential components of the new vision that formed Impressionism was still missing from Russian reality: the powerful and aggressive urbanisation and the appearance of megalopolises with their new rhythms, and fantastic flux of information. It became almost impossible to isolate the details in the flood of visual impressions. It was necessary to grasp an «instant picture» of the indivisible whole, the subject of which subject, deprived of all detail, became the general impression itself; necessary also to create a pictorial concentration, without primary or secondary elements, but where all elements dissolved into the «artistic substance». Urban landscapes were unknown to Russian Impressionism. Only western cities, and especially Paris, occupied the imaginations of Repin and Korovin.

Previous page
84. Sergei Vinogradov
Martzianovo village. 1902

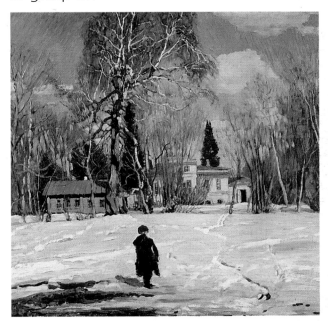

Repin undeniably experienced a crisis period. After Lev Tolstoy's «Death of Ivan Ilitch», and Dostoevsky's «Demons» (1871-1872) and «Brothers Karamazov» (1879-1880) and after Vrubel's «*Demon*» (1890), Repin's «*Arrest of a Propagandist*» (1881-1891) was already an achronism, both in subject-matter as well as in method. Repin probably realised that he could no longer develop his gift through traditional painting. His monumental «anecdote» entitled «*The Cossacks writing a letter to the Turkish Sultan*» (1878-1891, Russian Museum, St. Petersburg), testifies to this. And yet Repin made good use of the Impressionist devices in his traditional paintings. Even «*They weren't expecting him*» (1884, Tretiakov Gallery, Moscow), where he stages a social and ethical drama gained a lot from the *plein air* effects drawn from Impressionism. Repin was not destined to create the new painting of Modern times, but his preliminary studies for the canvas «*A Solemn Session of the State Council*» (1901-1903, Russian Museum, St. Petersburg), were an incontestable step into the twentieth century.

A new interest in painting for painting's sake, can be felt here, and it is not coincidental that these pieces opened

85. Sergei Vinogradov
The garden. 1910
Regional Museum of Fine Art, Irkutsk

86. Sergei Vinogradov
Spring. 1902
Tretiakov Gallery, Moscow

99

38 Constantin Pobedonostsev (1827-1907), states-man, public prosecuto of the Saint Synode, tutor of future emperors Alexander III and Nicolas II. Monarchist and conservative, he was against the diffusion of European culture in Russia.

39 Bastien-Lepage's painting *Amour Champêtre* (1885) was part of Sergei Tretiakov's Collection from 1888, where Serov may have seen it.

40 European Bulletin, 1879. Zola wrote of Bastien-Lepage: «His superiority over the Impressionist painters lies in the fact that he knows how to bring his impressions into being. He has understood that a simple technical question separates the public from the innovators. He therefore kept their spirit, while insisting on the expression and the technical devices. It is impossible to find a more skilful artisan. And that helps him communicate a subject and a tendency. The bourgeois is ecstatic because all his paintings are brilliantly painted.» Serov either did not read this text or did not pay very close attention to it.

the great «Moscow-Paris» exhibition in 1982. Many of them, especially the «*Pobedonostsev*» portrait (1902, Russian Museum, St. Petersburg), are startling, capturing the ephemeral instant of the character's psychological state and a vaporous-luminous atmosphere where volume disappears and where the expression of the eyes and face swallow the traits themselves (38). It is one of those rare moments when a certain version of the Impressionist vision becomes an important component

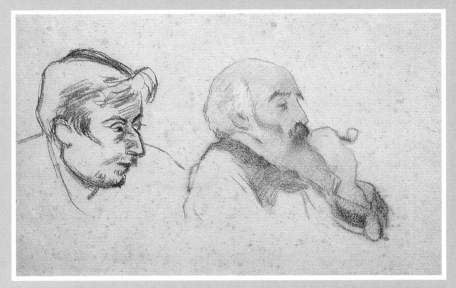

of the psychological characteristic, thus creating the effect of an «instant picture». The impression is enhanced by the fact that the «pictorial cooking» (a typically Impressionist phenomenon) is open to the viewer. The brushstroke itself retains artistic meaning. It is not the object but the manner of execution and the dynamic that impress the eye. Perhaps here the «inherent value of the pictorial surface» is reconciled with psychological dramaticism; a rare occurrence in Impressionism, especially in its Russian vein, but nonetheless interesting. This precision, reaching right from the surface down into the psychological depths, constitutes perhaps one of the last portraits of the New times where man is portrayed from the «outside» and not from the «inside», without attempting to plastically reproduce his subconscious etc. In order to understand the Russian version of the Impressionist perception of nature, it is imperative to study closely Valentin Serov's «*Girl with Peaches*» (1887, Tretiakov Gallery, Moscow), and «*Girl illuminated by the*

87. Portrait of Gauguin by Pissarro and portrait of Pissarro by Gauguin Around 1870-1883
Charcoal and pastel
Musée du Louvre, Paris

Sun» (1888, Tretiakov Gallery, Moscow).

The last Russian classic painter of the nineteenth century and first of this century, Valentin Serov, united the art of the two centuries in his painting. Without shattering or refuting anything, he showed, through his own quests, that it was impossible to avoid the new, and above all in portraits. In Serov's portraits, more so than in Repin's, a new quality is apparent: the aesthetic of psychology. Here, despite all Serov's personal gifts, the role of the Impressionist influence is particularly strong. It is difficult to say however, to what extent Serov was interested in Impressionism. At the age of nine he began painting in Repin's Parisian studio, at a time when the new French painters troubled Repin. It was precisely at that time that Repin wrote the previously cited letter to Kramskoi and conceived his *«Parisian Café»* . However, it is known that Serov distinguished Bastien-Lepage among his French contemporaries (39). It was probably this painter, with his timid attempts at lightening the palette and the

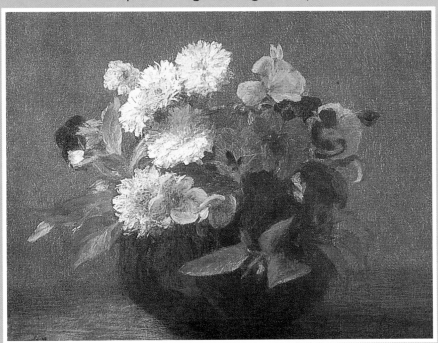

88. Henri Fantin-Latour
Flowers in a clay pot. 1883
Oil on canvas. 23 x 29 cm
Moscow

breadth of his work, who was first noticed by Repin's pupil (40). Serov's striving to paint «only the radiant» was a rare phenomenon in Russian tradition and very close to Impressionism. It is interesting to note that, like many Impressionists, Serov did not give his portraits the name of the models. Impersonal, they were not so much

Next page
89. Stanislav Jukovski
Spring floods. 1898
Tretiakov Gallery, Moscow

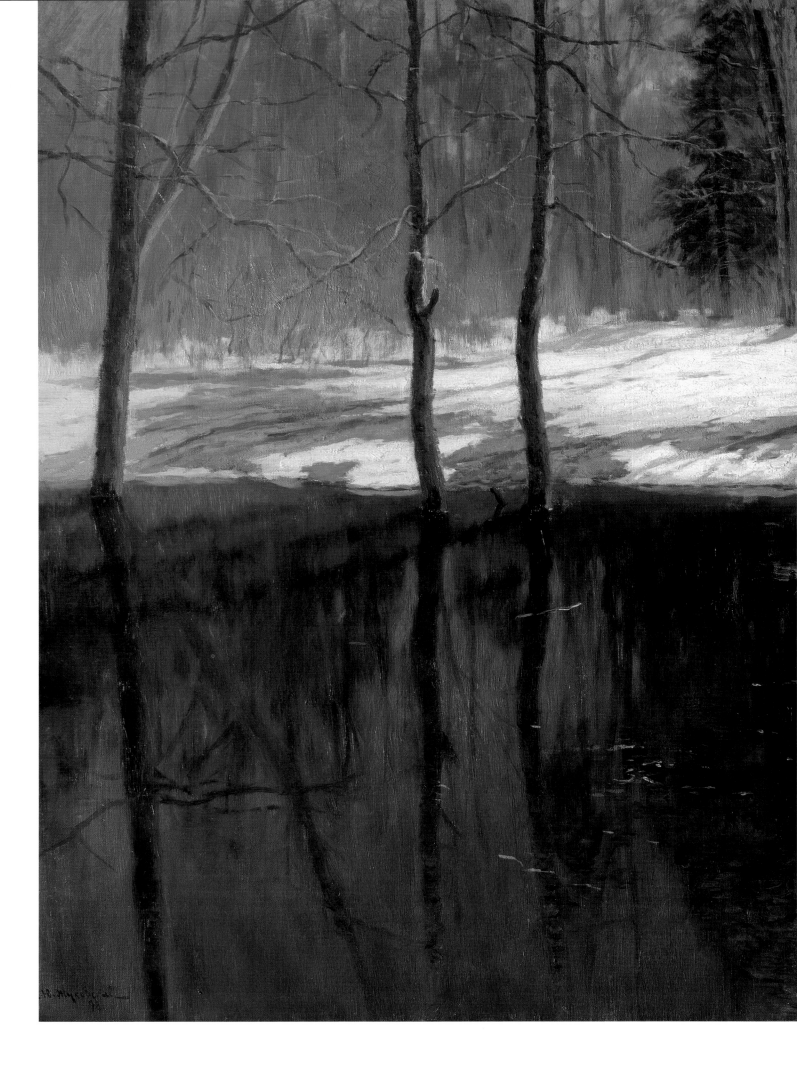

41 D.V. Sarabianov, Valentin Serov, Leningrad, 1982, p.11.

42 ibid, p. 12.

portraits of concrete characters but «animated subjects». Both paintings are in essence outdoor pieces even if the first one was painted in a room. The role of direct and reflected sunlight is paramount in both.

The surroundings, the «pictorial context» predominate. It is impossible to imagine either one in another surrounding - in that case they would be entirely different paintings with a different meaning. (41) Moreover, the same author makes the following judicious remark:

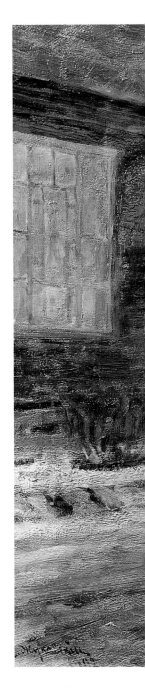

«Serov's paintings have preserved that essential difference between a human face, landscape or an interior" (42)

By the nature of his gift, Serov probably could not, and should not, have achieved the pure Impressionist vision. He remained a psychologist in the full traditional sense

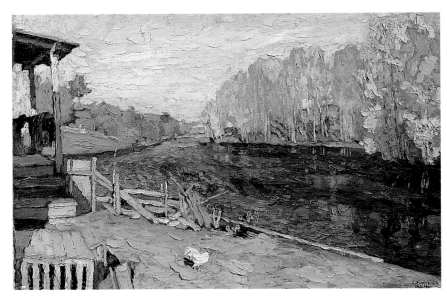

90. Stanislav Jukovski
Autumn

of the word, and did not strive to transmit psychology through the general artistic effect. But this general effect played a primordial role in his art and was close to the Impressionist method. «The Girl with Peaches» (portrait of V.S. Mamontova), is a rare example in world painting, uniting components that are difficult to combine: the Impressionist *étude* characteristic; carefully finished details, the feeling of a transient state and deep psychology. The «Impressionist *étude* characteristic» did not appear accidentally in this painting of course, but is the result of a subtle technique that gives the impression of light improvisation. There is no «staging effect» in the portrait as was common in Russian art at the time. Serov preferred to observe rather than direct characters on a stage, and drew a powerful expressive force from his observations.

91. Stanislav Jukovski
Guests departing in dusky sunlight
1902
Oil on canvas. 87 x 143.5 cm
Odessa Museum of Art

The interior seems accidental, as with an instant picture taken by a photographer who is not preoccupied by the

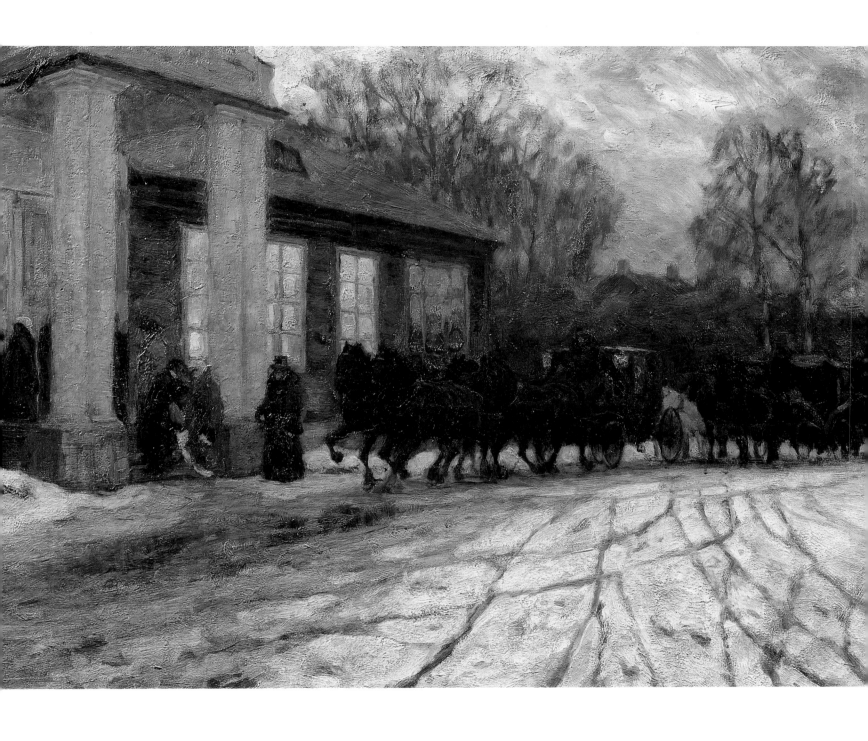

Next page
92. Stanislav Jukovski
Melancholy thoughts. 1903
Museum of Tashkent

Next page
93. Stanislav Jukovski
Road in Autumn. 1904
Museum of Astrakhan

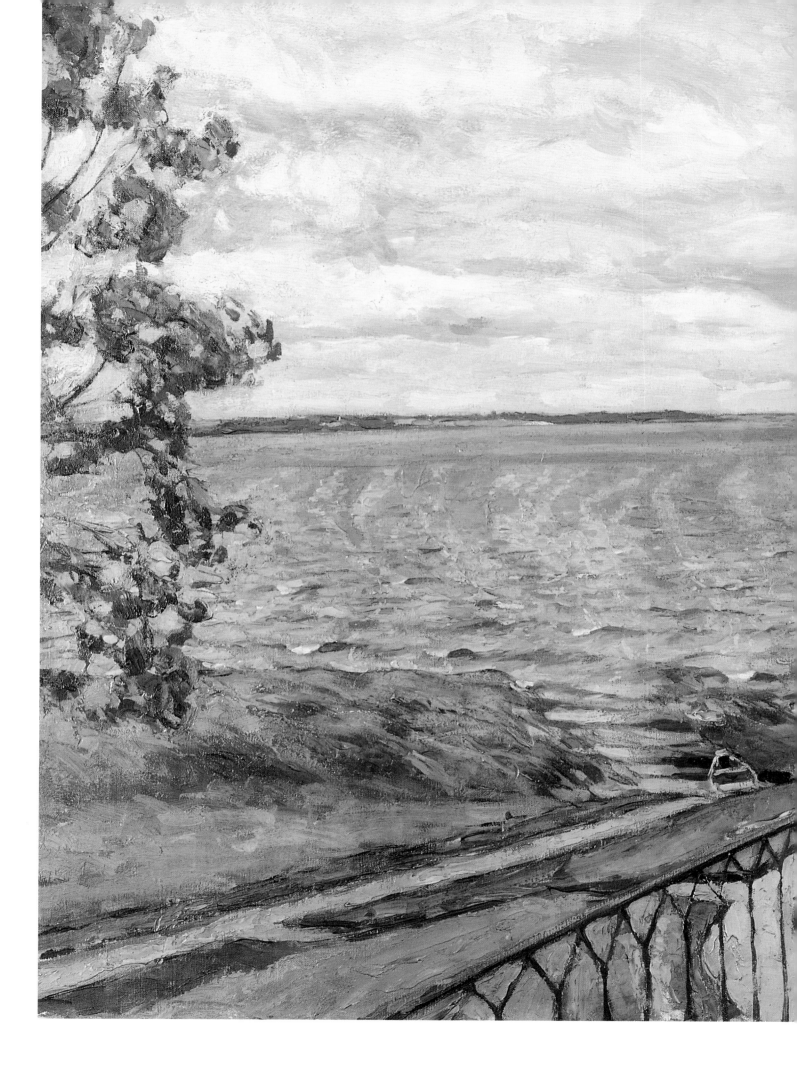

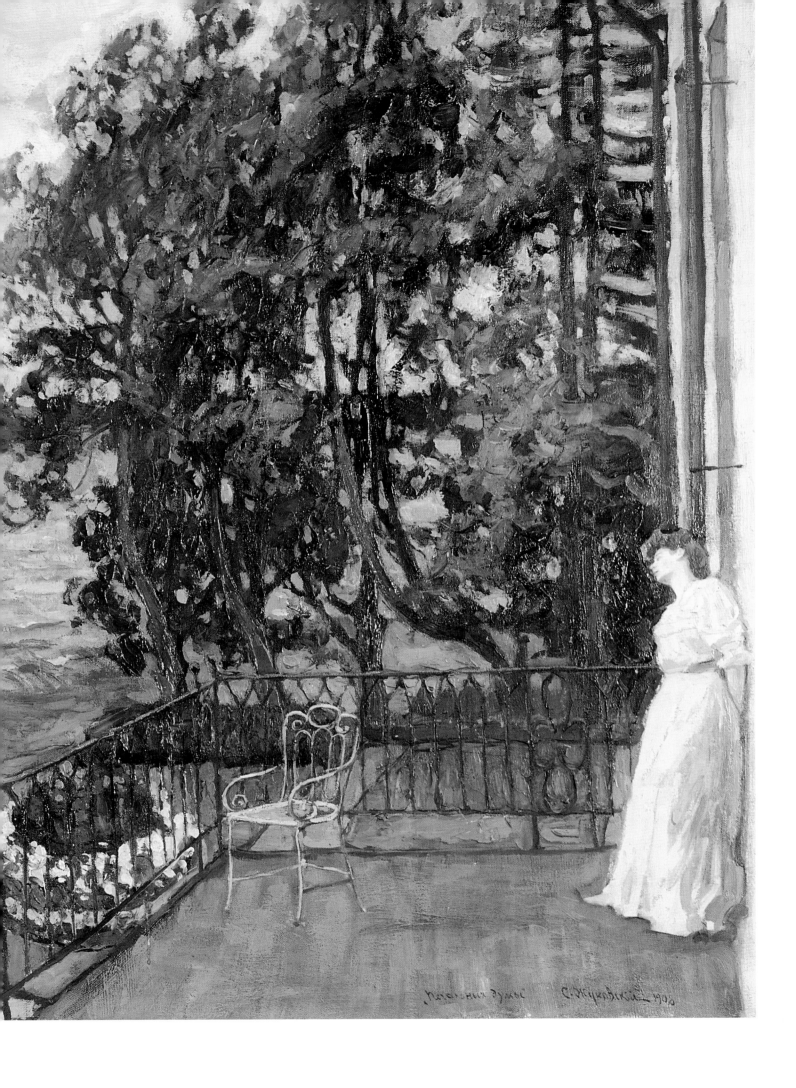

arrangement but only the face. This device, which can be called «hidden composition» was typical for Impressionism. The numerous details seem natural, neither invented, nor constructed, nor arranged in any way for the painting. And yet each detail plays its role, not only in a formal but in a narrative manner also: the white tablecloth, the clear walls, the chairs, the plate on the wall, the brightly painted «*Nutcracker*» - all the objects narrate the calm, steady and poetic existence of the Abramtsevo country-estate.

The formal construction is even more expressive. The phantasmagoria of the dark and sometimes black dots, exploding in the light radiant painting, the illusory chaotic syncope, inside which lurks prepensed equili-

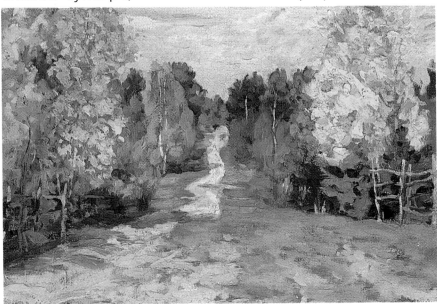

brium, it is all close to that «false hazard» of classic Impressionist compositions. It is enough to remember Degas' «Absinthe» (1876, Paris, Musée d'Orsay), with that very same powerful diagonal, the asymmetry, false disorder, and the dark spots in the background (shadows on the wall). The renowned Russian art critic, Jacob Tugendhold, wrote in 1922 that one of Degas' principal qualities of «modern expression» is the «intrusion of the unexpected and fortuitous in his composition». (43) These same qualities lurk in Serov's painting.

In his «Absinthe» Degas used the same principle of impersonal portraiture as did Serov later on. The singer Ellen André and the engraver Desboutin, both friends of

Degas, became characters in a painting and not concrete models. Just as Vera Mamontova became «The Girl with Peaches». The thick shadows behind the characters in Degas' painting, create a compositional stability, where the figures are sharply displaced to the right. And yet the viewer does not lose his balance.

It is not possible here to speak of influence and even less of borrowing. It is most likely that Degas' paintings were hardly known to Serov. Among the French artists, the works of a salon painter Bastien-Lepage, who subtly exploited the outdoor effect, appealed most to Serov. These were common trends to all national art movements at the end of the nineteenth century. They gradually developed into a community of different and non-overlapping phenomena in the artistic process. The syncopes of the dark spots merely imitated disorder while building a perfectly classic compositional plan. It is precisely these spots that unite in a rhythmic structure

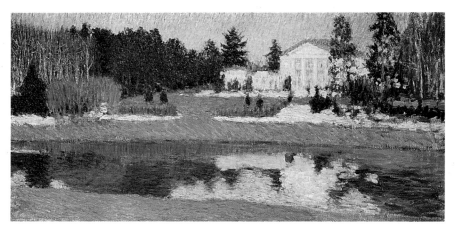

with the dark hair and eyes of the model, and the black ribbon on her breast. By force of contrast, they create the impression of radiant light flooding the room and animating Vera Mamontova's face with tender reflections. The girl's figure is inscribed in a triangle whose base is underscored by her left hand. The intricate play of the spatial and plane diagonals (the surface of the table, the knife, the line of the arm, the window-sill etc.), constantly draws the viewer's attention back to the model's eyes. But his bright and fresh portrait, which bespeaks the close of the Russian portrait tradition at the turn of the century, lives in a different world: the world

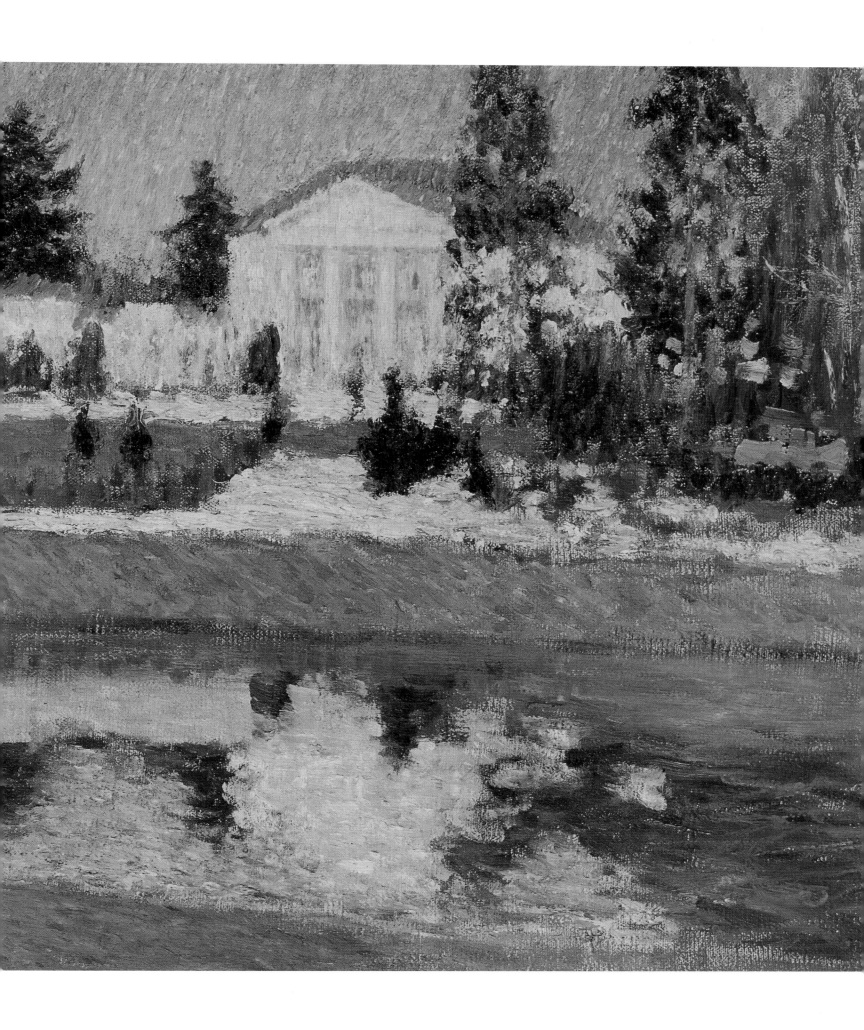

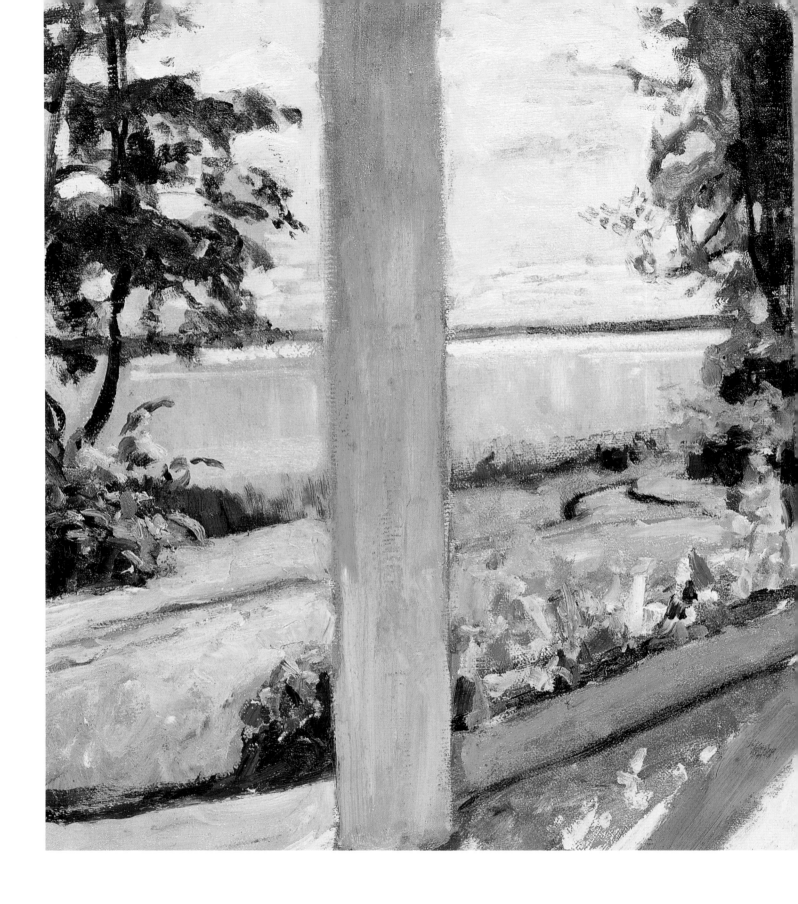

Previous page
94. Stanislav Jukovski
Fading day. 1904
Tretiakov Gallery, Moscow

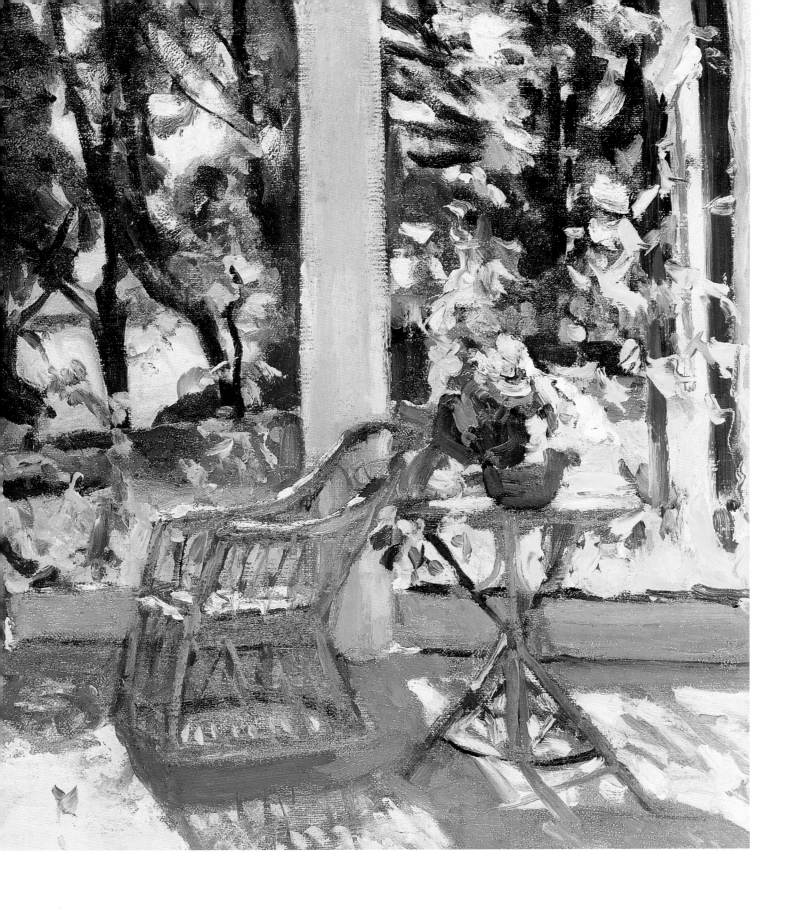

95. Stanislav Jukovski
The terrace. 1906
Russian Museum, St. Petersburg

of Impressionism. The ephemeral light behind the window, the bright and transparent colours of the shadows on the table, the multicoloured obscurity in the dark parts of the painting, the palpable warmth of the air, are all signs of the «Impressionist plasma». Yet the concentration is so focused on the material and psychological aspects of the portrait, that one can hardly speak of an Impressionist tendency here; even if this «psychological concentration» reveals a desire to capture the instant and fleeting state of mind, both of which were new in Russian art. Serov's painting retains a fascinating artistic paradox: the fleeting instant is drawn out in time. We can observe what has just been perceived. Serov (as Degas and all Impressionists) possessed a keen feeling for the «modern plastic».

«I said that each age has its bearing, its gaze and its gesture» (44) wrote Charles Baudelaire in his famous article on Constantin Guys in the «Figaro» newspaper in autumn 1863. The instantaneous gaze of man, the reconstruction of the whole through a part, *par pro toto*,

96. Stanislav Jukovski
The dike. 1909
Russian Museum, St. Petersburg

97. Stanislav Jukovski
The white house. 1906
Astrakhan Gallery of Art

98. Stanislav Jukovski
Twilight. 1908
Oil on canvas. 67 x 91 cm

Next page
99. Detail
Twilight. 1908

are to a large extent, the prerogatives of Degas. Serov was far more traditional. But he also rendered the gesture of age. And this is particularly clear when compared with Russian literature of that time. At the

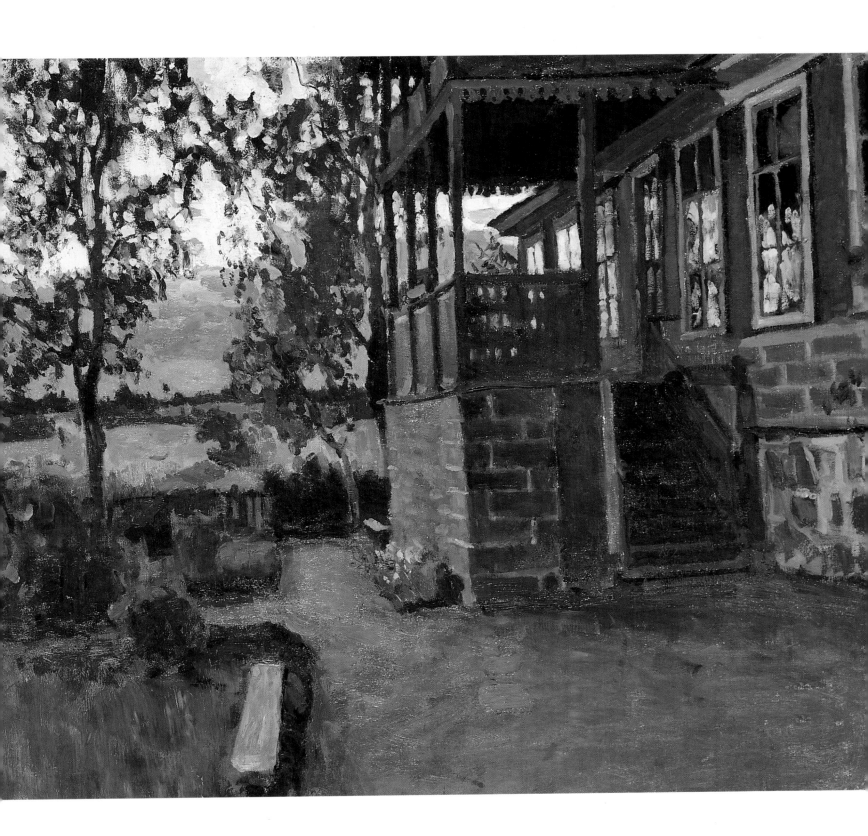

43 Quotation Edgar Degas, Letters: Recollections of Contemporaries, Moscow, 1971, p. 23.

44 Charles Baudelaire, p. 468.

45 A. P. Chekov Complete Works vol. 6, Moscow, 1976, p. 72.

46 Book of the Week, no. 5 p. 217.

47 Flaubert's novel was well known in Russia. It had already been translated in 1858. Turgeniev considered it the *best work of the new French school.*

48 G. E. Lessing, Selected Works, Moscow, 1980, p. 390.

beginning of 1887, when Serov finished his «Girl with Peaches», Chekov published a short story entitled, by coincidence, «Verotchka» (the diminutive for Vera). The hero of the story «reminisces about pretty Verotchka, unable to imagine her without her full blouse... without her lock of hair falling over her forehead... without her red knitted scarf... that she would dolefully hang over her shoulders like a flag in calm weather... A light homey laziness and tranquillity emanated from that scarf and the folds of the blouse». (45) It is not so much the resemblance between the two characters that matters here, but the «bearing, gaze and gesture» inherent in each age. The critic V. L. Kign, a contemporary of Chekov, pointed out that which is most essential. While analysing the author's stylistics he said: «It is the

combining of the psychological and outer manners that, to me, constitute the originality and charm of the young writer.» (46) Chekov was twenty-seven at the time and Serov twenty-two. The magical combination of the «psychological and outer manners» permeated Russian culture more and more, becoming an essential part of artistic thought of the Modern times. One can hardly interpret Chekov's fine literary fabric as Impressionism in Russian literature. The ability to see the whole through a part is a system of priorities that strives to bring out the

100. Alfred Sisley
Barges at Saint-Mammès
Oil on canvas. 50 x 65 cm
Museum of Modern
Occidental Art,
Moscow

characteristic trait. This however, cannot be regarded as Impressionism but only as the poetic role of a detail, an allusion that comes very near to Impressionism.

French Impressionism, if one looks for distant literary sources, is void of any psychological quest. In «Madame Bovary» (1857), Flaubert may be said to have written

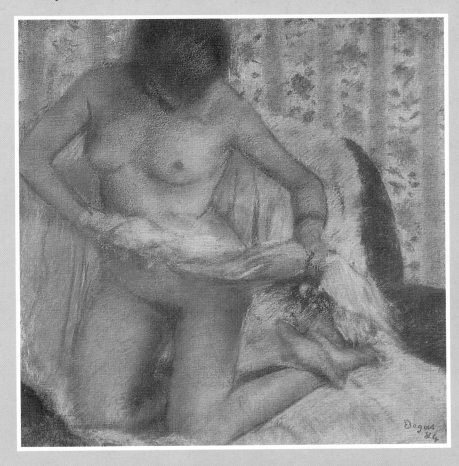

with an «Impressionist pen» (47). His «pictorial prose» was very figurative and similar to Impressionist painting, in that the principal and secondary are weighted evenly. Flaubert nevertheless remains a great psychologist; but when «representing» what he sees he writes as Monet and Renoir will paint twenty years later. As the sun shone through it, the umbrella, a silk the colour of a pigeon's breast, drew flickering reflections on her white face. Underneath, she was smiling at the warm air, and one could hear drops of water, one by one, dropping on the taut moire.

Serov's portraits of the *Simanovitch sisters Mary and Adelaide* (1888 Tretiakov Gallery, Moscow; Russian Museum, St. Petersburg), could be interpreted as

101. Edgar Degas
*Woman drying herself
(After the bath)*
Pastel on paper. 50 x 50 cm
Russian Museum, Moscow

119

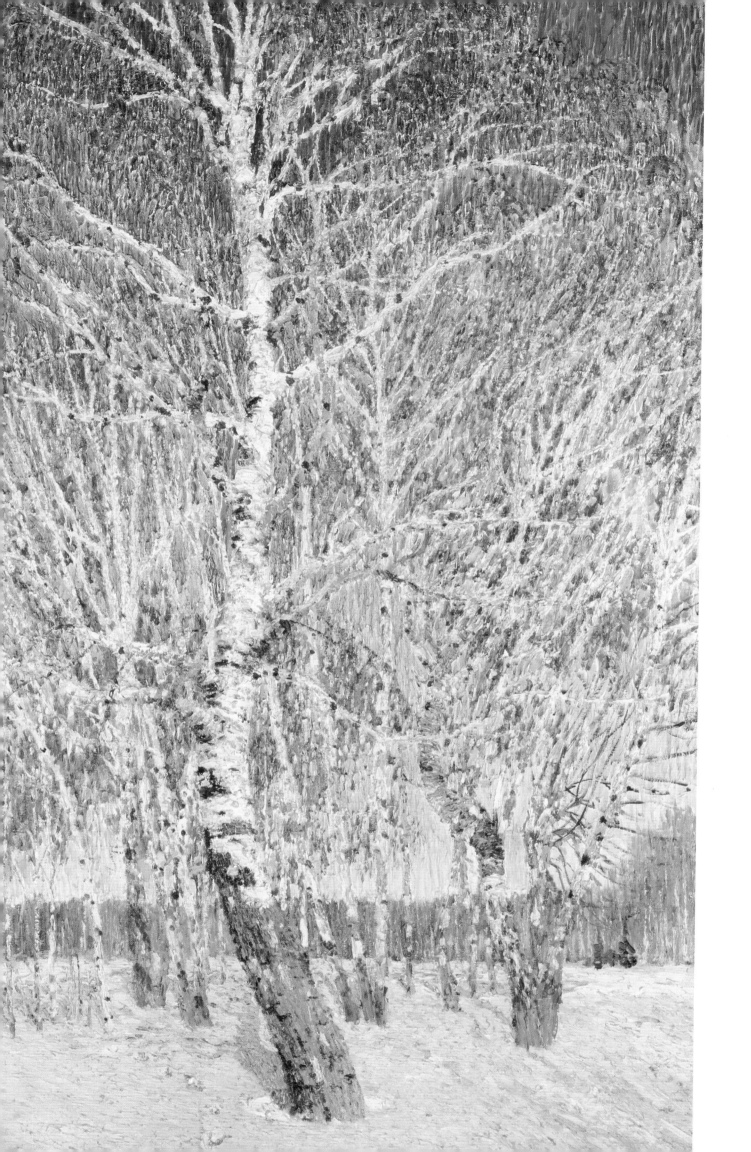

Impressionist works in motif and technique. And yet, nothing indicates that Serov held a special interest for French Impressionism. He had a predilection for Italy when travelling abroad (he went there in May 1887). Moreover, the interest in Impressionism in Europe had already begun to subside; the last exhibition was held in 1886. Nevertheless, its powerful influence spread throughout the world, even affecting artists who paid no particular attention to Impressionism. When he painted the «Girl with Peaches» and the Simanovitch sister portraits, Serov had an intuitive attitude towards Impressionism. The portrait of Mary Simanovitch *(The Girl, illuminated by the sun),* remains an attribute of nineteenth-century subject painting. Whereas the portrait of her sister, painted a year later, is extremely close to the Impressionist manner. All the elements in the painting form together the pictorial value; as with Renoir or Monet, the face is an integral part of the landscape, the dynamic dabs of colour are purposely devoid of contour. Only the dense and free brushstrokes, without the slightest allusion to divisionism, maintain a distinct distance between Serov and Impressionism.

More importantly, it is clear that for the artist this painting is a tribute to an aesthetic instant, not an artistic program. In fact, Symbolism, especially in its plastic expression, «Art Nouveau», had a strong impact on Russian painting. The semantic dominant in Russian culture demanded a current that would allow art to seek, discover and develop, if not social and ethical ideas, then at least a deep and psychological meaning and even prophetic signs (48). Although Symbolism in general as a world conception, does not exclude the use of Impressionist devices, «Art Nouveau» in its pure form, with its preconceived rationalism, anaemic decorativeness, its lack

102. Igor Grabar
February sky. 1904
Tretiakov Gallery, Moscow

103. *Portrait of Grabar by Custodiev*
Pastel on card. 106 x 71 cm
Russian Museum, St. Petersburg

104. Igor Grabar
September snow. 1903
Tretiakov Gallery, Moscow

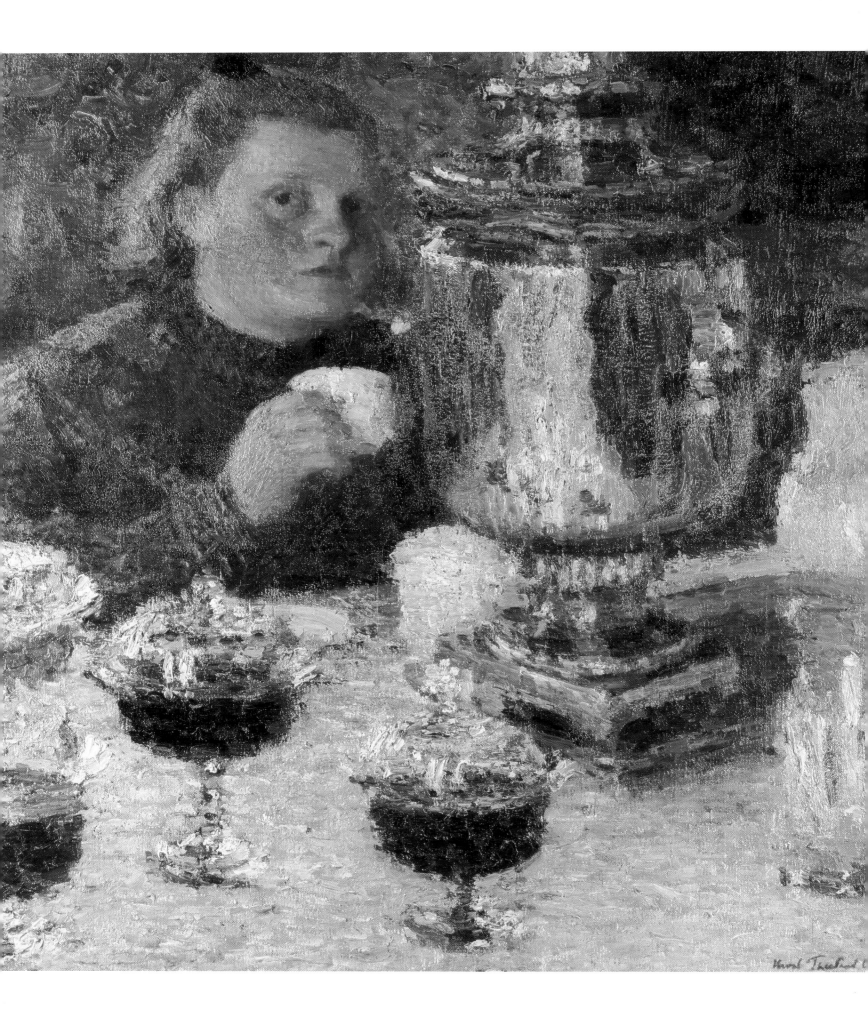

of air, and distinct linearity, became in fact the antithesis to Impressionism. And yet, in Serov's later works, where the influence of «Art Nouveau» is obvious, another Impressionist quality appeared: instantaneity, not of the moment or the statenor the lighting, but of movement and pose... A type of «Impressionist gesture». The gesture of a man and an era that Baudelaire spoke of. The famous portrait of Henrietta Girshmann (1907, Tretiakov Gallery, Moscow). The compact and intense painting - in which the brushstroke holds an intrinsic value, transposing the material world with one touch and creating a «portrait» of each object - conflicts with Impressionism. One gets the impression here not of a frozen instant, but of a minute particle of time, where an individuality is captured without the awkwardness of an instant photograph.

Previous page
105. Detail
Chrysanthemums. 1905

106. Igor Grabar
By the samovar

107. Igor Grabar
Chrysanthemums. 1905
Oil on canvas. 98 x 98 cm
Tretiakov Gallery, Moscow

Here, Serov intuitively moves closer to the Impressionist approach, more precisely the compositional devices of Degas. It is enough to call to mind his ballerinas and laundresses of the 1880s-1890s, whose movements were suddenly caught by the artist, in all their grace and awkwardness. Among Serov's paintings, one finds two diametric types of gesture-portrait; the gesture and the bearing of a statue type that is drawn out in time (Ermolova and Rubinstein), or the instantaneous effect that catches an unstable and fragile pose off-guard (Henriette Girschmann with Nadjda Lamanova). Here Serov reveals his unique ability to combine the Impressionist "portrait of an instant" with the distinct and profound characteristic of the model. In general, the classic painting, the portrait in particular, gives the viewer the opportunity to interpret the situation

Next page
108. Igor Grabar
Table in disarray (uncleared)
Tretiakov Gallery, Moscow

125

preceding the moment being depicted as he wishes: «only that which leaves the imagination free can bear fruit» (Lessing) (49) In such portraits, «the present is fraught with the future and heavy with the past» (Leibniz). (50) Such are the portraits of Vera Mamontova and Simanovitch, and such is the grandiose portrait of Maria Ermolova (1905, Tretiakov Gallery, Moscow). The Girschmann and Orlova portraits are not just drawn out in time, they also lack the Impressionist «instant picture» aspect with its luminescent and spatial

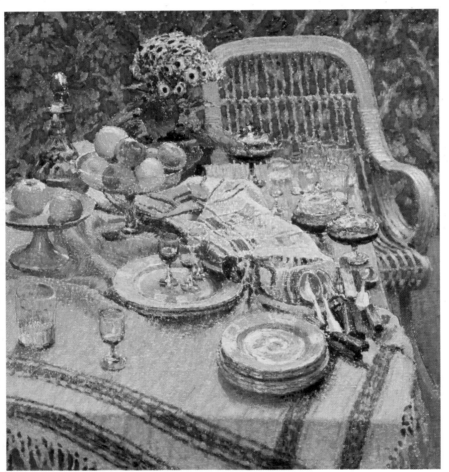

atmosphere. This atmosphere seems a stable and calm decoration in which the gesture «caught in flight» is the only paradoxical but essential tribute to Impressionism. Again paradoxically, the depth of the character is held in the expression of an instant.

It is typical that the Impressionist manner appears much earlier in Serov's works; whereas the «Impressionist gesture» comes out after Benois, who had so influenced Serov «appreciating the charm of Degas». All suppositions

126

are possible here, but it is most likely a question of a community of perception at a certain stage in the evolution of both artists. Moreover in 1902, Degas's «Dancer at the photographer's» (1873-1875, Pushkin Fine Arts Museum, Moscow), was already a part of Shchukin's collection (1854-1936), (51) and it would be ridiculous not to see everything this painting could have

49 G. V. Leibnitz, Works vol. 2, Moscow, 1983, p. 53.

50 Shchukin bought it from Durand-Ruel in 1902 for 35,000 Francs.

51 D.V. Sarabianov Russian Painting among European Schools of the XIXth Century, Moscow, 1980, p. 122.

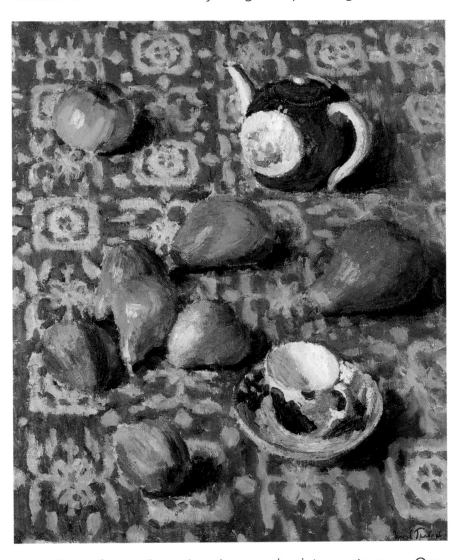

contributed to Serov's «Impressionist gesture». One parallel seems especially noteworthy.

In 1891, Serov painted the portrait of the artist Constantin Korovin. Through the characteristic gesture of the hand and the individual pose, this unfinished portrait presents an idea of the energetic movement of Korovin. The portrait is surprisingly reminiscent one of Manet's famous portrait of Stéphane Mallarmé (1876, Musée d'Orsay, Paris). Even the ironic and attentive gaze

109. Igor Grabar
Delphinium. 1908
Oil on canvas. 141 x 100.5 cm
Museum of Russian Art, Kiev

110. Igor Grabar
Pears on a blue cloth. 1915
Russian Museum, St. Petersburg

Next page
111. Detail
Pears on a blue cloth. 1915.

129

of both models is similar. What is important here is not whether Serov had seen Manet's painting and been influenced by it or not, but the similarity in the psychological and compositional quest of these two completely different artists who were fully independent of each other.

The sharp Impressionist manner also appears in Serov's officially ordered works, again, as with Repin, during the preparatory stages. Take for example the small sketch of «The Coronation» (43 X 64 cm, 1896, Tretiakov Gallery, Moscow), where along with the dense material painting in the foreground, the flying phantasmagoric brushstrokes create their own aesthetic effect. Of course the «Impressionist gesture» can be found in the works of other painters, but only Serov exploited it with such distinct and individual talent. Yet, when considering Serov's works, it is surprising to note that Impressionism did not penetrate there where it should have been most easy. In his landscape paintings. In these works Serov paid a noticeable but moderate tribute to Impressionism. In fact it is easy to see the almost Impressionist technique in the *étude* «*The Open Window. Lilacs*» (1886, Art Museum, Minsk), as well as in the portrait of the artist's wife «At the Window. Portrait of O.F. Trubnikova» (1886, Tretiakov Museum, Moscow). It is also interesting to note that the manner of painting is freer in the unfinished portrait than in the étude. In the landscape genre, Serov's work is openly material, and the «unfinished» aspect is too artistic and careful to remind one of Impressionist canvases.

Pure Impressionism presented a far more destructive and dangerous force for Russian art, especially in the landscape genre. The Russian landscape movement jealously guarded the image of the «lyric and dramatic hero», the most eloquent example of which is Levitan's «*Road to Vladimir*» (1892, Tretiakov Gallery, Moscow). There is distinct social and lyric meaning in this calm canvas; the painter depicts the convicted on the road to their own exile and penal servitude. For any liberal intellectual the pictorial qualities of the canvas do not exist

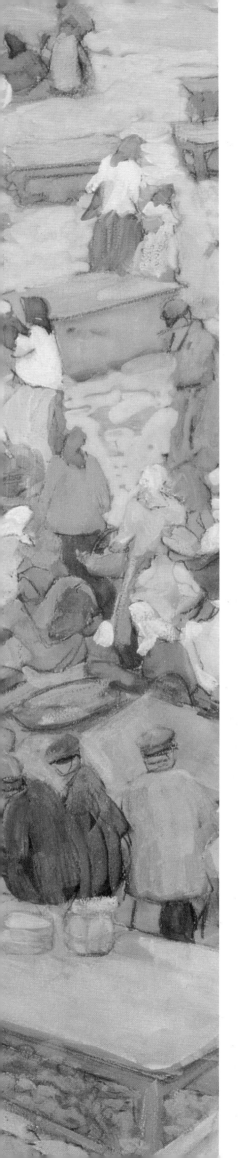

autonomously. «*The Road to Vladimir*», first and foremost, was a civil act, an invective, and only secondly a work of art. In other words the situation was similar to that in France at the time of the *Marat de David.* And yet «*The Road to Vladimir*» was painted four years after the final Impressionist exhibition.

Of course it is true that the early 1990s retained a different meaning for the Russians.

1888 marked the opening in St. Petersburg of the first French art exhibition. In 1889 many Russian artists, including Serov, Polenov, Nestrov and Golovin, visited the Universal Exhibition in Paris.

The Impressionists were becoming better known and took possession of the imaginations of young and even very young Russian painters. New notions of the potential for thought and art appeared; the Eiffel Tower itself, which had created such a scandal; everything shook traditional thought and led artists on to daring experiments.

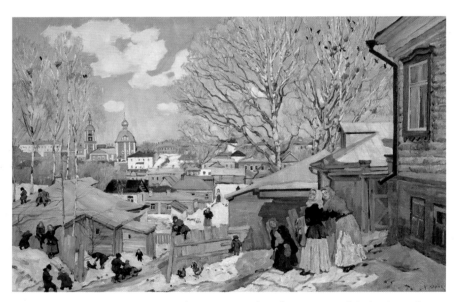

Russia was entering the period of time which is often called the «Silver Age» today. At the turn of the century, (or if you will, the German «Jahrhundertwende» this being more capacious), art changed with an impetuous rhythm. However these changes did not preoccupy the minds of all creators; irrespective of his innovations in art, Dostoevsky's books were always perceived as moral phenomena. In the West daring social ideas were

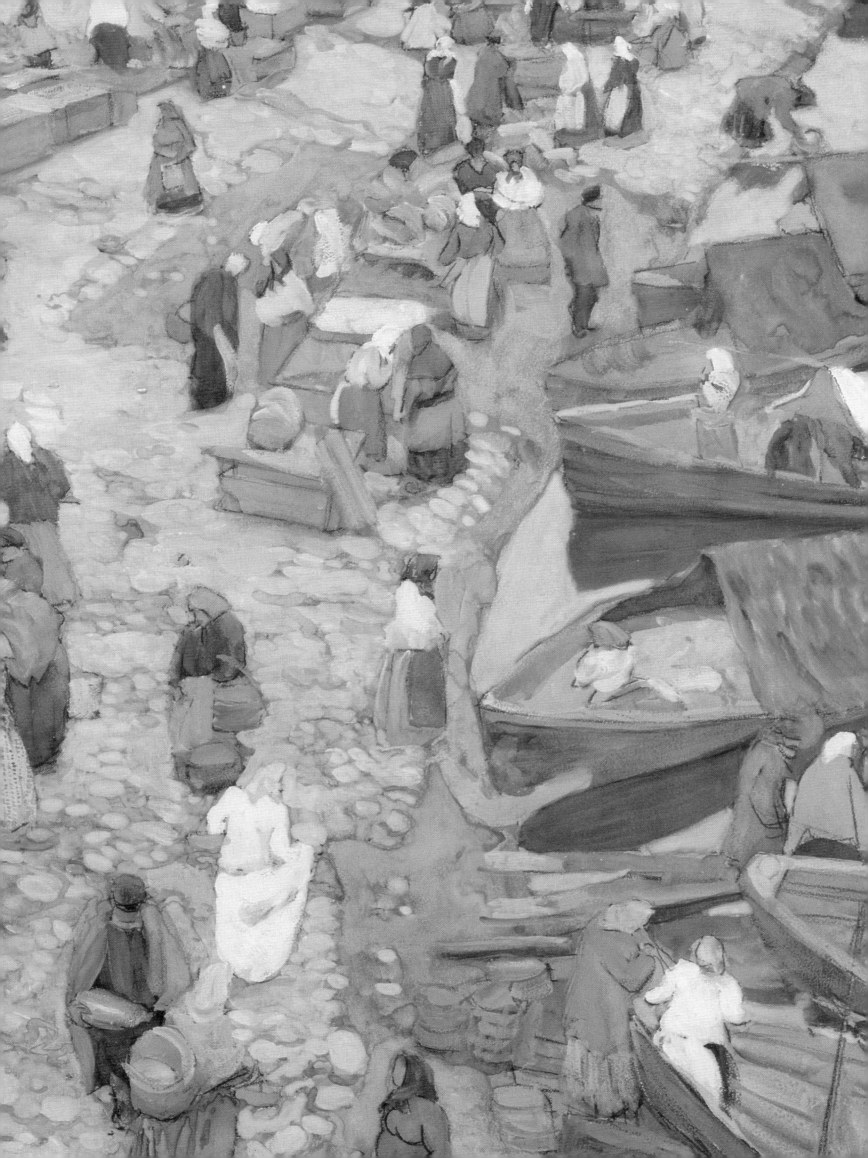

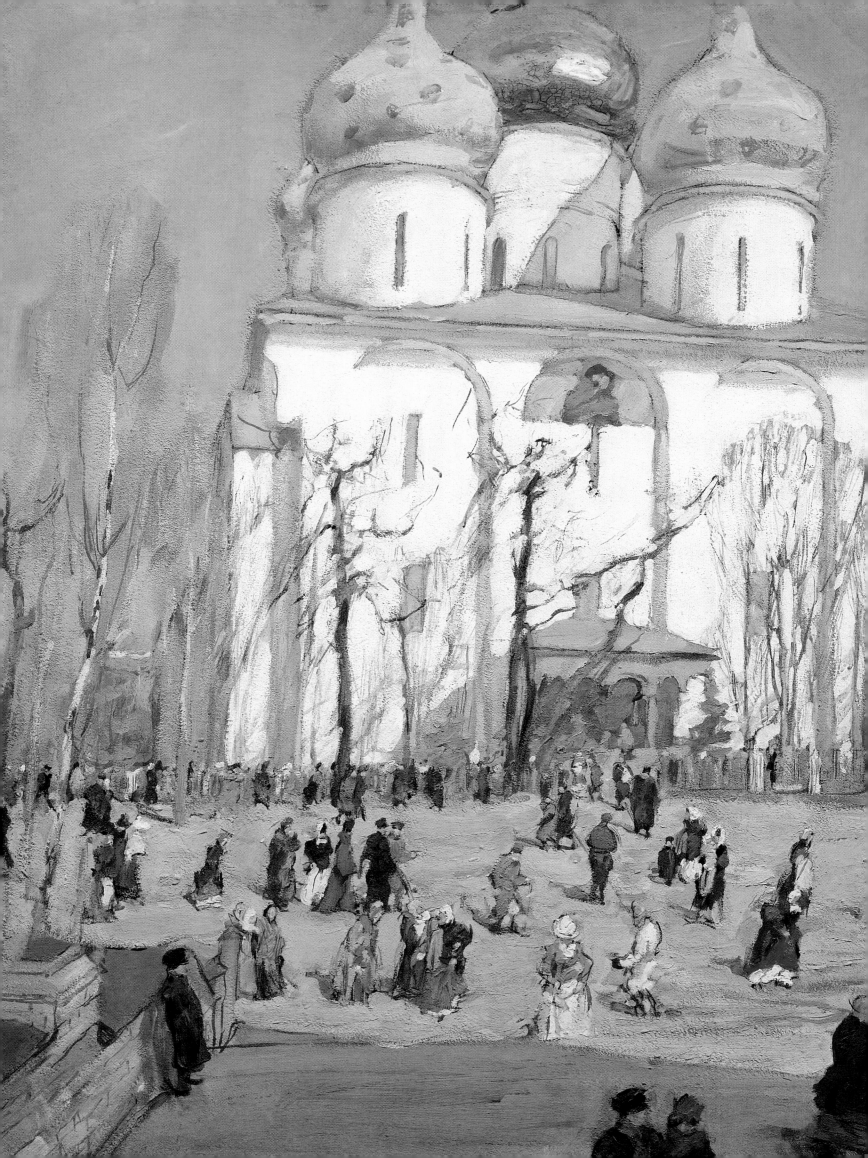

expressed through new artistic forms (Goya, Delacroix, Courbet). In Russia, as a rule however, traditional methods were used. The feats of the Itinerants were recognised as self-destructive; preaching in plastic art was said to be limited rigorism. The near future inspired hope but also fear and disillusionment. In 1890 Vrubel finished his «Sitting Demon». He was then convinced that it was not the «monumental Demon» he would paint «in time».

The «Great Demon» was never created. Dostoevsky never wrote his «Life of a Great Sinner». A little later, Alexander Blok's work on his poem «The Retribution» became interrupted. It seems as if the grandiose works in progress in Russian culture at the turn of the century could not withstand the new rhythm and vanished without being completed.

The creator's idea left behind traditional forms and traditional genres; under the pressure of new passions and ideas, former artistic structures collapsed. Only a penetrating

eye could discern beyond the ruins the dawn of the art of the new century.

At the time it was not seen as a new beginning but as a decline, the desecration of the traditional understanding of what is beautiful. In the eyes of the traditional viewer, Impressionism also threatened the very foundation of culture. Russian culture slowly and indecisively freed itself from

Previous page
113. Constantin Yuon
March sun. 1910
Tretiakov Gallery, Moscow

114. Constantin Yuon
Holiday. 1903
Russian Museum, St. Petersburg

115. Constantin Yuon
Rostov the Great. 1906
(The Hermitage)

its «literary egocentricity». Writers still considered themselves the centre of the spiritual life of society; but at the close of the century, literature in Russia was no longer the dominant influence. Even Tolstoy was seen as a prophet,

the bearer of the national conscience, and not the writer of great works. As for Chekov, he was regarded much in the same way as Trigorin, the hero of his play «The Seagull», saw himself: «He was a good writer, but not as good as Turgeniev». The excessive seriousness of literature and art again and again brought to mind Levitan's *Road to Vladimir* where the beautiful pictorial qualities seemed buried under the weight of political significance.

«Étudisme»

According to a famous art historian: *étudisme* was not inherent to French Impressionism. In fact, the sketchy aspect in the works of classic Impressionists was feigned. Behind the improvisation, there was always compositional logic, and most importantly, none of Monet's or Renoir's paintings, whether painted spontaneously or completely *alla prima*, suggested a further transformation into a finished artistic structure.

The outdoor study is one source of what is commonly termed Russian Impressionism.

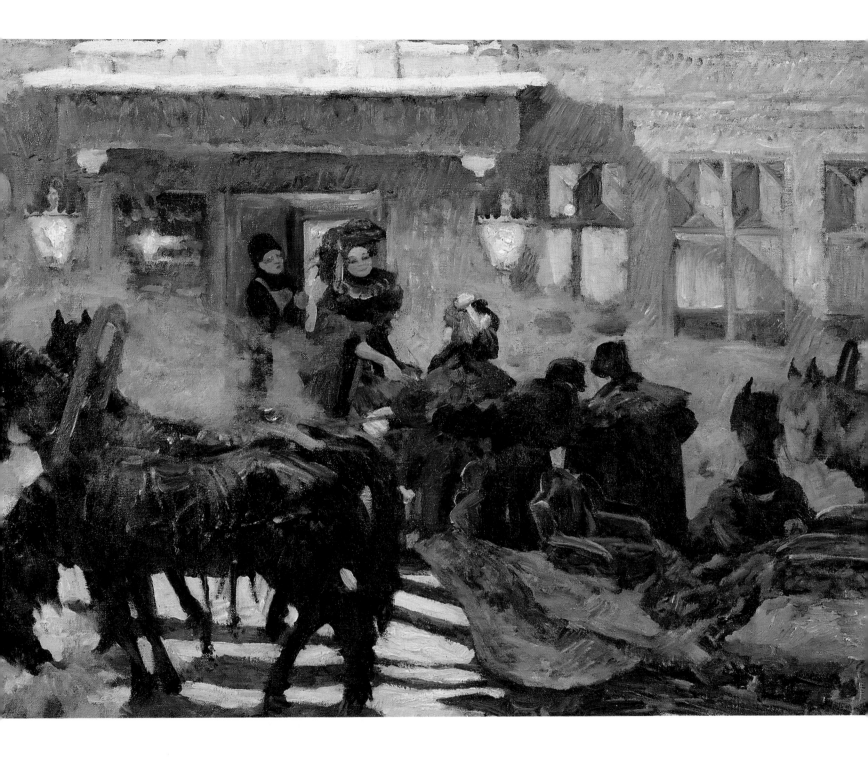

116. Constantin Yuon
Elder bush. 1907

117. Constantin Yuon
*Troika near the old «Iar» restaurant
in winter. 1909*
Russian Museum, St. Petersburg

Next page
118. Constantin Yuon
Detail
Elder Bush. 1907

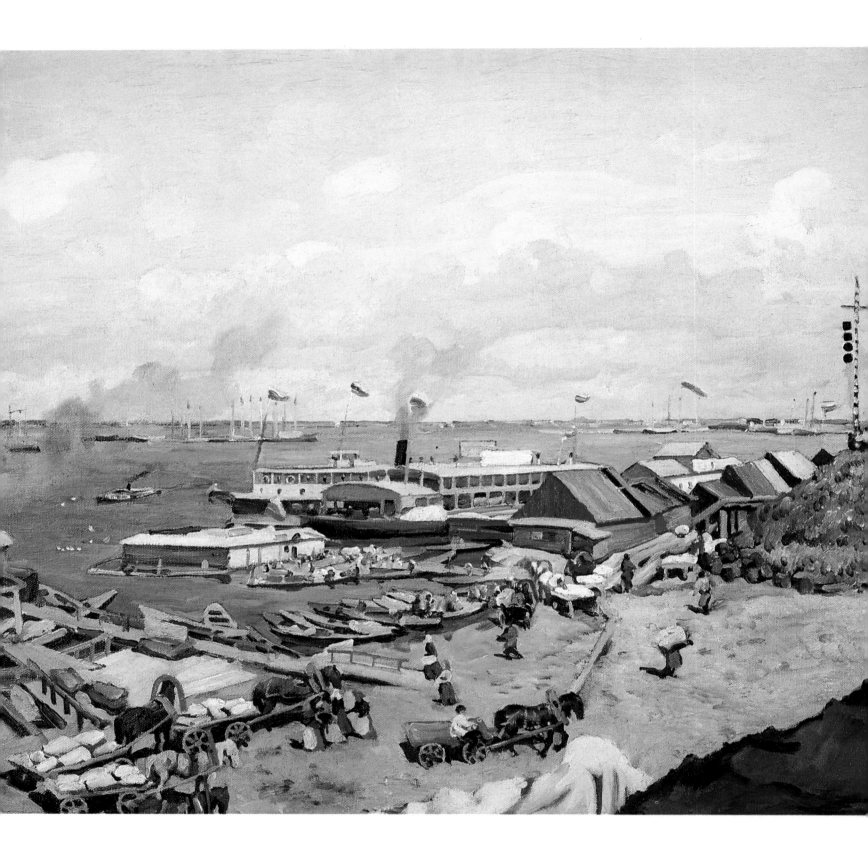

Previous page
119. Constantin Yuon
Trinity Sunday. 1903
Tretiakov Gallery, Moscow

120. Constantin Yuon
Pskov. 1904
Russian Museum

52 Constantin Korovin Recollects, Moscow, 1971, p. 118.

Moreover, Russian «Impressionist painting» kept that inherent sketchy quality even when not painted from life, as if not daring to join the ranks of the great subject canvases, from which a «grand and majestic idea» was expected.

In this aspect Russian Impressionist painting not only differed from French paintings, but also from Impressionist art which was developing at the time in different countries, and where *étudisme* was avoided.

Thus, American «Impressionist» painting, furthest from the influence of European artistic practices, was marked in the beginning by the desire to create far more subject oriented paintings than the French. Canvases such as Vonnon's famous «Poppies» (1888, Indianapolis Fine Arts Museum), with its free sketchy aspects, are rare exceptions in the American tradition. The compositional basis and elaborate motifs contribute to the pictorial structure of the painting. (James Whistler, «Cremorne Garden», circa 1875, Metropolitan Museum of Art; John Sergeant, «The Luxembourg Gardens at Nightfall», circa 1879, Minneapolis Art Institute.)

To a certain extent, this also refers to the Italian Giuseppe De Nittis (1846-1884) and the refined English artist Philip Wilson Steer (1860-1942). In coming to France however, many painters simply adopted Impressionist recipes with either more or less success, like, for example, the artistic but hardly independent American Childe Hassam (1859-1938; "The Pont Royal", 1897, Art Museum, Cincinnatti).

Constantin Korovin, who is rightly considered the most consistent Russian Impressionist, studied under Vasily Polenov (1844-1927) at the Moscow School of Painting, Sculpture and Architecture. At the time, Moscow cultural life was freer and more democratic from a professional point of view (52).

Far from the academic theatres and exhibitions, private galleries and theatres flourished. It was in Moscow that the Shukin and Morozov collections appeared as well as the Stanislavsky and Nemirovitch-Dantchenko Art Theatre. Far from academic traditions, the school was free and open to modern ideas.

145

As regards Polenov, he was a member of the Itinerant Association, a master of philosophical temperament. Like Alexander Ivanov and Kramskoi, he was forever preoccupied with the problems of existence and religious philosophy.

Many of his paintings testify to these preoccupations. «*Christ and the Sinner Woman*» (1886-1887, Russian Museum, St. Petersburg), for example, is in direct opposition to any «non-subject» painting.

However, he also created such famous works as «*Moscow Court Yard*» (1878, Tretiakov Gallery, Moscow), or «*Pond overgrown by weed*» (1879, Tretiakov Gallery, Moscow), where the *plein air* and enhanced sketchy aspect testify to his concern for formal modern problems. Korovin thus wrote of his teacher: «Polenov brought a breath of fresh air to the school, as in Spring when a window is opened in a stuffy room. He was the first to speak of pure painting of diversity of colours...» (53)

It would be erroneous to identify Korovin's artistic development in general with the specific path that led him to become the most important Russian Impressionist painter. For Korovin was a man prone to deep thought, and a gifted writer and artist who often worked in the theatre; he only devoted a part of his artistic talent (which was typical of Russian «Impressionism») to the Impressionist

121. Claude Monet
A mill near Giverny. 1886
Oil on canvas. 61 x 81 cm
Hermitage Museum, St. Petersburg
(S. Shchukin Collection)

146

culture. Moreover, he was perfectly aware of the dangers of any repetition in art. «And if the works that make up the majority of this new art were but the creation of people smitten with the great artists in the West; voluntarily and fanatically taking the bridle of imitation and tying themselves to the post of modern routine.» (54)

53 ibid, p. 124.

54 R. I. Vlasov, Constantin Korovin, Creation, Leningrad, 1969 p. 18.

55 ibid, p. 20.

This short sentence reveals a deep understanding of the tragedy of Russian art; too often bowing before Western masters or spurning them without thinking. Thus, Korovin came to understand Impressionism slowly and with difficulty. The early works of the artist hardly merit particular attention. Only a certain predilection for a broad and strong brushstroke and for light and energetic planes bespeaks the young painter's attachment to improvisation and the swift «modern» manner. Polenov, who highly regarded Korovin's talent, warned him against haste, fearing his works might become «confused and slapdash». (55) While respecting his teacher, Korovin remained faithful to his new bold manner. The aforementioned «Portrait of a Chorist Singer» 1883 was harshly criticised by his teacher and its viewers. Contrary to the advice of his teacher Korovin left it at the exhibition. To a certain extent this piece can be considered a landmark in «Russian Impressionism»: lacking the significance and

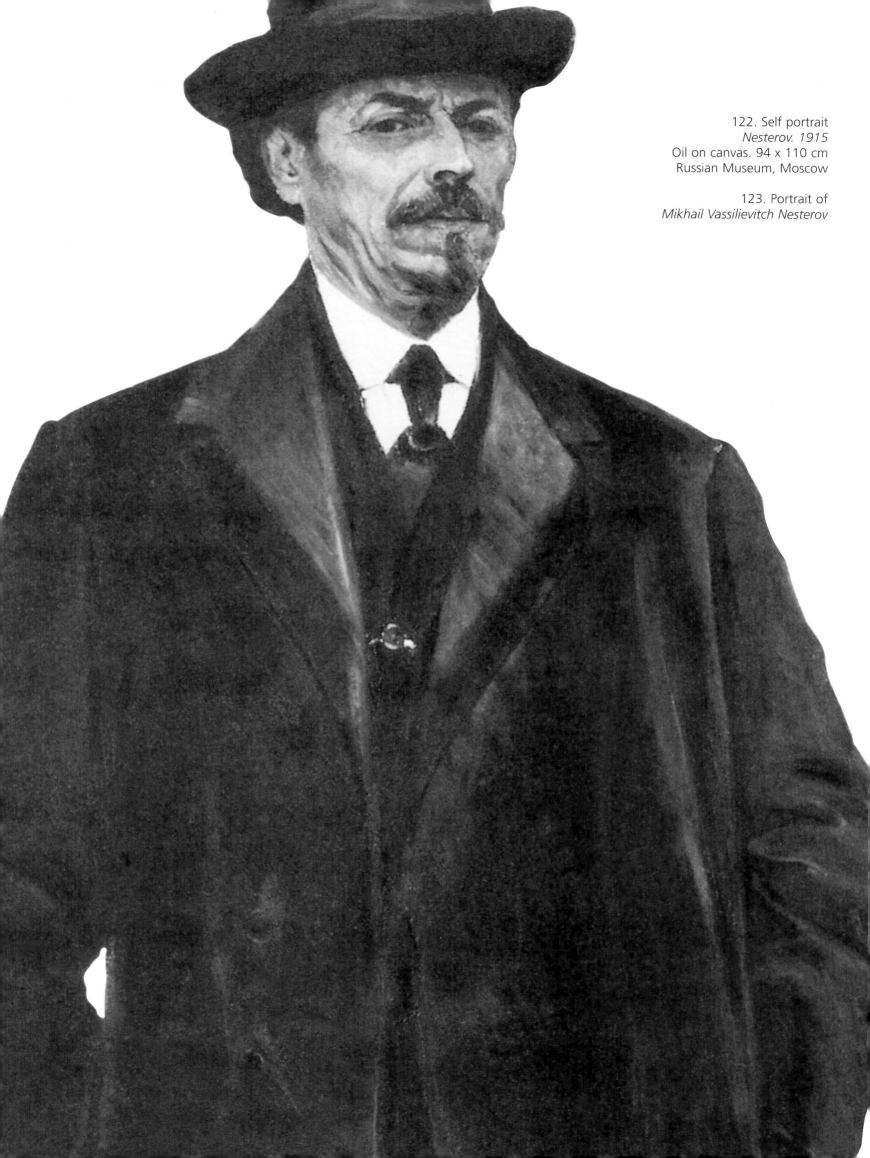

122. Self portrait
Nesterov. 1915
Oil on canvas. 94 x 110 cm
Russian Museum, Moscow

123. Portrait of
Mikhail Vassilievitch Nesterov

virtuosity of Serov's «*Girl with Peaches*», «*The Chorist Singer*» is unquestionably a typical example of *étudisme*. The most consequential Russian «Impressionist» works preserved this aspect of the *étude*. They never became «paintings» because the Russian painter, once embarked upon the path of direct observation of nature, focusing all his attention on pictorial forms, and ranked among the «heretics», no longer strived to compete with the custodians of tradition. «It is painting for painting's sake» remarked Repin harshly on the subject of «*The Chorist Singer*». Indeed, the painting was too unwonted and lacked too much of what was considered necessary. A distinct hierarchy of genre had always existed in Russian painting.

Korovin's piece (although officially called a «Portrait» is in fact an Impressionist painting; all the components are equal, the artist's exalted approach is uniformly applied to all the elements of the motive. Like Renoir or Claude Monet, he paints the spots of the sun on the leaves, the shimmer of light on the blue fabric of the dress, and the shadow caressing the pretty, mischievous face, with the same casual enthusiasm.

Free of traditional portrait structure however, Korovin did not create an «Impressionist» painting, where the «pictorial substance» is self-sufficient. Thanks to Korovin's example, the main difference between French Impressionism and its Russian variant becomes evident.

For the French Impressionist, the *étude* is created according to the rules of the painting and itself becomes a painting. Take for example Renoir's famous portraits of the actress Jeanne Samary, (1877, Comédie Française, Paris, 1877, Pushkin Fine Arts Museum, Moscow, Hermitage Museum, St. Petersburg). In the Moscow portrait-*étude*, the surface of the canvas and the face, peeping through the vibrant, iridescent mist, form a completely finished piece of art. The subtle contrast between the face, which seems to dissolve, and the sharply defined mischievous smile, the

149

enhanced stability of what is transient... It is not so much the eyes, but the gaze, not so much the lips, but the expression that are depicted here, while everything is subdued by the colouristic and compositional effect.

One is reminded of Repin's portrait-sketches for his «Solemn meeting of the State Council». The character is slightly outlined, the facture remains sketchy, but the final effect is that of a finished piece where «all has been said». This applies even more to the Hermitage full-length portrait.

In his youth however, Korovin followed a path quite similar to that of the French Impressionists. Rigid «staged» portrait paintings can also be found in the early works of Basile and even Renoir. It is unknown if Korovin saw them, but his «At the Tea-Table» (1888, Memorial Museum V.D. Polenov), calls to mind Basile's «Family Portrait» (1868, Louvre): the same dense painting of the figures, the paradoxical combination of sharply defined tonalities and coloured spots, mixed with the light translucent vibrant atmosphere and the same genre ambiguity, (is it a garden scene or a group portrait?) One could mention Renoir's famous «Portrait of Sisley and his Wife» (1868, Wahlraf - Richard's Museum, Cologne). The artistry of this painting is far superior to Basile's, but it is nonetheless close to the

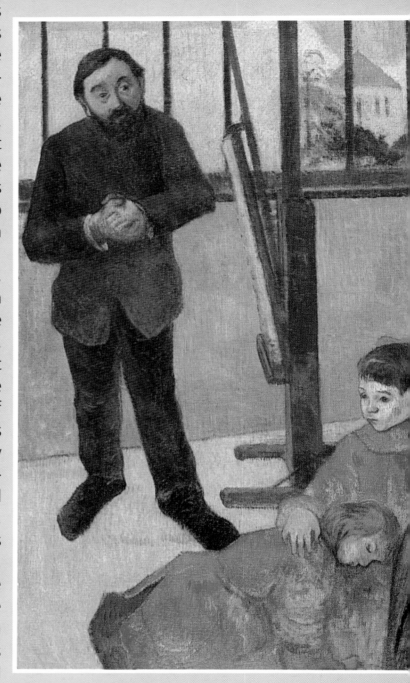

124. Paul Gauguin
The Schuffenecker Family. 1889
72 x 92 cm
Musée d'Orsay, Paris

150

portrait-scenes or the new variant of what was called «conversation pictures» at Hogarth's time. One finds even more similarity between this painting of Korovin's and Mary Cassat's exquisite «Cup of Tea» (circa 1880, Fine Art Museum, Boston), that Korovin could not possibly have known (56). All this testifies to Korovin's sensitivity to the atmosphere of the times.

It is interesting to note that immediately after his vibrant «Chorist Singer» Korovin turned to a completely different manner while painting his «At the Tea-Table».

He meticulously portrays all the numerous objects as if elements in a still-life. Moreover, a still-life so detailed that it creates the illusion of materiality, concentrating all the artists attention towards the centre. Even the faces seem accidental, whereas the samovar and the folds of the tablecloth are scrupulously delineated. This is not incompatible with the salient portrait characteristics, but they remain merely a part of the general pictorial effect.

Constantin Korovin once declared Velasquez as «the epitome of an Impressionist». (57) Just as Edward Manet did, Korovin also had his period of infatuation for Spain (58). In the nineteenth century Spain had become a virtual Mecca for European artists East of the Pyrrenees. Having visited this country, Korovin was inspired by the art of

56 The dates of Kovovin's first trips abroad are unknown. However, judging by the dates of his first pieces painted there, *The Tea* was finished after and *The Chorist Singer* before the painter may have seen the collection at the Luxemburg Museum in Paris.

57 Constantin Korovin Recollects, Moscow, 1971, p. 137.

58 It is not known exactly when Korovin visited Spain. He claims (Constantin Korovin Recollects, Moscow, 1971, p. 489) to have been there around 1885 in order to gather material for the scenery for the opera *Carmen* at the Mamontov Private Opera House. (Historians insist that Korovin first travelled abroad with Mamontov at the end of the 1880s. (R.I. Vlasov p. 36; Constantin Korovin Recollects, p. 858.)

151

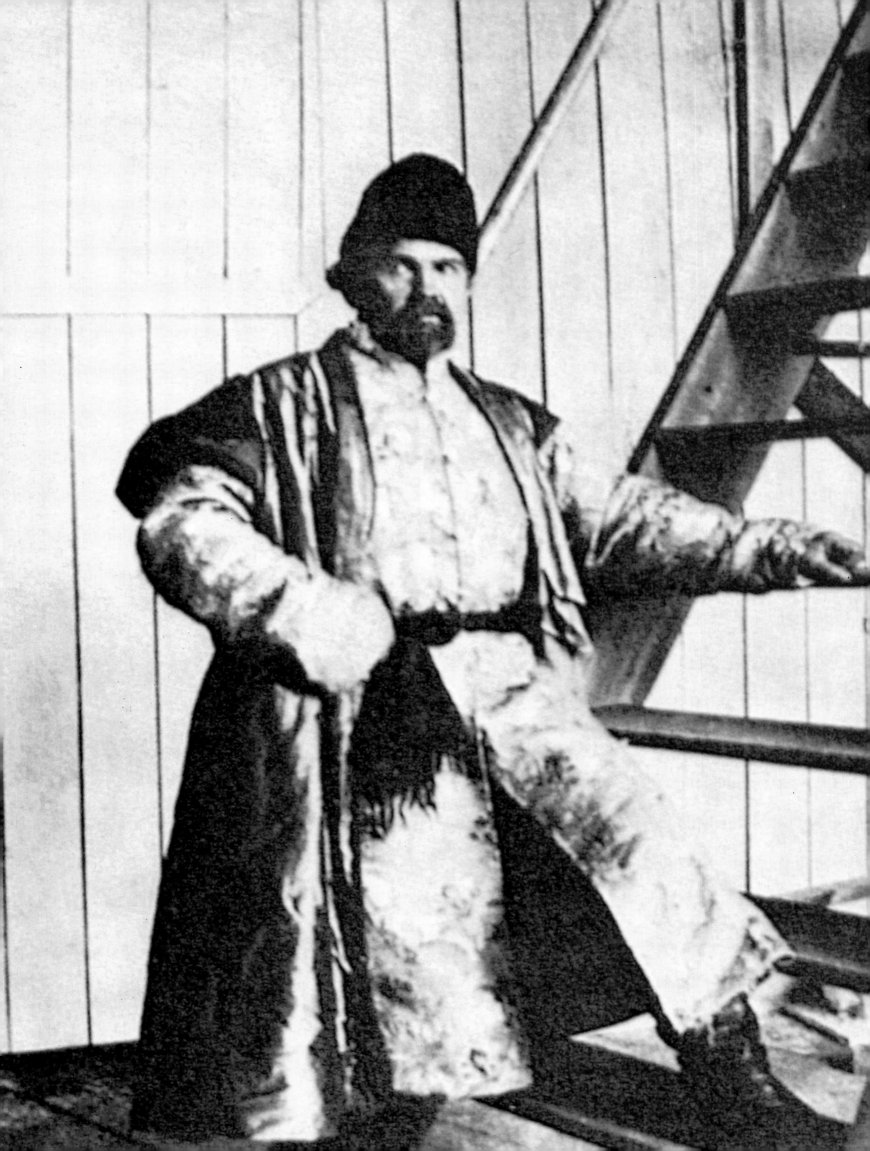

the old Spanish masters and their exotic motives. (59) Spanish motives however were present already in the imaginations of Russian readers before the mid-nineteenth century. Spain represented the unknown and romantic, unencumbered by political problems and having no real knowledge of their country. The Russian cultural conscience discovered the real Spain at the end of the eighteen-fifties, when Vasily Botkin published his famous «Letters from Spain». The subtle text, free from clichés and banalities, was greatly appreciated by the Russian reading public. It is not vital to know whether Korovin read the book or not, but rather, important to realise that Russian enlightened society already had a fairly concrete idea of a Spain no longer wrought with banalities and common clichés. Moreover, Korovin could have seen Edward Manet's paintings in which Spain appears as a new «pictorial source». Vrubel painted his panel «Spain» having never been to Spain. It remains true that Korovin's panel «*On the Balcony. Leonora and Ampara*» (1880s, Tretiakov Gallery, Moscow), is more authentic and closer to an «étude», but also far less profound. Nonetheless, it is filled with a «mighty breath», a feeling of strange and powerful impressions that are not fully understood.

Korovin painted his panel in Spain. In Valencia according to one source, and according to others in Barcelona. (60)

125. Surikov working on his painting Stepan Razin. 1906

126. Vasily Surikov Italian woman (Study for Rome Carnival). 1884 Oil on canvas. 40 x 30.4 cm Tretiakov Gallery, Moscow

127. Portrait of Vasily Surikov

With a true gift for subtle and yet naive observation, the artist describes the behaviour of the young Spanish beauties while in his studio: «I asked the hotel porter to find me a Spanish woman for a model. An hour later he brought me two young women. One, Ampara, wore a long mantilla; the other Leonora, a lighter brunette, was more modestly attired: a tight bodice and a black skirt. After entering the studio they stood by the window and without moving looked askance. I told them to keep the pose got my paints and started painting.» (61) In this passage the words «looked askance» are the most noteworthy. It is precisely this sharp and spontaneous impression of awkwardness that creates the originality of the scene, reminiscent of Serov's «Impressionist gesture».

The painting however does not have the majestuous *bas-relief* aspect that one finds in Manet's «Balcony» (1868, Musée d'Orsay, Paris), nor the mysterious force of Goya's «Mayas on the Balcony» (1808, Metropolitan Museum, New York) which inspired Manet and was probably also known to Korovin. (62)

Perhaps Korovin had even seen Goya's incredible frescoes where he depicts women on a balcony (1798) in the San Antonio of Florida church near Madrid.

One way or another the source of Korovin's painting can certainly be found in the Franco-Hispanic tradition.

In this painting, as in Serov's works, the characteristic of the «psychological study» remains. Here, Korovin does not present himself as a fully-fledged Impressionist. This aspect of the *étude* is achieved through the rapid and precise rendering of the characters and the volatile light, but not through the immediacy of the captured instant. Nevertheless, the painting possesses a careful and even monumental compositional structure rare for Korovin.

Impressionists were little interested in national colour or character and Edward Manet's Spanish paintings can hardly be ascribed to Impressionism. In England Claude Monet created his own London through Impressionistic pictorial molecules. These artists were neither preoccupied with a man's character nor the national particularities of a landscape, but moreso with the character of an instant, of the state of nature. In fact, Impressionist landscapes

128. Vasily Surikov
Boulevard Zubov in winter
Oil on canvas. 42 x 30 cm
Tretiakov Gallery, Moscow

154

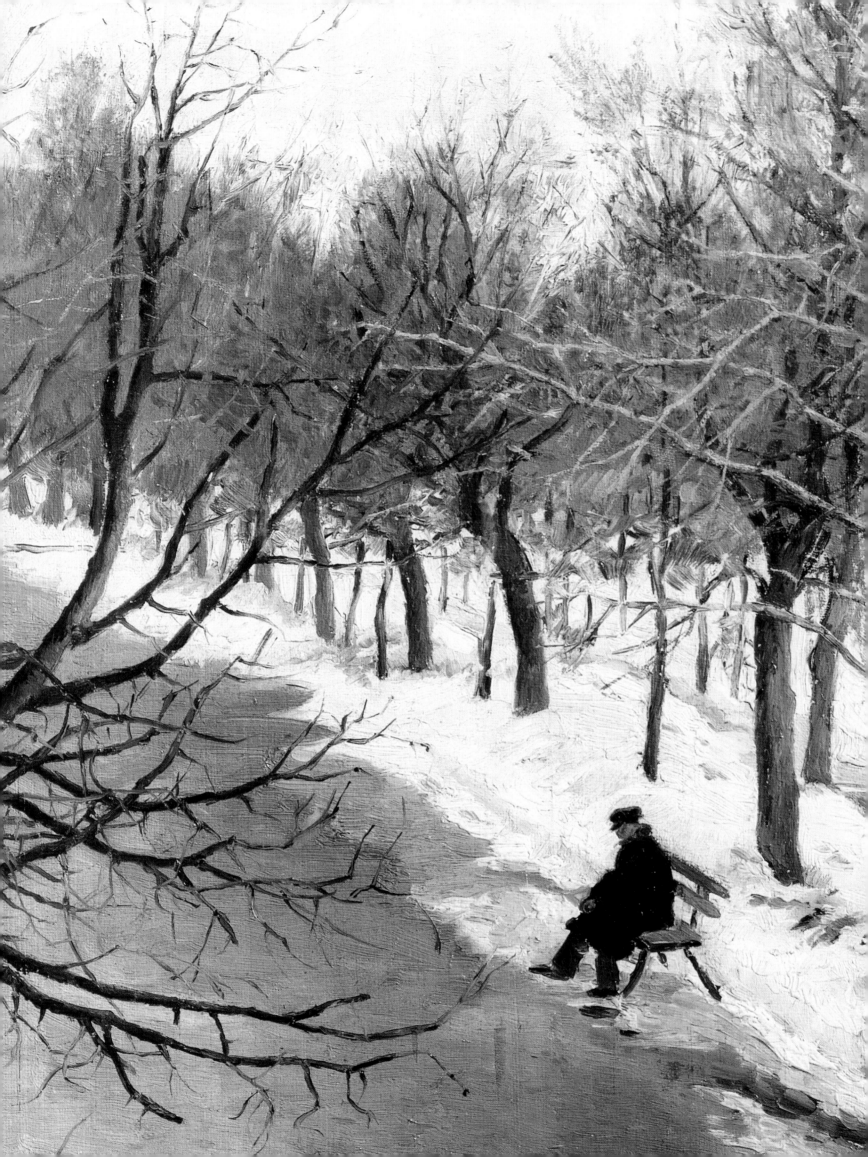

59 It is not exactly known where he painted this painting, in Valencia or Barcelona.

60 Constantin Korovin Recollects, Moscow, 1971, p. 501.

61 At that time *The Mayas on the Balcony* was still located in a private collection in Madrid.

62 Bunin compared the Parisian spring with spring on the Black Sea in Odessa: «... the painter got carried away by the beautiful Parisian spring and by the charming Parisian women in their spring clothes... And I thought of spring in Odessa for some reason... As an Oddessite, you know her particular charms. It's that mixture of the hot sun and the cool winter freshness of the sea, the bright sky, and the spring sea clouds.» (Bunin, Complete Works, vol. 7, Moscow, 1961, p. 121.)

always have a touch of French colouring. Russian painters, and primarily Constantin Korovin, either depicted Russian reality with French colouring or simply painted France.

A comparison of «*A Parisian Café*» (1892-1894, Tretiakov Gallery, Moscow), with «*A Café in Yalta*» (1905, Tretiakov Gallery, Moscow), (63) is sufficient to realise how the «Parisian pictorial substance» became universal and how Korovin's vision was completely subjugated by the French Impressionist vision. Indeed, Korovin worked in Paris in 1892 and did not conceal his enthusiasm for the paintings of his French contemporaries: «The French paint exceptionally well... Their technique is painfully good... it's impossible to paint anything after them.» (64) But it is unknown precisely who Korovin admired to such an extent. His «*Parisian Café*», just as his «*Café in Yalta*» are distinctly Impressionist in style. Yet the models painted in his studio (*In the Artist's Studio,* 1892-1893, Tretiakov Gallery and others), evoke more the brilliant masters of the Parisian salons who skilfully used Impressionist devices while painting their absorbing subjects. The weary ladies of Korovin's canvases, however paradoxical it may seem, remind us of the Parisian debuts of Giovanni Boldini (1842-1931) and the appearance of a new type of character found later in Proust's novels. Korovin's works of that period remained true to the narrative tradition, and yet were severely criticised in Russia: «...The young

129. Eugène Boudin
On the beach
Oil on wood. 23.5 x 33 cm
N. Altman Collection - Leningrad

artist is clearly slave to an unoriginal manner that is better known in the West. We fear that C. A. Korovin may take the slippery path of conventionality that will lead him straight to hideousness.» (65) The true affliction of traditional Russian and later Soviet criticism is the belief that conventionality is a vice. This constantly pushed Russian art in the direction of subject matter keeping it out of the general movement of European culture.

Korovin was able to stay true to himself even once he had begun painting France more often than Russia. His Paris may lack in originality, but the temperament of his brush retains the spontaneity which gives his paintings that particular fervent sketchiness.

Apparently Korovin was interested in Pissarro's works. (66) And one must assume that it was the older Impressionist's spatial structure that particularly appealed to the Russian-trained artist.

Korovin's Parisian night landscapes constitute particularly Impressionistic works. Perhaps here he was most Impressionistic when he tried to capture the instant effect of the night's lights and painted with feverish speed (67) It is doubtful that Korovin may have seen Whistler's famous «*Night in Black and White: the Fall of the Rocket*» (circa 1874, Art Institute, Detroit), but the French-American artist was fairly well known and Korovin could very well have been

63. Constantin Korovin, Life and Works, Letters and Recollections, Moscow, 1963, p.227

64. V. Mikheyev, Russian Art in 1894, The Artist, 1894, No. 37

65. R.I Vlasov, Constantin Korovin, Creation, Leningrad, 1969, p.97

66. Vlasov, ibid, p. 99

67. K.S Malevitch, Chapters from the Artist's Biography (1933) Kasimir Malevitch, Exhibition Catalogue Leningrad-Moscow- Amsterdam 1988-1989, p. 111

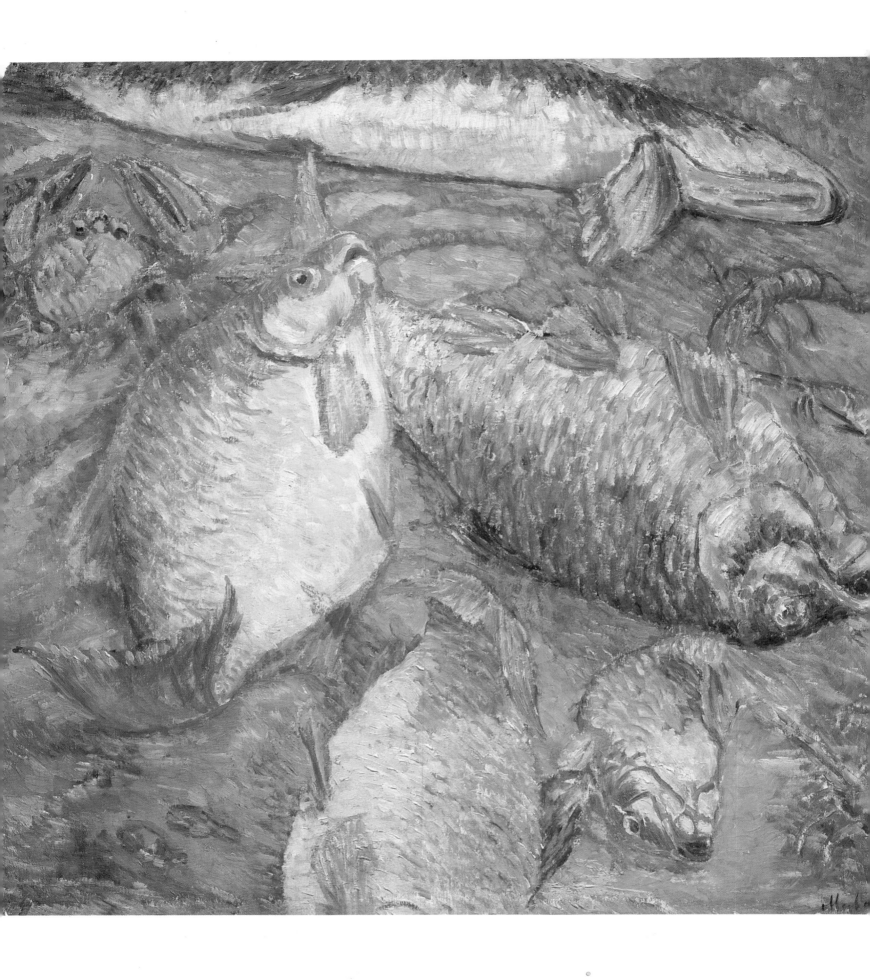

familiar with his nocturnal effects. The spatial dynamic of the Parisian night landscapes strangely blend with instantaneity of the motives captured in motion. The perspectives seem purposely careless, as if the artist wanted to create the impression of rapid movement. (*Paris. Café de la Paix*, 1906; *Paris at Night the Boulevard des Italiens,* 1908, Tretiakov Gallery.) Painted *alla prima,* the brushwork is unusually dynamic and dense; the atmosphere of the modern city, troubling and festive, is conveyed with rare force. In his «Paris in the Morning» (1866, Tretiakov Gallery, Moscow), to a certain extent Korovin combines the lessons learned from Corot's daybreaks with the Impressionist cityscapes. Of course only the Impressionists remained fully dedicated to Impressionism; but not all of them and not all of the time. Claude Monet alone stayed devoted to the cult of instantaneity until the end. As an old man at Giverny, he painted his never-ending lily-pads in the ponds, going from one easel to the next as the light changed. In this sense, no Russian painter, including Korovin, was truly

an Impressionist. The Impressionist lightness and the studied carelessness added vivacity to the Russian portraits, but was not able to give them what classic Impressionists considered most crucial; the effect of the fleeting moment. The famous «Portrait of F. I. Shalyapin»

130. Mikhail Larionov
Fish at sunset. 1904
Russian Museum, St. Petersburg

131. Mikhail Larionov
Radiating landscape. 1913
Russian Museum, St. Petersburg

132. Mikhail Larionov
Self Portrait Lithograph.
11.6 x 9.3 cm
Lenin Museum, Moscow

Next page
133. Mikhail Larionov
Rose bush. 1904
Russian Museum, St. Petersburg

159

(1911, Russian Museum, St. Petersburg), presents academic traits: the technique, the broad brushstrokes, everything seems as if dictated from a set recipe instead of the fruit of a moment's inspiration. Most importantly, even the loosest, seemingly careless and spontaneous brushstroke is subordinate to the object in Korovin's works. He does not want to let himself go and give himself entirely to the surface of the painting. This is very important in order to understand the difference between classical French Impressionism and its Russian counterpart. Russian Impressionism is eclectic and inconsequent, which is neither its weakness nor its strength, but merely a fact. This can also be said of other national versions of Impressionism. The powerful impact of the new artistic vision touched other Russian masters, although to a lesser degree than Constantin Korovin, who painted similar subjects to those of the French. On the contrary, Abraham Arkhipov (1862-1930) depicted traditionally Itinerant themes. Yet his Impressionist quest added a surprising and intense poetry to his old subjects, transforming and ennobling the «pictorial substance». In this respect Arkhipov was closer to the German tradition. Arkhipov's paintings are a special phenomenon in the history of Russian art. A pupil of Perov and Polenov, he was able to harmoniously combine the civic zeal and the gift of observation of the former with the *plein air* experience of the latter. In this sense, Arkhipov was surely an exception. Even if his later pieces evoke the superficial mastery of the Korovin of the 1910s or even Maliavin's phantasmagoria (*The Guests,* 1914, Tretiakov Museum, Moscow), his works from the turn of the century, and especially «The Laundresses» (1890s, Russian Museum, St. Petersburg; 1901, Tretiakov Museum, Moscow), bear witness to the «germination» of the Impressionist vision in a dramatic subject. The warm noble pearly colouring of the spots, distinctly outlined and alternating rhythmically with the silver streaks of reflections, create a precious pictorial substance. The epic sadness of the colouring and the harsh exactitude of the drawing transform this genre scene into an epic tale that is perhaps less artistic than works of Degas, but undoubtedly more tragic. This

134. Claude Monet
Rouen Cathedral. 1893
Oil on canvas. 101 x 65 cm
Pushkin Museum of Fine Art, Moscow
(S. Shchukin Collection)

163

astonishing painting is an exception in the evolution of late «Russian Impressionism», which tended toward the decorative effect, for example with the works of Jukovsky and Vinogradov. Sergei Vinogradov (1869-1938), like Korovin, was Polenov's pupil; Stanislav Jukovsky (1873-1944) studied under Kovorin, Arkhipov, Levitan and Serov, who were all artists of subtle but moderate talent. The wearied *étudisme* slowly dissolved into decorative colourism. Sometimes «Russian Impressionism» served as a basis for dreamy melancholy landscapes (*Spring* Vinogradov, 1902; *The Estate in the Fall*, 1907; *Spring Water*, Jukovsky, 1989, Tretiakov Museum, Moscow; *The Dam* 1919, Russian Museum, St. Petersburg). From being a means of liberating artistic creation, it slowly became a mere device, fully subordinate to subject-matter or even stylistics. But «Russian Impressionism» was destined to play a short but impressive historic role at the roots of the avant-garde.

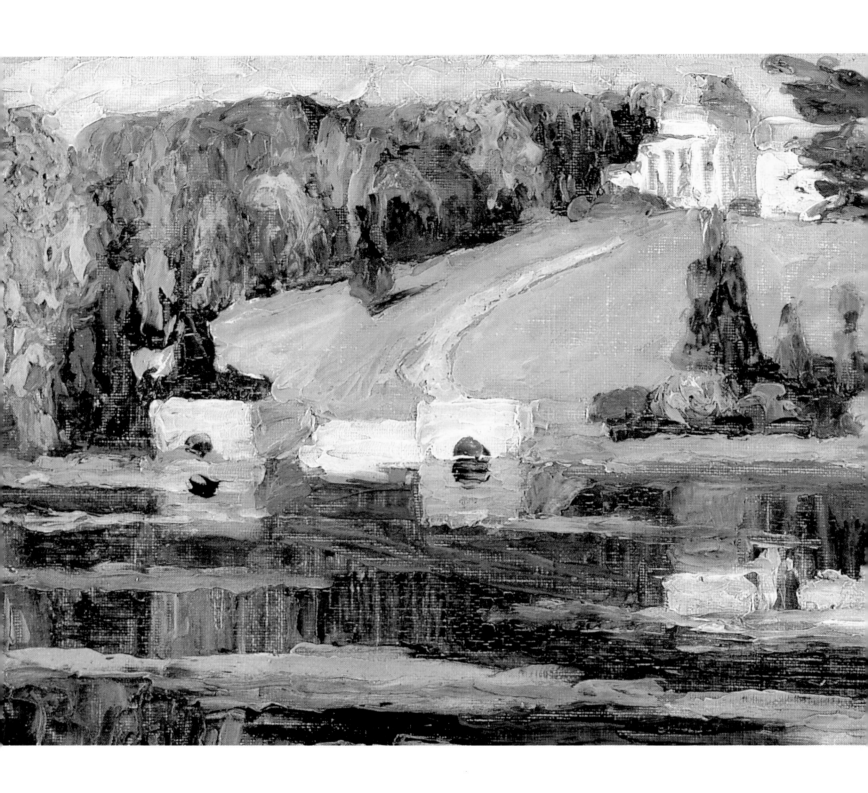

Epilogue: Impressionism at the roots of the avant-garde

It is difficult to discern the ardent and poetic spontaneity in the later works of many masters who as youths experienced Impressionism; difficult, when looking at Malevitch's mature conceptual abstractions or earlier cubist works, to imagine that in the beginning his artistic

creation was marked by the naive lyricism of the Impressionist experience. Indeed it seems that as Impressionism ceased to be a movement capable of generating new art, it remained the life-giving force that freed the artist from the fetters of tradition. What is more, the powerful temperament of Impressionist painting took hold of the young, pushing them to independence and daring quests. Impressionism transfigured the devotion to the ideals of art and the disdain for official success into a principle of intransigence, and as such inspired young artists not only in their choice of manner but in their choice of destiny, of which manner was but a component. Choosing the

Previous page
135. Vasily Kandinsky
*Kochel (Lake and Hotel Grauer Bär),
around 1902*
Oil on card, 23.8 x 32.9 cm
Tretiakov Gallery, Moscow

Previous page
*136. Vasily Kandinsky with students
of the «Phalanx» art school,
Munich around 1902
(Gabriele Münter centre, Vasily
Kandinsky right foreground)*

Previous page
137. Detail
*Kochel (Lake and Hotel Grauer
Bär).* Around 1902

*138. Vasily Kandinsky in front
of «Small Pleasure»*

139. Vasily Kandinsky
*Sketch for Akhtyrka.
Autumn 1901*
Oil on canvas. 23.6 x 32.7 cm
Städtische Galerie, Munich

*140. Kandinsky with his students
at Kochel, 1902*

141. Portrait of Kandinsky, 1976
Kindler-Verlag, Munich

Impressionist experience at the beginning of their careers, the young artists committed themselves to independence and daring innovations.

The majority of the famous artists at the turn of the century considered it their duty to visit Paris; some of them even sojourned there. By that time it was already impossible to see Paris other than through the «Impressionist prism». The blue-green colour of the trees

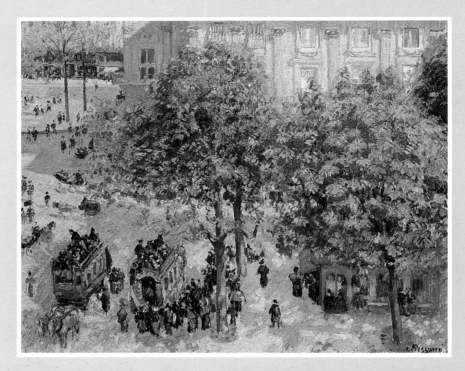

and parks, the dark-silver rooftops, the smoky-blue sky, the shifting translucid shadows, the specks of light on the roadways and the impetuous perspectives of the streets; they were all signs of a city transfigured by the new vision. The city literally «contaminated» artists with Impressionism.

Many artists, including Malevitch, never went to Paris. But the dream of modern art was already inseparable from Paris and Impressionism. Thus the adolescent paintings of Marcel Duchamp (1887-1968) (the painter was only fifteen at the time), «*Church in Blanville*» (1902, coll. Loise & Walter Arensberg, Museum of Art, Philadelphia), and «*Landscape in Blanville*» (1902, coll. Vera & Arturo Schwartz, Milan), carry the mark of a childhood under the influence of Impressionist painting. Edward Munch (1863-1944), before the influence of

142. Camille Pissarro
Place du Théâtre-Français, spring. 1898
Oil on canvas. 65.5 x 81.5 cm
Hermitage Museum, St. Petersburg
(Shchukin collection)

170

Gauguin and Van Gogh, and before he developed his own expressionist method, was not only influenced by Impressionism but interpreted it in his own way. During his first trip to Paris (1889-1892) he painted «*Rue la Fayette*» (1891, National Gallery, Oslo), depicting a summer stroll near *La Gare du Nord* with the full Impressionist gamut and even a touch of divisionism, thus paying tribute to Seurat's recent discoveries. The influence of Impressionism is equally present in the early works of J. Ensor. However the Impressionist period of these painters is far less distinguished than that of Malevitch or Larionov.

Russian Impressionism, as a form of «*protoavant-garde*», was all the more a completely different phenomenon from Korovin's empirical Impressionism. Kazimir Malevitch is perhaps the most renowned modern Russian

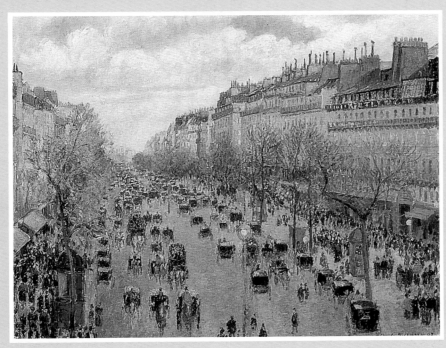

artist in the West, and his contribution to twentieth century art has been carefully analysed in recent years. In his works, Impressionism represents a natural landmark on the road towards non-figurative art, especially for an artist who grew up on the classics of traditional realism in the provinces. He studied at the Kiev School of Art and knew the works of Repin and Shishkin through reproductions. And yet even before his first trip to Moscow (1904) he became interested in the ideas of

143. Camille Pissarro
Boulevard Montmartre. 1897
Oil on canvas. 73 x 92 cm
Russian Museum, Moscow

171

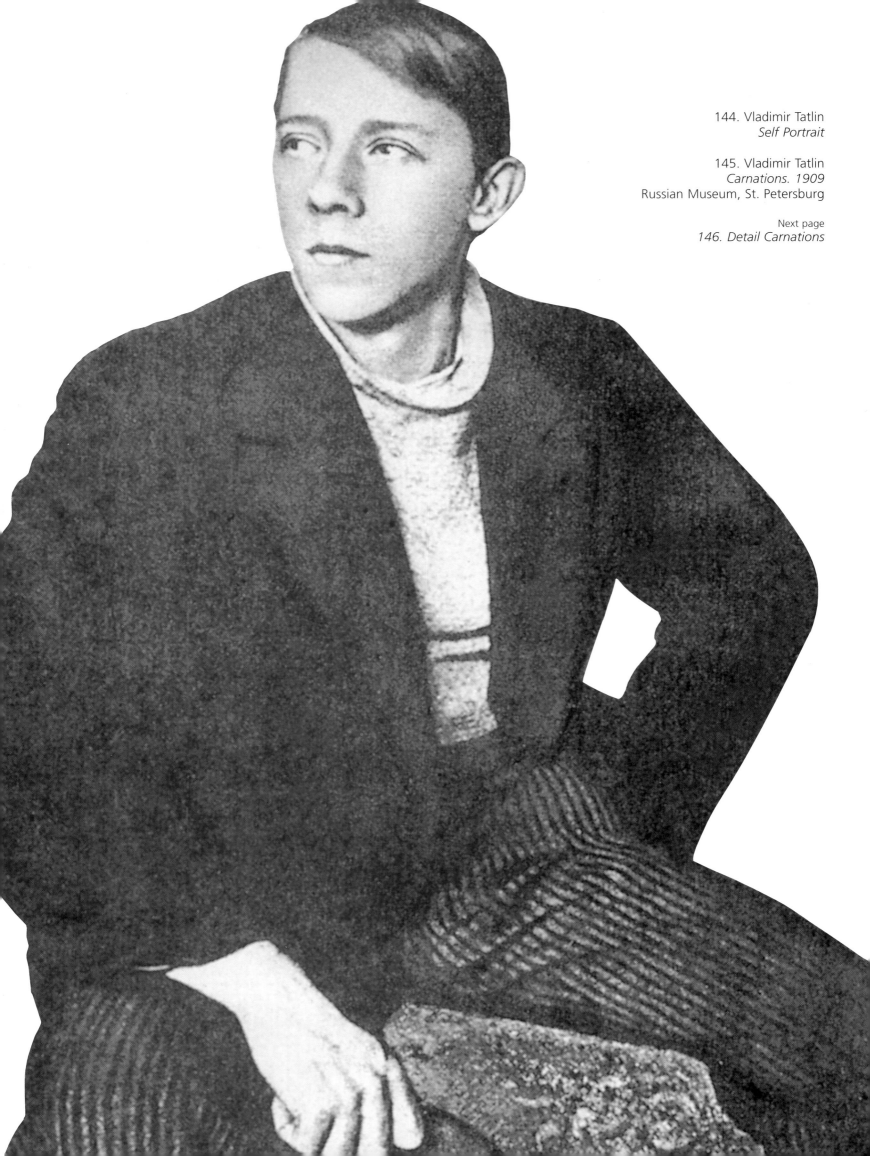

144. Vladimir Tatlin
Self Portrait

145. Vladimir Tatlin
Carnations. 1909
Russian Museum, St. Petersburg

Next page
146. Detail Carnations

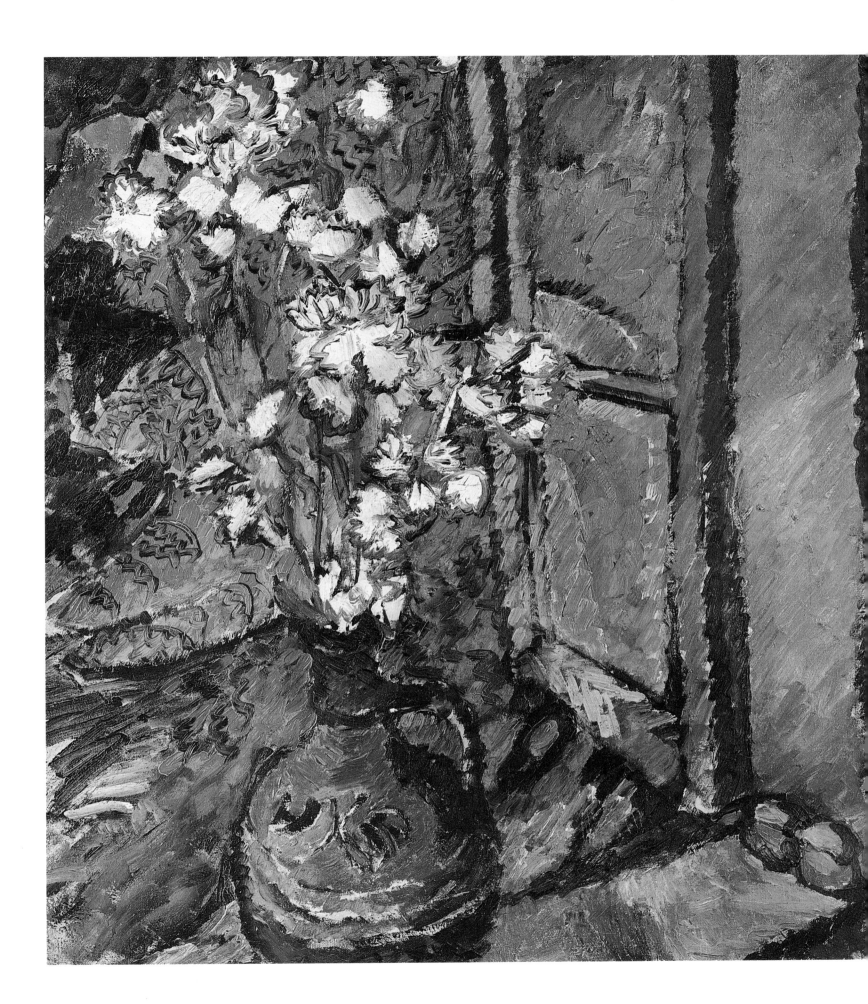

Impressionism. With his enormous talent and force, his reaction to the New art was impetuous. Thanks to his passion for analysis of contemporary art and his amazing intuition, he was able to grasp the very essence of the final conquests of the French school. Malevitch also possessed an incredible feeling for what was modern and was thus at ease in the elements of the new movements. « ... I stumbled upon an extraordinary phenomenon in my pictorial perception of nature... For the first time I saw the light reflections of the blue sky and its pure translucid tones. From that moment on, my palette became clear, gay and sunny...From that moment on I became an Impressionist.» (68) True, his «Impressionist» works are painted with such a heavy and doughy brushstroke, and such a weighty feeling of space, that one is inevitably reminded of Pissarro or more particularly Cézanne's Aix-en-Provence landscapes. In Malevitch's «*On the Boulevard*» (1903, Russian Museum, St. Petersburg), the pinetrees seem almost taken straight from Cézannne, and the shifting spots of the sun on the ground are so thick and pasty that the light seems as material as the earth itself.

147. Paul Cézanne
Still life with curtain. 1898-1899
Hermitage Museum,
St. Petersburg

For Malevitch Impressionism was a testing-ground, where he quickly added elements of Cézannism. In most of his works from the first half of the nineteen-hundreds, he builds space avoiding diagonals,

176

arranging the plans parallel to the pictorial surface with the majesty of «protorenaissance» monumentalism. Even his lightest almost «pastel» landscapes are underscored by a latent gloomy solemnity. «*The Apple-Trees in Bloom*» (1904, Russian Museum, St. Petersburg), is still a completely figurative and lyrical piece, but one can already sense the uncompromising structuralisation while the object world is reduced to slightly flattened volumes. The light-scarlet spots in the painting «The Flower Girl» and

its *étude* (both - 1903, Russian Museum, St. Petersburg), are considered Supremacist inlays in an Impressionist painting. The presentiment of future achievements and perhaps other factors (69) make this painting a strange mixture of what is to come and what is past, allowing one to understand how Suprematism stems from the paintings of the early nineteen-hundreds. Camilla Gray, for example, sees the lessons of Cézanne, Van Gogh, Gauguin, Derain, Vuillard and most of all Bonnard underscored in this painting. «From Bonnard he has borrowed a double plane, simply divided, using a prominent foreground figure seen against a plunging perspective.» (70)

Remembering the time after his trip to Moscow in 1904 Malevitch wrote: «In my garden-studio I continued to work on Impressionism. I understood that the essence of Impressionism does not lie in an exact depiction of the

68 It is possible that Malevitch finished both of these works in the 1920s, when it was necessary to show paintings of the artist's first period to the West.

69 Camilla Gray, The Russian Experiment in Art: 1863-1922, Leningrad, p. 145. Camilla Gray considers that *The Florist Woman* was painted after Malevitch's stay in Moscow, dating it between 1904-1905. The date is however not definitive.

70 K.S. Malevitch ibid, p. 108-110.

148. Igor Grabar
The Blue Tablecloth
Russian Museum, St. Petersburg

Next page
149. Detail
The Blue Tablecloth

phenomena or objects, but in the pure pictorial facture...
Analysing my own behaviour, I realised that I was in fact
working to disentangle the pictorial elements from the
contours of the phenomena of nature and free my
technique from the «domination» of the object... The
naturalisation of the objects did not satisfy me and I
began to search for different possibilities, not on the
outside however but inside the pictorial feeling, as if
expecting the painting itself to create the form emana-
ting from the pictorial qualities and avoid the electric link
with the object and with non-pictorial associations.» (71)
The exhaustion of the possibilities of ressemblant form,
the gradual reinforcement of an alternative value system
combined with the exterior qualities of the Impressionist
palette, are all present in the painting «*Girl without a
Job*» (1904, Russian Museum, St. Petersburg). A genre
painting in title as in theme, the woman's figure is trans-
formed into a harmonious spatial structure of intense
colourful radiating volumes, in no way connected with
the subject or the heroine. From one painting to the next
Malevitch's world becomes more and more material, but
it is not the materiality of the real world but once again
the materiality of the «pictorial substance», which is
thick, malleable, and heavier than reality itself; they are
clots of spatial substance, an abstraction of the object
world. (*Spring,* 1905-1906, Russian Museum, St. Petersburg.)
Although art historians have noted Malevitch's brief
infatuation with Bonnard, Art Nouveau, Symbolism, and
even Fauvism, they were nothing more than the necessary
steps made by an artist at the beginning of the century,
searching for his personality. Impressionism alone
remains the root of Malevitch's creation of the early
nineteen-hundreds. Irrespective of his brief predilection
for one or the other of these movements, all the works
from this period reveal the delicate painting of his
Impressionist youth, which can be discerned in the
«colouristic foundation» of his paintings, including his
«*Carpenter*» (1908-1910 or after 1927?), in which the
geometric structure, the manner reminiscent of icon
painting, and the approach of non-figuration suggest a
prologue to Suprematism.

71 «...Icon painters... rendered the content without respecting true anatomy and without spatial or linear perspective. They developed the colour and the form on the basis of a purely emotional perception of the theme.» The artist is prone to discovering things well-known to everyone, but this makes it possible to better understand his evolution.

72 See T. Goryacheva, Malevitch and Metaphysical Painting, Questions on Art Criticism, Moscow, 1993, No 1, p. 57.

73 Nicolas Punin (1888-1954), a remarkable art historian, professor at the Leningrad University, author of books and articles on art history and the problems of contemporary art. Victim of Stalin's repressions, he died in a concentration camp.

74 Article published in 1928. Quotation, N.N. Punin, Russian and Soviet Art, Moscow, 1976, pp. 134-135.

150. Paul Cézanne
Mont Sainte-Victoire.
1896-1898
Oil on Canvas. 78 x 99 cm
Museum of Modern Occidental
Art, Moscow

Malevitch's «*Sisters*» (1910, Tretiakov Gallery, Moscow), served as a sort of epilogue to his "Impressionist" period. He wrote on the back of the canvas: «*Two Sisters*» painted during Cubism and Cezannism. I painted this canvas while greatly influenced by Impressionist painting (during my work on Cubism) in order to free myself from Impressionism.» (72). Most of all the painting calls to mind Cézanne's brilliant water-colours which Malevitch could hardly have seen. The specific combination of lilac, rusty-red and cold-green, the modelling of the forms through colour and not tone, the use of an unprepared canvas, and the dense and heavy planar space; all this is obviously close to Cézanne's works. Especially if one considers his watercolour «*Potted Flowers*» (Musée d'Orsay, Paris), or his «*Women Bathing*» (private collection). Truly, if Impressionism helps the artist find freedom, then Cézanne helps him find himself. Two years earlier in his «*Women Bathing*» (1908, Russian Museum, St. Petersburg), Malevich creates an aggressive world of immobile phantoms where one can find a distant resemblance to metaphysical art (73) and Cézanne's colourism. In fact, it is not nature passing through the prism of the artist's temperament, but his predecessors means of interpreting it that leads Malevitch to his own vision.

Yet, Mikhail Larionov (1881-1964) was the only avant-garde painter who was not only captured by Impressionism but who also interpreted its essential principles. Nikolai Punin (74) perceived the main qualities in Larionov's approach to painting: «No other Russian «Impressionist» of these times has so fully conceived the unity of the pictorial surface. In all of his works, Larionov has realised the fundamental law of the pictorial construction, according to which the surface must not be destroyed by the explosion of separate planes.» For the Impressionist movement, which fought against the illusion of depth (perspective) and the modelling of forms through the *clair-obscur* effect, it was crucial to preserve this surface. The problem of «light and air» inevitably led the Impressionists to a unity and integrity of the surface. Contrary to most Russian imitators of

Impressionism, Larionov alone, fully sensed this essential quality of Impressionism... The second characteristic of Larionov's Impressionist works is their spontaneity. Again, contrary to the great majority of Russian Impressionists who had only assimilated the exterior devices of Impressionism and either stopped there or gone on to other methods (or manners), Larionov spontaneously mastered the entire pictorial culture, thus guaranteeing himself a broad and rich development. (75) Of course one must make allowances for the radicalism of the times and Punin's temperament. It is difficult to speak of a true understanding and practical use of Impressionism at a time when it had become a sort of «democratic academic manner». But Punin justly notes Larionov's ability to perceive the surface of the canvas as a value in itself; something the other disciples of Impressionism did not even attempt to do. Indeed, it was the appeal of formal values that determined the young artist's interest in Impressionism which was perceived as a way out of the traditional understanding of space and the illusory dwelling of the characters. Larionov's infatuation with Impressionism is usually dated from 1899, (76) when he could see the Monet's works at an exhibition and in Shchukin's collection. However, Larionov's earlier works already testify to an indubitable Impressionist influence and reveal a very original perception of the movement. Through colour planes and shifting light which do not disturb the overall feeling of rigorous logic, Larionov creates a solid, compressed, spatial structure in «A Square in a Provincial Town» (circa 1900, A. K. Larionov coll., Paris). All this calls to mind Pissarro's ability to combine the solidity of spatial structure with the fleeting sensation of instant colour-light effects. Later, Larionov uses the Impressionist repetition technique, painting the same motive several times in different lighting. The same subject «*A Corner in the Barn*» was exhibited under different names at the 27th exhibition of the students from the School

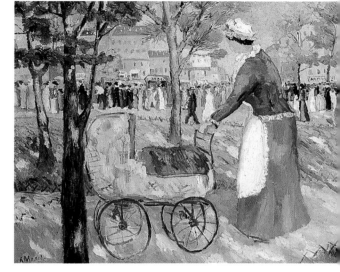

151. Kasimir Malevitch
Flower Seller. 1903
Russian Museum, St. Petersburg

152. Kasimir Malevitch
The Boulevard. 1903
Russian Museum, St. Petersburg

153. Kasimir Malevitch
Self Portrait

Next page
154. Detail
Flower seller. 1903

185

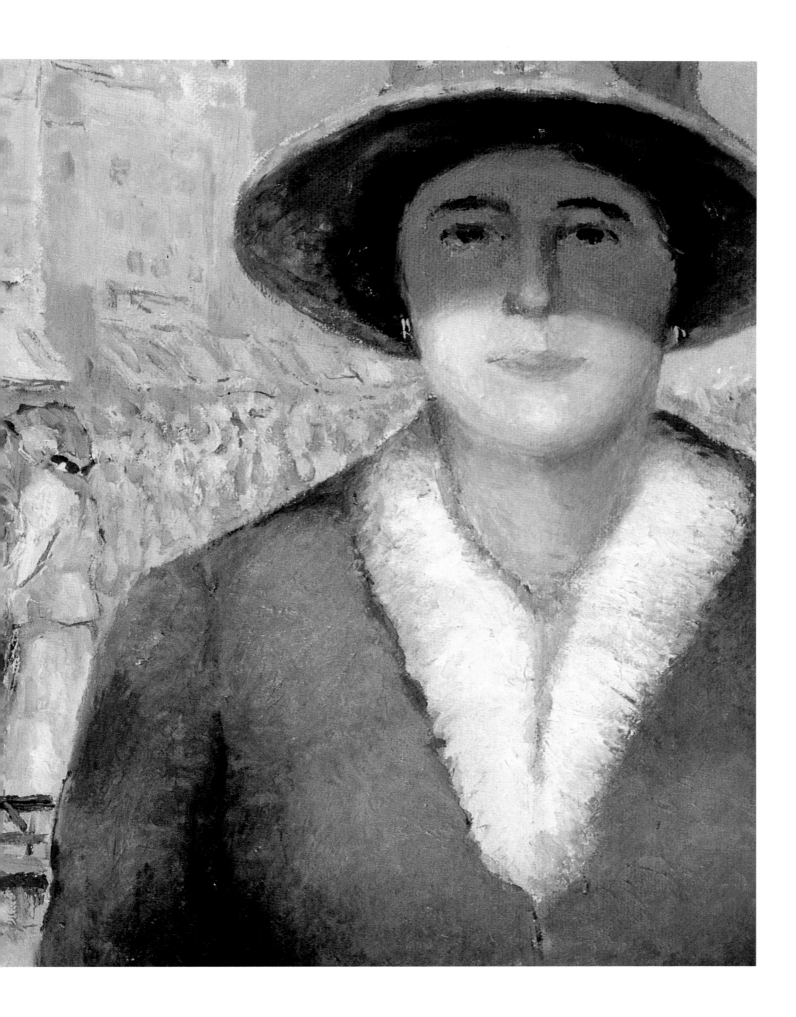

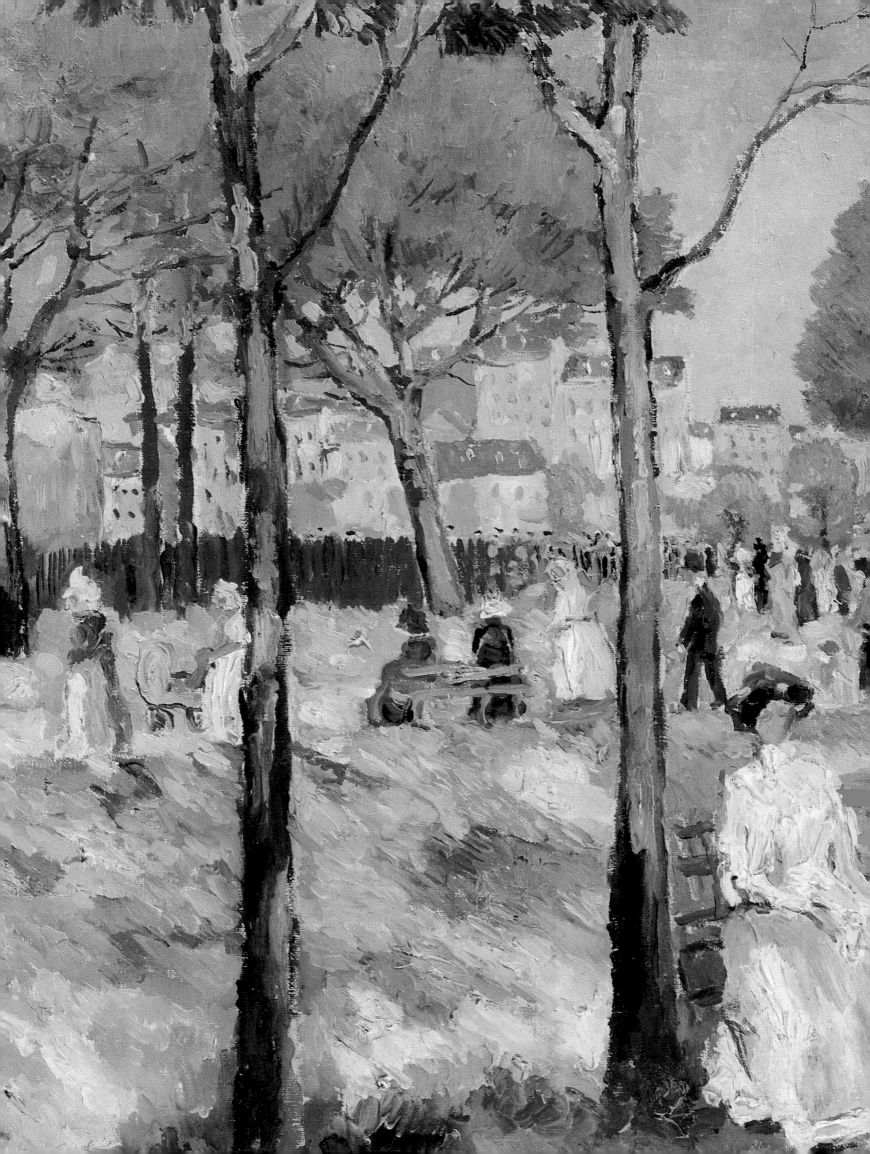

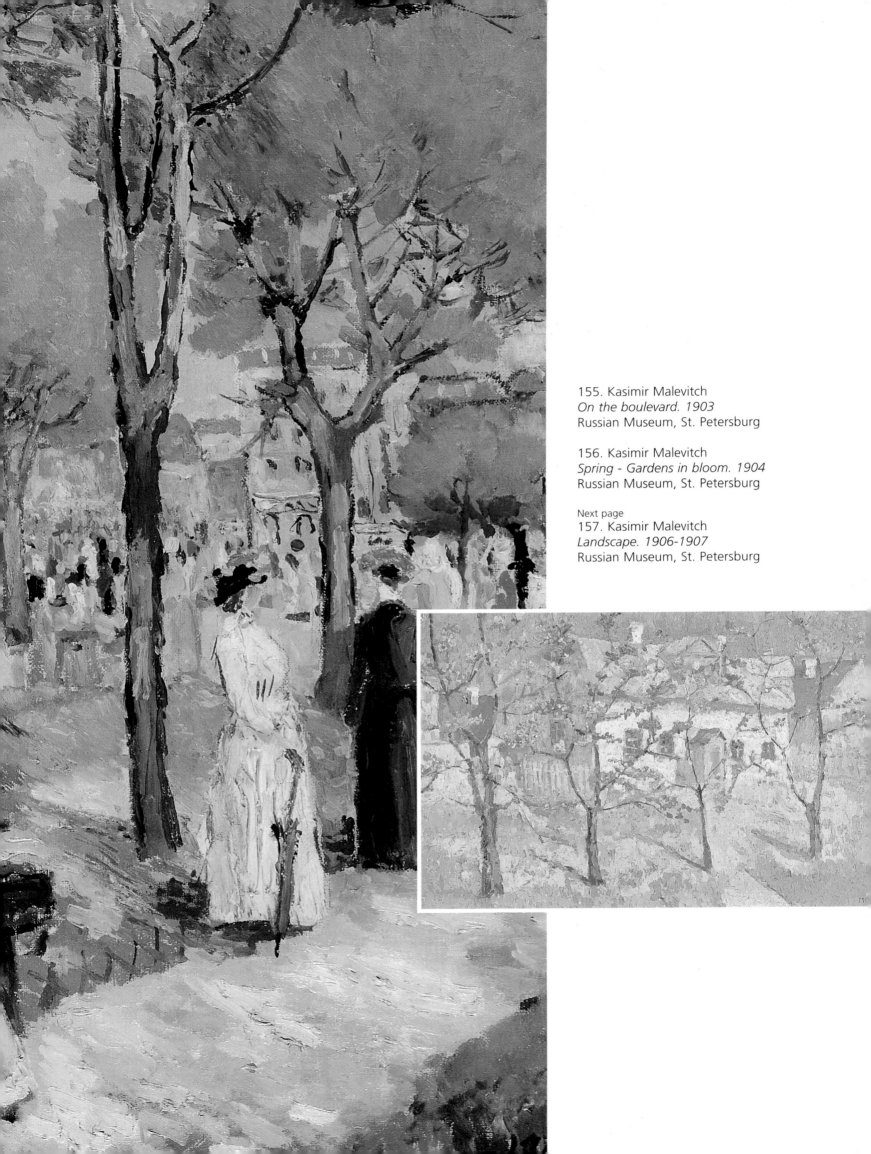

155. Kasimir Malevitch
On the boulevard. 1903
Russian Museum, St. Petersburg

156. Kasimir Malevitch
Spring - Gardens in bloom. 1904
Russian Museum, St. Petersburg

Next page
157. Kasimir Malevitch
Landscape. 1906-1907
Russian Museum, St. Petersburg

of Painting, Sculpture and Architecture: «First Hour. Combination of Rubies and Emeralds», «Second Hour. Combination of Topaz and Agate», «Grey Day» etc. In the painting «Twilight» (1902, Larionov coll.) the effect of the instantaneity of the lighting with a refined decorative landscape is united in a strange and wonderful way. But Larionov's paintings which have been classed under his «Impressionist period» (by Punin in the article cited above) clearly go beyond the limits of Impressionism. Contrary to Korovin's and Arkhipov's works, they are fully dominated by the precious pictorial

plane, the effect of the whole. With «The Rosebush after the Rain» (1904, Tretiakov Gallery, Moscow), one is bewitched by the almost aggressive energy of the diagonal brushstrokes that seem to claw at the canvas, transforming it into a taut and pulsating surface. In this sense Larionov is the first Russian painter whose interpretation of the Impressionist method succeeds in fully dissociating the pictorial facture from the object world. Only his painting is victorious over the object and achieves full independence. It is true that the creative force that gives this canvas its demiurge virtue also distances it from Impressionism and approaches Cézanne's attempts not only to create painting for painting's sake, but also his own universe.

Larionov's pictorial system developed somewhat paradoxically later on. In his earlier paintings, contrary to the Impressionists, the world existed outside the

158. Kasimir Malevitch
Fields
Russian Museum, St. Petersburg

objective state of natural lighting. The details of the landscape knew neither light nor shadow. They possessed a type of crystalline luminosity themselves diffusing intense coloured light. For this reason, the term «Rayonnism» proposed by Larionov himself as the term to define his works from 1912-1914 seems limited and belated. Larionov's «Rayonnism» is a Russian variant of Postimpressionism. He uses the achievements and palette of the Impressionist school, but rejects all the transient effects and builds a new reality, as in the words of Cézanne, realising his own sensation.

Moreover, Rayonnism was preceded by different quests that had no link with Impressionism. In 1906 Larionov, along with Diaghiliev and Kuznetsov visited Paris. After this visit, the attraction for intense coloured spots becomes the determining principle of Larionov's art. Undoubtedly, he was influenced by the Fauvists who had become quite famous after their first scandalous success at the 1905 Autumn salon. The end of the nineteen-hundreds also saw the appearance of Larionov's much acclaimed naïve «Soldiers Series». Rayonnism was a form of synthesis of Impressionism and Cubism; a fully original synthesis. Larionov himself affirmed that Rayonnism synthesised Cubism, Futurism, and Orphism.

Larionov's famous painting «Glass» (post 1912, Gugenheim Museum), can be considered a manifesto of Rayonnism. The Impressionist palette has become wan, but continues to burn at the syncopal edges of the complex construction, strangely calling to mind both crystal and picturesque forms of organic life. This painting echoes «The Rayonnist Landscape» (1913, Russian Museum, St Petersburg), and «*The Seaside*» (1913, coll. P. and I. Ludwig). One can find several parallels; however it is sufficient to recall that Erich Heckel painted his «*Glass Day*» (1913, Bavarian Government Collection, Munich), during this time, where the effect produced by the rays diffusing from the objects comes close to Larionov's vision. But perhaps Larionov was the only one - albeit not for long - to form this original synthesis between Cubism and colour, who was not fully

75 G.G. Pospelov, M.F. Larionov, Soviet Art Criticism '79, Moscow, p. 243.

76 «Thus, many things introduced by Larionov have been considered as a simple echo of the quests of Italian Futurists;» Filippo Marinetti noted at the time of his visit to Moscow: «Rayonnism, with which Larionov tried to «trump» the Italians, can be held in Boccioni's waistcoat pocket.» (Winter 1914.)

193

159. Kasimir Malevitch
Reapers.
1909-1910 (or after 1927?)
Russian Museum, St. Petersburg

160. Kasimir Malevitch
Carpenter.
1908-1910 (or after 1927?)
Ply and wood. 71 x 44 cm
Russian Museum, St. Petersburg

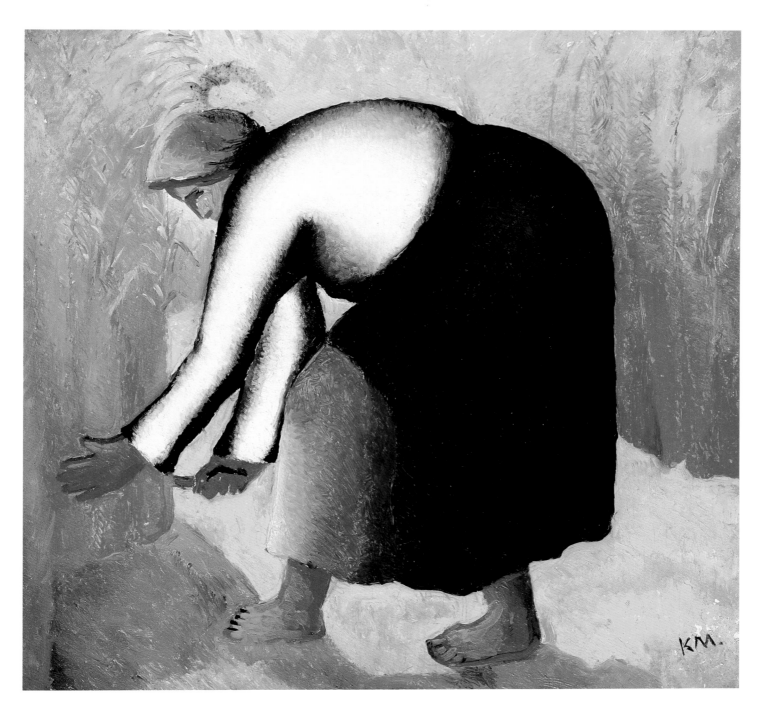

161. Kasimir Malevitch
Reapers. 1909-1910 (or after 1927?)
Russian Museum, St. Petersburg

appreciated at the time. Having fulfilled its historic mission, Impressionism faded into the past. Yielding to the cruel logic of the history of culture, the gay tranquillity of the Impressionist palette gave way to the rational constructions of *avant-garde.*

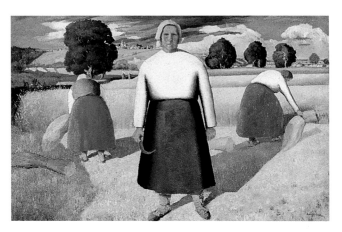

But Impressionism remained a type of «purgatory» allowing access to twentieth century Modern Art, through which all the great avant-garde painters passed. Even Kandinsky paid his tribute if not to Impressionism in its purest form, then to its clear and energetic palette.

His paintings «Kochel am See» (circa 1902, Tretiakov Gallery, Moscow), and «Akhtyrka» (1901, Lenbachhaus Gallery, Munich), are marked by the same *étudisme* as the works of Repin, Serov and Korovin.

The early works of the spirited Expressionist Alexei Yavlensky (1864-1941) offer a tender clarity (*Still-Life,* 1902, coll. V. Kudakov and M. Kashuro), while anticipating the intensity of colour of his Murnau landscapes.

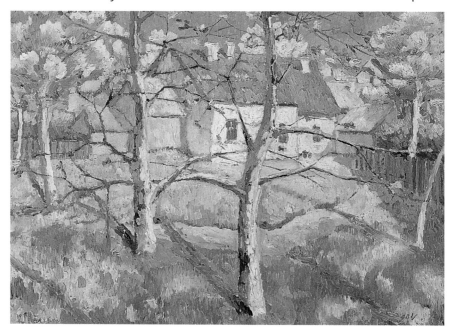

This also refers to David Burliuk (1882-1967) and many other painters who remained devoted, if not to the spirit of Impressionism, then to its devices.

At the time of his first contact with Larionov, Vladimir Tatlin also painted similar pieces (*The Carnation*, 1909,

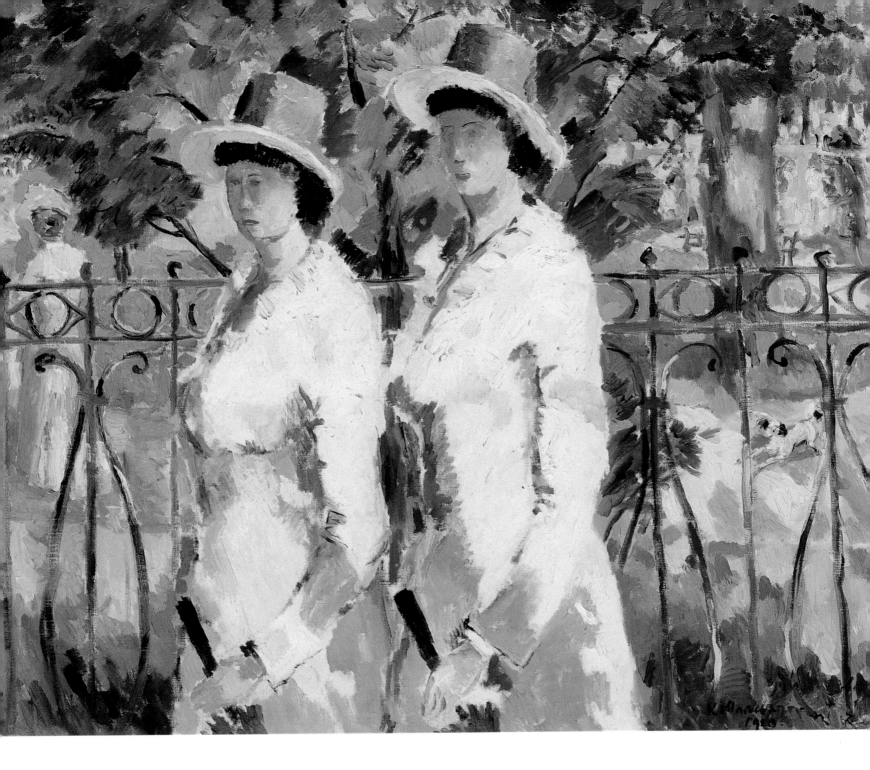

162. Kasimir Malevitch
Reapers. 1909-1910 (or after 1927?)
Russian Museum, St. Petersburg

163. Kasimir Malevitch
Blossoming apple trees. 1904
Russian Museum, St. Petersburg

164. Kasimir Malevitch
The Sisters. 1910
Tretiakov Gallery, Moscow

Next page
165. Detail
Blossoming apple trees. 1904

77 At the end of his life, when he was *excommunicated* from the *grand painting*, Tatlin returned to his manner of the 1900s in his still-lifes.

78 European Bulletin, 1879, L.

Russian Museum, St. Petersburg), turning later to a wholly different kind of medium.(77) Even Surikov used the Impressionist experience in his last landscape sketches. (*Square in front of the Moscow Fine Arts Museum,* 1910, Tretiakov Gallery, Moscow.)

The vitality of Impressionism and the provocative role it played in stimulating quests and innovations are truly extraordinary. So much so, that even in the thirties when *avant-garde* had already been repressed and where any reference to it was considered a crime, Soviet totalitarian criticism regarded Impressionism as one of the greatest dangers to «Socialist Realism».

Zola was certainly right when he wrote for his Russian Readers: «In the arts as in literature, form alone is capable of creating new ideas and methods.»(78)